The Politics of Modernism

The Politics of Modernism

Against the New Conformists

RAYMOND WILLIAMS

Edited and Introduced by Tony Pinkney

VERSO

London · New York

First published by Verso 1989
© The Estate of Raymond Williams 1989
Introduction © Tony Pinkney 1989
All rights reserved

Verso
UK: 6 Meard Street, London W1V 3HR
USA: 28 West 35th Street, New York, NY 10001-2291

Verso is the imprint of New Left Books

British Library Cataloguing in Publication Data

Williams, Raymond, *1921-1988*
 The politics of modernism : against the new
 conformists.
 1. Arts. Modernism, ca 1830-1976
 I. Title
 700'.9'034

 ISBN 0-86091-241-8
 ISBN 0-86091-955-2 Pbk

US Library of Congess Cataloging in Publication Data

Williams, Raymond.
 The politics of modernism : against the new conformists / Raymond Williams.
 p. cm.
 Bibliography: p.
 Includes index.
 ISBN 0-86091-241-8.–ISBN 0-86091-955-2 (pbk.)
 1. Modernism (Art) 2. Arts, Modern–20th century. 3. Avant-garde
 (Aesthetics)–History–20th century. 4. Arts–Political aspects.
 I. Title.
 NX456.5.M64W5 1989
 700'.1'03–dc19

Typeset by Leaper & Gard Ltd, Bristol, England
Printed in Great Britain by Bookcraft (Bath) Ltd

Contents

Acknowledgements

'When Was Modernism?' was a lecture given at the University of Bristol on 17 March 1987; the text is a reconstruction by Fred Inglis, Reader in Education at the University of Bristol, from his own notes and the lecture notes used by Raymond Williams. 'Metropolitan Perceptions and the Emergence of Modernism' was first published as 'The Metropolis and the Emergence of Modernism' in Edward Timms and David Kelley, eds, *Unreal City: Urban Experience in Modern European Literature and Art,* Manchester University Press 1985. 'The Politics of the Avant-Garde' and 'Theatre as a Political Forum' were first published in Edward Timms and Peter Collier, eds, *Visions and Blueprints: Avant-Garde Culture and Radical Politics in Early Twentieth-Century Europe* Manchester University Press 1988. 'Language and the Avant-Garde' was a lecture given at the conference 'The Linguistics of Writing' at the University of Strathclyde, 4–6 July 1986, and subsequently published in Nigel Fabb, Derek Attridge, Alan Durant and Colin MacCabe, eds, *The Linguistics of Writing: Arguments between Language and Literature,* Manchester University Press 1987. 'Afterword to *Modern Tragedy*' was published in *Modern Tragedy,* revised edition, Verso 1979. 'Cinema and Socialism' was a lecture given at the National Film Theatre, London on 21 July 1985; it is published here for the first time. 'Culture and Technology' forms chapter five of *Towards 2000,* Chatto and Windus 1983. 'Politics and Policies: The Case of the Arts Council' was the 1981 W.E. Williams Memorial Lecture given at the National Theatre, London on 3 November 1981, and first published in the pamphlet *The Arts Council: Politics and Policies,* Arts Council of Great Britain 1981. 'The Uses of Cultural Theory' was a lecture given at the conference 'The State of Criticism' organized by Oxford English Limited at the St Cross Building,

Oxford, on 8 March 1986; it was first published in *New Left Review* 158, July–August 1986. 'The Future of Cultural Studies' was a lecture given to the Association for Cultural Studies at NorthEast London Polytechnic on 21 March 1986; the text is an edited transcript of the recorded lecture. 'Media, Margins and Modernity: Raymond Williams and Edward Said' is an edited transcript of a conversation which took place as part of a conference on Cultural Studies, Media Studies and Political Education, which was held at the Institute of Education, London, in 1986.

Editorial Note

Raymond Williams's own most detailed plan for his 'possible book' is reproduced overleaf, but the reader will at once notice that our own organization of the essays differs from William's own in some respects. There are three reasons for not taking Williams's draft scheme as definitive. First, it omits 'Language and the Avant-Garde'; second, as the various arrows, asterisks and brackets on it suggest, Williams himself seems still to have been juggling with different possibilities for his essays; third, there exist two other, only slightly less detailed plans which differ in important respects from that reproduced here. Moreover, the absence of final drafts of two chapters and indeed of certain key pieces which Raymond Williams in the end never did write; and our decision, as explained in the Introduction, to include other, related texts which might thematically stand in for these unwritten texts itself necessitated further changes to the order of the essays. We have accordingly had to fall back upon what we believe to be the underlying logic of a developing argument to organize these essays, hoping in this to have remained faithful to the project that Raymond Williams had in mind.

TP

The Politics of Modernism
↓
Possible book

Now →*

* (New) Modernism & the Modern

Culture & Technology (from 2000) 12

Politics of the Avant-Garde 7

Metropolitan Perceptions ?

Theatre as a Political Form 7

Cinema lecture 5

Arts Council lecture 3

Nature of Cultural Theory 8

→ the New

−X Against the Conformists 10

———

Development of Cultural Studies 5
(London lecture)

62

Editor's Introduction:
Modernism and Cultural Theory

Invited in December 1987 to address the plenary session of a forth-coming conference on 'The Politics of Modernism', Raymond Williams replied, on 14 January 1988, 'I would be very glad to give the talk on "Marxism and Modernism" at Oxford on 7th May', adding, 'I have two new essays on Modernism just coming out in *Visions and Blueprints*.'[1] The essays did indeed come out a few months later, but the conference paper was never written or delivered. For twelve days after accepting the invitation, Raymond Williams died, aged 66, at his home in Saffron Walden.

That Williams had been working on or around Modernism and the avant-garde had been clear for some time. A set of five speculative 'hypotheses' about the nature of avant-garde formations appeared in *Culture* in 1981; trenchant brief analyses of Modernism and its para-doxical fate in the epoch of 'paranational' capitalism feature in 'Beyond Cambridge English' in *Writing in Society*, and in *Towards 2000*. In 1985 Williams contributed a keynote essay on 'The Metropolis and the Emergence of Modernism' to the volume *Unreal City: Urban Experience in Modern European Literature and Art*, finding here an intellectual team with which he would collaborate again in *Visions and Blueprints*. No one present at the conference on 'The State of Criticism' in Oxford in 1986 is likely to forget the resonating passion of his demand for a 'discrimination of modernisms' (to borrow an old phrase of Frank Kermode's); the very 'Uses of Cultural Theory' would then be the separating out of 'reductive and contemptuous forms' from the genuinely exploratory and experimental. In the same year Williams delivered 'Language and the Avant-Garde' to a conference at Glasgow. Some related book reviews also appeared in this period, including 'Real-

1

ism Again' on Lukács's *Essays in Realism* in 1980 and 'The Estranging Language of Post-Modernism' in 1983. And finally 'The Politics of the Avant-Garde' and 'Theatre as Political Forum' were published post-humously in *Visions and Blueprints* in spring 1988.

But after Williams's premature death, it wasn't initially clear what this body of work amounted to, and it seemed likely that the essays I've enumerated would be absorbed piecemeal into the various collections of Williams's writings that at once began to be planned. Only with the discovery, among his papers and notes, of detailed plans for a 'possible book' on *The Politics of Modernism* did the scope and unity of this, his last project, finally become clear, and could its components be rescued from distribution among several sets of *Selected Essays*-to-be: one of these plans is reproduced here as a frontispiece. Yet they themselves posed several editorial problems. The body of the text substantially existed, though a key piece on 'The Development of Cultural Studies' was never worked up into its final written form; in particular, Williams's thoughts on advertising as the final home of Modernism were never fully developed. More significantly, however, the first and last chapters – alpha and omega of Williams's reflections on Modernism, and titled 'Modernism and the Modern' and 'Against the New Conformists' respectively – seemed not to have been written. A set of lecture notes on 'When Was Modernism?' survives, and this seems likely to be a draft of the first chapter; but of the Conclusion, nothing beyond its intriguing title remains.

The loss of that paper is a grievous one, depriving this volume of the decisive polemical formulation of an intellectual case it is working towards throughout. Ever since Edward Thompson in his review of *Culture and Society* proposed 'whole way of struggle' as a better defini-tion of culture than Williams's own 'whole way of life', it has often been averred that Raymond Williams was too morally and politically gener-ous (and also too stylistically abstract) to be an effective polemicist. But just how wrong that assumption is can be felt here in the sustained power and vehemence of 'The Uses of Cultural Theory'; that 'Against the New Conformists' does not exist is no doubt fortunate for its intended objects, who were likely to have felt the justice of Williams's description of himself as at times a 'cold, hard bastard' in the wake of it.[2] But 'conformism', as *The Politics of Modernism* overall suggests, names an attempted break with or diagnosis of Modernism which in fact remains secretly in the grip of the latter's own categories – an instance of that tragic 'incorporation' which for Williams is decisively focused in the dramas of Henrik Ibsen. We have accordingly decided to include in this volume the 1979 Afterword to *Modern Tragedy* which captures at least the specifically literary side of any critique of 'new conformism', sober-

ingly demonstrating how self-congratulatory dramatic radicalisms so often remain captured by the very structures of feeling of their apparent opponents. And it will be one task of this Introduction to extend this case into cultural theory. For *The Politics of Modernism* insists that Modernism as a historical and cultural phenomenon cannot possibly be grasped by brands of literary theory which, in a self-serving circularity, are actually born out of its own procedures and strategies; and the book must accordingly be grasped as powerful topical intervention as well as local historical case-study in some general sociology of culture.

In 1983 Williams grandly announced that 'the period of conscious "modernism" is ending';[3] but if this was so, when had it begun? Whom did it include? Was the 'avant-garde' a synonym for it, a subsection within it, or an alternative *to* it? And what is a 'conscious' modernism? Could there be an *un*conscious one? As critics of many persuasions have pointed out, 'modernism' is the most frustratingly unspecific, the most recalcitrantly *un*periodizing, of all the major art-historical 'isms' or concepts. Announcing merely the empty flow of time itself, modernism in one sense begins when the static, mythic or circular (non-)temporality of the 'organic community' ends; and that tragic, dissociating moment – as Williams shows in his finely acerbic survey of the 'escalator' of organic society retrospects in *The Country and The City* – is subject to an infinite regress. No doubt all aesthetic innovations are felt as startlingly modern in their own historical moment, even when they launch themselves under the polemical slogan of a 'return to origins'. Yet when such unavoidable novelty, mere formal by-product of a stylistic innovation whose substance derives from other (religious, social) sources, is at last abstracted out as a content in its own right – a form become a substance, a matrix now paradoxically serving as its own material – we have indeed entered the epoch of 'conscious modernism'.

Yet the boundaries of this epoch prove troublingly elastic. A 'conscious' modernism by definition carries a theory of its own modernity, euphoric or dyspeptic as the case may be. In the former instance, art must enact, in both theme and form, the exhilarating dynamism of a post-traditional society which is brusquely sweeping away the restrictive remnants of feudalism, liberating not just science and industry but also the experiential possibilities of the individual self. True, such dynamism may have its destructive as well as energizing aspects; but its very devastations are of such 'world-historical' magnitude or unprecedented inner intensity that an art which turns its back on such turbulence has condemned itself in that very gesture to the greyest academicism. This ideology of modernism certainly captures much that we would conventionally want to pigeonhole with that label: the poetry of Baudelaire, of

whom Williams writes in *The Country and the City* that 'isolation and loss of connection were the conditions of a new and lively perception . . . a "spree of vitality", an instantaneous and transitory world of "feverish joys" . . . a new kind of pleasure, a new enlargement of identity, in what he called bathing oneself in the crowd';[4] or Rimbaud's famous clarion call, '*il faut être absolument moderne*'; or the enactment in the 'stream of consciousness' of Joyce and Woolf of the simultaneously fragmented and multiplied perceptual identities of contemporary urban living; Ezra Pound's 'Make it New'; and, most clamorously of all, Italian and Russian Futurism, for whom Marinetti's First Futurist Manifesto is representative: 'Up to now literature has exalted a pensive immobility, ecstasy, and sleep. We intend to exalt aggressive action, a feverish insomnia, the racer's stride, the mortal leap, the punch and the slap.'[5]

But this chronological focus, from about 1850 to 1920, cannot be sustained. The celebration of dynamism, the delirious multiplication of the possibilities of self, substantially precedes and succeeds this particular phase. William Wordsworth, after all, had not read Marinetti or Mayakovsky when he none the less registered an intoxicating 'post-traditionalist' expansion of the psyche in the opening lines of *The Prelude*:

> The earth is all before me. With a heart
> Joyous, nor scared at its own liberty,
> I look about; and should the guide I choose
> Be nothing better than a wandering cloud
> I cannot miss my way. I breathe again!
> Trances of thought and mounting of the mind
> Come fast upon me . . .

Once modernism is defined essentially as *acceleration*, Romanticism's exploration of the perils and possibilities of cultural deracination ('Liberty') and its infinitized subject, at once becomes a modernism – even if it remains notably short of Marinettian motorbikes and machine guns. But so too, at the other end of the chronological spectrum, does much of what we might otherwise regard as *post*-modernism. When Deleuze and Guattari declare in *Anti-Oedipus* that 'a schizophrenic out for a walk is a better model than a neurotic lying on the analyst's couch',[6] they clearly remain within the modernist problematic of Baudelaire's *flâneur* or Woolf's Mrs Dalloway ambling decentredly through central London. 'Flows' and 'deterritorializations' are here another jargon for Marinetti's 'beauty of speed' or 'multicoloured, polyphonic tides of revolution'; and the immobilizing enemy is no longer the Italian art establishment but the Freudian Oedipus. Modernism, in short, has on this showing become a perennialism, encompassing virtually the

entire span of post-feudal modernity; at a pinch Shakespeare's Edmund, Goneril and Regan might even get in.

'So let them come, the gay incendiaries with charred fingers!' Thus Marinetti, to the new Futurist generation he sought to call into being. But within a second 'conscious modernism' the incendiaries had *already* come, setting fire to the libraries and diverting canals through the museums, destroying aesthetic standards in the name of a banalized 'mass culture'. This second modernist ideology will sometimes overlap with the first in terms of its ultimate values – intensity, quality – but it sees these as virtues to be defended against the grain of the new (industrial, democratic, 'mass') civilization, not liberated by it. Modernism in this sense is *re*active, not enactive in Futurist fashion: still committed to the 'multi-coloured' and 'polyphonic' (though it would certainly baulk at 'revolution'), it sees these as threatened by the greyly 'standardizing' pressures of its contemporary environment. The greyer that world becomes, the more luridly its own apocalyptic rhetoric reads – to the point where T.S. Eliot sees in his secretary's supper of baked beans in *The Waste Land* ('lays out food in tins') a terminal threat to a Great Tradition that has come down to us from Homer. Modernism and modernity are by now mortal antagonists, not blood brothers.

As Raymond Williams notes in several of the essays below, this social position tends to come through as a proposition about language: 'ordinary' language is clichéd, one-dimensional, abstract; and 'poetic' language will accordingly embrace difficult, experimental forms in an effort to revitalize perception. This argument too captures much that we conventionally bracket together as 'Modernism': Flaubert and his *Dictionnaire des Idées Reçues*, Henry James's endlessly involuted late style, Eliot on the modern poet's need to 'force, to dislocate if necessary, language into his meaning',[7] Russian Formalist 'defamiliarization', the narrative dislocations of the later chapters of *Ulysses* or of the novels of William Faulkner. Within the binary opposition of ordinary and poetic language (or *fabula* and *syuzhet*, in terms of fiction), various kinds of cultural politics are possible. The Modernist work may disrupt routinized linguistic expectations: (1) because renewed perception is a Kantian end-in-itself (Russian Formalism); (2) because by showing social norms as historically constituted we may gain the power to historically change them (Brecht); (3) because by disrupting 'false' totalities – realism, say – the text gives the reader access to 'true' ones (the mythic substructure of *Ulysses* or *The Waste Land*). But the use-value of this Modernist hypothesis for literary periodization remains dubious. As with its Futurist counterpart, Romanticism is at once sucked in: Coleridge and Shelley had spoken of 'stripping the veil of familiarity from common objects' long before Viktor Shklovsky ever dreamed up

ostranenie; Goethe and Schiller agonized over linguistic degeneration a century and a half before T.S. Eliot in *Four Quartets*, pirating a phrase from Mallarmé, announced his intention to 'purify the dialect of the tribe'. And formal dislocation, obviously enough, continues to characterize many works, from the French *nouveau roman* onwards, that we might now want to term post-modern.

All of which is to say (as Williams will insist) that Modernism cannot be periodized by drawing upon its own internal ideologies – not even if we recognize that the 'enactive' and 'reactive' positions sketched above are part-truths which must be synthesized, Adornesque twin halves of an integral modernist practice to which they do not quite add up. But if its 'interior' were so treacherous, Marxist cultural historians were at once inclined, in a violent application of the maxim that 'social being determines consciousness', to leap to an absolute 'outside' and locate the origins of Modernism there.

The best known version of the argument is that of Georg Lukács and Jean-Paul Sartre: as the Paris proletariat headed militantly for the barricades in 1848, it took *out* the classicist or realist literary tradition before or as it took *on* the National Guard.[8] As the bourgeoisie, under working-class pressure, compromised its 'world-historical' anti-feudal role all along the line, so its artistic and other ideological production fell into terminal decline or 'decadence'. From Baudelaire on, but acceleratingly with the serried aesthetic 'isms' of our own century, literature marches down the stations of its Modernist 'degeneration'; and the task of the socialist critic is then to recall it to its former realist or representational glory, though now on a new class basis. Whereas the realist novel shows the dialectical interaction of individuality and politics within the active historical self-making of the bourgeoisie's 'heroic' period, in the cold climate after 1848 realist dialectics split apart into exacerbated subjectivity (Munch's *The Scream*, say) and extreme objectivity (Zola, documentary, photo-realism). And it was just such an analysis of the Modernist 'dissociation of sensibility' that Raymond Williams offered in 'Realism and the Contemporary Novel' in *The Long Revolution* of 1961: the novel of evanescent subjectivity and of 'social formula' – *The Waves* and *Brave New World* – confront each other stonily across a great chasm, as Zola and Mallarmé had for Lukács.

But the '1848 case' may have been most influential through Roland Barthes. For in *Writing Degree Zero* (1953), Barthes provided a mechanism of internal literary crisis more specific than Lukács's epochal 'decline' and, crucially, valued the subsequent Modernist project more positively than either Lukács or Sartre had been inclined to do. As the bourgeoisie rounds savagely upon the Parisian masses, so the claim to *universal* emancipation built into bourgeois ideology and Enlightenment

tragically confronts its own bloody limits; 'henceforth, this very ideology appears merely as one among many possible others; the universal escapes it, since transcending itself would mean condemning itself.'[9] Universality had been embodied in the linguistic 'transparency' of classical writing, an *écriture* that had once identified itself with Nature, Reason, 'things as they are', but which now finds itself stained with the blood of the proletariat. Modernist formal experimentation, thickening, twisting and dislocating the medium, both acknowledges and resists this 'guilt' of Literature; it is (*pace* Lukács) more contestatory than symptomatic.

> These have been, *grosso modo*, the phases of the development: first an artisanal consciousness of literary fabrication, refined to the point of painful scruple (Flaubert); then, the heroic will to identify, in one and the same written matter, literature and the theory of literature (Mallarmé); then the hope of somehow eluding literary tautology by ceaselessly postponing literature, by declaring that one is going to write, and by making this declaration into literature itself (Proust); then, the testing of literary good faith by deliberately, systematically, multiplying to infinity the meanings of a word without ever abiding by any one sense of what is signified (Surrealism); finally, and inversely, rarefying these meanings to the point of trying to achieve a *Dasein* of literary language, a neutrality (though not an innocence) of writing: I am thinking here of the work of Robbe-Grillet.[10]

But the very neatness of this thumbnail sketch at once exposes its limits. It is too specific to a single national tradition to serve as a general theory of Modernism; in Britain, after all, the upheavals of 1848 lead to a powerful *re*affirmation of classical writing in Matthew Arnold and George Eliot, not its Flaubertian disintegration into a 'problematics of language'.[11] Secondly, apart from the massive initial kickstart to the whole process given by the 1848 insurrections, this account of modernism is as internalist as those sketched above, which were based on its *own* ideologies; evolution, after the initial cataclysm, is purely autogenetic. Moreover, no significant sub-periodization within this epoch of the 'modern' seems possible for Barthes – though his own list, in which Surrealism as a collective movement immediately stands out from the other individual aesthetic projects, itself demands it. Even in Barthes's more finessed formulation of it, then, the 1848 theory remains too external to the Modernism it aims to explain, merely tacking a political bloodbath onto the front of what otherwise remains an autonomous literary series. 1848 is not a genuine alternative to Modernism's ideologies of itself; it is more in the nature of their mirror image, the grisly outside of their streamlined interiors. And whatever *did* change in European culture then will have to be thought through in models of tempor-

ality and the social formation much more complex than that 'expressive totality' which lets Lukács and others see every last tiny poetic image obediently mutating at the very instant the barricades are thrown up.

It was the steady strength of Raymond Williams's work over many decades to avoid the kind of sterile binary impasse I have been sketching here in the field of theories of Modernism; the most persistent conjunction in the titles of his books has been, precisely, 'and', attempting to put back together the scattered pieces of the jigsaw of our social being. Many of the terms which most preoccupied him fertilely yoke in a single category the entrenched positions of otherwise warring camps: 'culture', the body of intellectual and artistic activities but also a 'whole way of life'; 'literature', a privileged selection of creative works but also, in its older eighteenth-century sense, the whole field of writing; 'tragedy', what *Antigone* and *King Lear* exemplify, but also 'a mining disaster, a burned-out family, a broken career, a smash on the road'.[12] Such a theoretical habit of mind was always of course the product of a whole social experience rather than a deft intellectual knack; and this is perhaps nowhere more the case than in Williams's early exposure to Modernism. For as a student at Cambridge in the late 1930s he inhabited an intensely Modernistic political subculture around the university Socialist Club, which itself at that time connected with a socially broader-based radical Modernism; I have described the latter elsewhere.[13] Whatever discriminations he might later find it necessary to make among the varieties of avant-garde, all of them at this point seemed to condense into a buoyant cultural-political iconoclasm. In literature, *Ulysses* and *Finnegans Wake* were 'the texts we most admired'. In film, 'admiration for *Dr Caligari* or *Metropolis* was virtually a condition of entry to the Socialist Club', but 'we were also drawn to Surrealism'. In music, 'jazz was another form that was important to us.'[14] Nor was this Modernist orientation abandoned in the immediate post-war period. Williams's compulsive reading of Ibsen ('until, for a few necessary weeks, I had in effect to be stopped') opened a lifetime's concern with modern drama; and Ibsen was not so much *a* Modernist, a specific position within Modernism, as the whole gamut in a single extraordinary oeuvre of *all* its subsequent possibilities. Inventor of that crucial first bourgeois-dissident form, Naturalism (which Williams in this volume dubs 'Modernist Naturalism'), then of that mode of dramatic 'symbolism' whereby Naturalism gestures at all that which exceeds the windless closure of its bourgeois living rooms, Ibsen finally, with *When We Dead Awaken*, himself makes the break into Expressionism. Moreover, it was an encounter with the social thinking of the major strand of Anglo-American Modernism that triggered what we now take to be

Williams's most self-defining concern. Eliot's *Notes Towards the Definition of Culture* in 1948 brought forcefully back to mind the linguistic bewilderments of postwar Cambridge when 'I found myself preoccupied by a single word, *culture*';[15] and this debt to Eliot is then registered in the dramatic sphere by the overvaluing of his 'break' with Naturalism in *Drama from Ibsen to Eliot* in 1952.

But as Raymond Williams in these various ways pondered Modernism, postwar capitalism put it into *practice* in the 'glossy futurism' of the 'stylish consumer society which would be the new form of capitalism' from the 1950s on.[16] Blending Futurist dynamism with the cooler technopastoralism of the Bauhaus or Le Corbusier, such consumerism drove Richard Hoggart in *The Uses of Literacy* to fulminations against 'the shallower aspects of modernism', 'the nastiness of their modernistic knick-knacks', 'cheap gum-chewing pert glibness and streamlining',[17] and pushed even Williams back into what we might term his 'Lukácsian' phase. Yet the analogy with Lukács – a persistent one in discussions of Williams's work – at once needs qualifying. For even as Williams defended classical realism in *The Long Revolution* and announced that the critique of Modernism in *The Meaning of Contemporary Realism* 'deserves the most careful examination', he was also bluntly declaring that he 'disagreed fundamentally' with *Studies in European Realism* and found the argument of Lukács's *The Historical Novel* 'not easy to accept as stated'.[18] And clearly the detailed studies of an 'expanding culture' in *The Long Revolution* – education, the press, the reading public and, a year later in *Communications*, of radio and television – implicitly contradict the cultural nostalgia of 'Realism and the Contemporary Novel'. This structural contradiction then arrives at virtually explicit formulation in Williams's analysis of 'The Social History of Dramatic Forms', and in a manner that takes us to the heart of his later reflections in *The Politics of Modernism*. For Williams sees dramatic realism, in the naturalist social drama of John Osborne and his Angry Young Men, as part of the problem, not the solution. In contrast:

> the dynamism of which film technique and the Expressionist theatre have been masters, with the association of contemporary music, dance and a more varied dramatic language, seem to me the elements which correspond to our actual social history.[19]

It is, I would argue, *film* that is for Williams the pre-eminent Modernist medium; and this fundamental aesthetic predilection, which now needs to be established, decisively colours all his later theorizing on the topic.

'More than anything else the films', wrote Williams, fondly recalling Cambridge in 1939–41, 'virtually the entire sub-culture was filmic.

Eisenstein and Pudovkin but also Vigo and Flaherty.'[20] In 1948 he wrote a documentary film script for Paul Rotha on the agricultural and industrial revolutions, though the film itself did not in the end get made. In 1953 he was planning a film with Michael Orrom – 'an attempt to rework a particular Welsh legend in terms of a contemporary situation' – though this project too was not in the end made. The rewritten *Drama in Performance* in 1968, with its culminating chapter on Ingmar Bergman's *Wild Strawberries*, powerfully affirms the pre-eminence of film as a contemporary dramatic medium; and much of the thinking behind this claim derives from the 'manifesto' which Williams co-authored with Orrom in 1954, *Preface to Film*. As an extended critique of naturalist film-making, even in its 'modernist' guise as Eisensteinian montage, this book found its positive aesthetic exemplars in the German Expressionist films of the 1920s. *Caligari, Metropolis, Destiny, The Last Laugh*, despite certain reservations, best bear out Williams's notion of 'total expression' (a conclusion, one feels, that's preprogrammed by the very term itself); and Orrom insists that 'our task is to apply the principles established in these films to present-day dramatic feelings.'[21] Film then emerges as the *telos* of the great Naturalist dramatists: what Ibsen had imagined in *Peer Gynt* or Strindberg in *The Road to Damascus* would only become technically possible with the 'moving images' of the twentieth century. And Williams then rethinks the whole of Modernism in the light of film. Woolf and Joyce too, it seems, are film-makers *manqués*; for their fragmented 'stream of consciousness' is 'deeply related to several characteristic forms of modern imagery, most evident in painting and especially in film which as a medium contains much of its intrinsic movement.'[22]

This last quotation, however, is from *The Country and the City*, which breaks decisively beyond the aesthetic positions of *Preface to Film*. For though the earlier book is a defence of 'abstraction', 'stylization', 'formalization', it remains in the grip of a tenacious residual organicism; 'integration' is a term at least as frequent as the three buzz-words I've already listed. Orrom focuses the issues here in his critique of montage. This method of 'clash' or '"impact" cutting' creates, in his view, 'a feeling of shock which is generally undesirable', it verges on being a mere 'technical trick', even a 'disintegrating weakness'; in this filmic mode 'adequate spatial relationship is never established'. In contrast to all this, 'film expression demands movement, and *flow*':

> To get 'flow', the new concept is introduced from within the expression of the old; it begins as a small part of the first and gradually eclipses it. But the new is presented from a reference point within the old. This is precisely the method which must be used in film to avoid the disturbing jerks of cutting.[23]

That Williams shared these positions is clear from the closeness of the rhetoric to his own concerns in this period: to the defence of Edmund Burke in *Culture and Society*, whose 'circumspection' and sense of 'difficulty' emerge from a reverence for the slowly evolving organic textures of community, as against those rationalist innovators (the Futurists of their own day) who would wipe out the old in the name of the 'new' in a single stroke; or to the narrative method of *Border Country*, whose 'jerky' cutting between the father's past and the son's present is precisely related to a social failure of the new to find its 'reference point within the old'.

But in the two decades that separate *Preface to Film* from *The Country and the City* Williams's conception of the inherent nature of film as a medium shifts decisively. In 'Cinema and Socialism' in this volume, Williams notes that 'the first audiences for cinema were working-class people in the great cities of the industrialized world'; but this as it stands might still be a merely external connection between medium and venue. But already in *Second Generation*, when film is used as metaphor, a stronger relation between it and urban modernity is implied; as Peter Owen motors back to Oxford, roadside scenes 'momentarily flashed on a screen. . . . As in the traffic, most people were known in these isolated images, with a quick decision on relevance to oneself, in the rapidly changing series.'[24] *The Country and the City* then theorizes what had been felt on the pulses in the fiction. The quotation I began above continues: 'there is indeed a direct relation between the motion picture, especially in its development in cutting and montage, and the characteristic movement of an observer in the close and miscellaneous environment of the streets.'[25] Far from denaturing film, montage is now its very essence; or rather, it is the essence of film to have no essence, to be uniquely responsive as a medium to the disorientating ephemerality of the modern city. Film secretes the city in its very *form* long before it has ever announced it to us as an explicit theme (*Metropolis* and its successors) – and, indeed, even if it does not address it specifically. But if film is the definitive Modernist mode, then Modernism can now be located, not on the 'inside' of its self-validating ideologies nor in the 'outside' of a political trauma of the order of 1848, but in the *intermediate* zone of urban experience, in solution not as a precipitate, in a 'structure of feeling' that has not yet assumed the relatively formalized shape of aesthetic doctrine or political act.

Williams's position by now recalls Walter Benjamin's attempts to situate the origins of Modernism in 'Paris – the Capital of the Nineteenth Century'. Benjamin's claim that 'Dadaism attempted to create by pictorial – and literary – means the effects which the public today seeks in the film' anticipates Williams's own sense of the prefigurative dramatic

imaginings of Ibsen and Strindberg; and for Benjamin too, in the great
modern cities 'the shock experience has become the norm' and 'in a
film, perception in the form of shocks was established as a formal princi-
ple'.[26] However, it is not in the end twentieth-century technology but
nineteenth-century lyric poetry which is central to Benjamin's theory of
Modernism; and his focus on Baudelaire then at once has its limits as
well as its manifold illuminations. For Modernism in Baudelaire is a
matter of theme rather than form. True, the French poet once declared
of that indeterminate genre, the prose-poem, that it was 'a child of the
great cities, of the intersecting of their myriad relations',[27] but in *Les
Fleurs du Mal* the tight rhyming quatrains of the traditional lyric poem
survive intact. Both Baudelaire and Proust may (in Benjamin's phrase)
be attempting to produce authentic experience (*Erfahrung*) synthetic-
ally, but the former takes six neat stanzas to do this and the latter two
thousand odd pages; a theory of Modernism grounded in Baudelaire can
clearly not touch the specificity of these extraordinary later Modernist
projects. If the question of forms does not arise, neither does the issue of
formations – a more crucial absence still in the terms of Williams's own
cultural materialism: bold pioneer, Baudelaire is by virtue of that very
fact distinct from the militant avant-garde *groups* that succeed him.

Benjamin's elaborating outwards from Baudelaire of a general theory
of Modernism, his identifying of 'problems of perception and obser-
vation, leading to problems of writing, which [are] then referred to
social phenomena', was in Williams's view 'a sophisticated late form of
idealism' and the 'least interesting' of Benjamin's modes of cultural
analysis.[28] It was, indeed, in danger of being *absorbed* precisely by that
which it claimed to be analysing. Though in the case of Baudelaire,
Benjamin retains a properly critical distance to the shock aesthetics that
constitutes his subject's modernity, recognizing in the doctrine of *corres-
pondances* an indicator of 'the price for which the sensation of the
modern age may be had: the disintegration of the aura in the experience
of shock',[29] his massively influential essay 'The Work of Art in the Age
of Mechanical Reproduction' tends to fetishize just such an experience;
the aesthetic 'aura', which in the work on Baudelaire is the memory of a
prehistoric *promesse de bonheur*, is there almost purely elitist, passive
and ideological. Moreover, Modernism of the Baudelairean type
expands beyond any possible historical specificity, despite the initial
stress on a unique phase of Parisian history: it embraces equally *Les
Fleurs du Mal* of 1857, the first writing of Proust's *Recherche* between
1909 and 1912, and a potential anti-Fascist aesthetics in the late 1930s.
For those who uncritically endorsed Benjaminian or Brechtian positions
in the 1960s or 70s, its empire clearly extends even further. But by now
we have returned to the intractable dilemmas of periodization with

which we started, arriving once more at a 'perennialism' which we there noted as characteristic of Modernism's own internal ideologies.

Yet it can't be said that Williams's own *The Country and the City* successfully negotiates the problems which he had aptly identified in Benjamin. It implicitly seeks to periodize Modernism (a word which it in fact never uses), but can do so only in terms of a binary model of rise and fall – thus falling victim to the kind of critique that Perry Anderson launched of Marshall Berman's *All That Is Solid Melts Into Air* in *New Left Review*. For *The Country and the City*, as for Berman, the great 'Modernists' of the early twentieth century are paradoxically not really modern at all. True aesthetic modernity captures the indissociable ambiguities of modern city life: its simultaneous liberations and dissociations, its bizarre yoking of existential isolation and intense social proximity and even solidarity. Whereas Berman extols the multi-faceted grasp of modernity in Goethe, Marx and Baudelaire, Williams's heroes are Blake, Wordsworth and Dickens, authors alive to the constitutive contradictions of 'social dissolution in the very process of aggregation' in contrast to 'the later, more totalizing visions of the period after 1870'.[30] In this cultural phase, which is another version of *Culture and Society's* unsatisfactory 'interregnum', the earlier productive ambivalence splits 'into a simpler structure: indignant or repelled observation of men in general; exceptional or self-conscious recognition of a few individuals.'[31] This division is then taken into the very form of Modernist artefacts in the dissociation within *The Waste Land* or *Ulysses*, those great prototypes of twentieth-century urban Modernism, between texture and structure, between heightened or even pathological subjectivity and the static, absolutist myths which govern these texts. The argument exactly parallels Berman's claim that, after the heyday of his nineteenth-century triumvirate, their successors 'have lurched far more towards rigid polarities and flat totalizations', with genuinely Modernist ambivalence breaking down into Futurist or Le Corbusian technopastoralism and Expressionist or Eliotic *Angst*.[32]

This periodization of Modernism as 'decline and fall' is accompanied in *The Country and the City* by an unannounced methodological shift. For whereas the social situations of Blake, Wordsworth and Dickens are factored into the literary analysis of their texts, thus adumbrating the procedures that Williams would later theorize as 'cultural materialism', passages from Eliot, Woolf and Joyce are simply thrust at us as practical-critical 'words on the page', with no reference to the extremely diverse cultural formations and situations of their authors. The (unnamed) Modernism criticized here is as much an immanent textual construct as that celebrated in some of Benjamin's work on Baudelaire. Its analysis has not yet moved from the formal to the *formational*, and

we thus need to bring to bear on *The Country and the City* itself
Williams's methodological reflections on Benjamin and Baudelaire. For
of the three 'stages' or methods employed in Benjamin's *Passagenarbeit*
– 1. identifying urban features and then sketching their cultural impli-
cations; 2. identifying of social formations and social types, tracing their
milieux by economic analysis and their modes of observation and writing
by cultural analysis; 3. identifying problems of perception and writing
which are referred to social phenomena – it is 'in the first and second
stages' only that Benjamin is 'indispensable as well as brilliant'.[33] One
further reflection on *The Country and the City* is called for here. Much
of the book is in an 'English' idiom familiar from Williams's earlier
work. Its initial impulse came from the Leavisite ideology of the English
country-house poem, and even as it moves into the modern epoch its
focus remains narrowly English: Balzac, Baudelaire and Dostoyevsky
are consigned to a single paragraph of a four hundred page book. Only
the chapter on 'The New Metropolis' transcends this national frame-
work; for 'one of the last models of "city and country" is the system we
know as imperialism.'[34] Williams's analysis leaps, in a sense, from Blake,
Wordsworth and Dickens to Wilson Harris and James Ngugi, from
England to Third World in a single bold extension of cultural imagin-
ation and political sympathy. What is then missing, above all in terms of
a theory of Modernism, is Europe. The simplest meaning of 'new metro-
polis' – not world-system but the internal mutations of the European
capitals as a result *of* such a system – is effectively absent from the book.

It is this silence that Williams seeks to make good in 'The Metropolis
and the Emergence of Modernism' in the present volume – in the
process providing a new 'frame' for the polemic over Modernism in *New
Left Review* between Anderson and Berman. Williams here aims to
periodize Modernism by tracing the effects of a cultural imperialism
within Europe that accompanies its domination over the rest of the
world. Modernism is formal innovation as well as Baudelairean theme,
but then, crucially, such forms themselves have a *formational* basis – not
in the *bohèmes* or *flâneurs* of mid-nineteenth-century Paris but in the
'metropolitan-immigrant functions' of early-twentieth-century London,
Berlin, Vienna, Paris, St Petersburg.[35] Immigration had always been a
major imaginative preoccupation of Williams's: Matthew Price in *Border
Country* is studying population movements into the Welsh mining
valleys in the nineteenth century, and both he and the Owens family in
Second Generation represent a major population shift back *out* of them
in the twentieth. From fiction, the theme of immigration immigrates into
cultural theory; and for Williams it is in a generation of 'provincial'
immigrants to the great imperial capitals that avant-garde formations
and their distanced, 'estranged' forms have their matrix. Cubism may

well afford the most graphic instance, premised as it was upon the gathering of Guillaume Apollinaire (born Wilhelm Apollinaris de Kostrowitzki) and the Spaniards Picasso and Juan Gris in Paris in the first decade of this century. If immigration in this sense defines the new social base of Modernism, the paradox of the movement is that it is simultaneously the last gasp of the old cultural technologies: writing, painting, sculpture, drama, the 'little magazines'. Film then occupies a paradoxical position within cultural modernity, dealing it a deathblow in the very instant that it brings its most intimate aesthetic potentialities to birth. For though as a medium it is founded upon Modernist 'shock' experience within the metropolis, it leaps almost at once both behind and beyond Modernism, allowing only the briefest moment for the classic silent directors to actualize its 'inherent' experimental potentialities. In one sense, film announces the supersession of metropolitan Modernism in its mass-distributional aspects (later more fully actualized in television), with the Modernist dichotomy of mass civilization/ minority culture then giving way to the still undefined cultural relations of the 'modern transmitting metropolis'. But in another sense, as it moves into its own new technological phases of sound and colour, film takes a backward somersault behind Modernism, reinventing the latter's own realist past so thoroughly in the Hollywood domination of the medium that after the Second World War a whole new brand of *auteur* Modernism has to seek all over again to return film 'to itself', to drag it back into that twentieth century whose very epitome it once was.

We can resituate Perry Anderson's critique of *All That Is Solid Melts Into Air* within this broader framework. Anderson's assault on Berman's undifferentiated version of Modernism proposes that the latter 'can be understood as a cultural field of force triangulated by three decisive coordinates': (1) the persistence of aristocratic or agrarian ruling classes down to 1914, whose cultural analogues were the torpid aesthetic academicism against which the avant-gardes rebelled but also the aristocratic codes, values, motifs which they invoked as a critique of bourgeois social relations; (2) the arrival in relatively backward economies of the key technologies of the second industrial revolution; (3) the proximity of social revolution, especially after the Russian Revolution of 1905. Or in brief, Modernism 'arose at the intersection between a semi-aristocratic ruling order, a semi-industrialized capitalist economy, and a semi-emergent, or -insurgent labour movement.'[36] Within the new world-system whose nodes were the great imperial metropolises, these developments, which as listed by Anderson have a certain *ad hoc* air to them, fall into place. Already in *The Country and the City* Williams noted that though the aristocracy had lost much of its actual power, 'its social imagery continued to predominate';[37] in the epoch of competitive

imperialisms there was no more potent or 'visceral' a source of national-
ist ideology. And in *The Politics of Modernism* the latent tension
between 'aristocratic' and proletarian senses of 'anti-bourgeois' is seen
as a key determinant of the later political destinations of the avant-
gardes. Anderson's second and third coordinates are also brought to a
sharp focus in the metropolitan phase, where two 'layers' of urban
modernity productively fuse in ways we can no longer even imagine.
The 'Great Depression' from the early 1870s reinforced the urban vision
of the 'classic slum' from which socialism as a mass movement had
emerged – constituting in Williams's phrase 'the city's human reply to
the long inhumanity of city and country alike';[38] by the 1890s the
amorphous Baudelairean 'crowd' had given way to the massed, disci-
plined ranks of the Second International parties. But the world econ-
omic revival from the mid 1890s, fuelling new transport innovations and
research into the application of electricity to industry, inaugurates a new
phase of urban planning in which some of the worst horrors of the nine-
teenth-century slum are tackled and utopian visions of urban
decentralization are mooted (Ebenezer Howard's 'garden city' above
all). As cause and effect of this revival, there also emerge that whole
series of new inventions and products – mass-produced clothes, shoes,
china, paper, food, bicycles; but also cars, aeroplanes, telephones, radio
– which seem to announce a new human epoch and of which, for
Cubism at least, the Eiffel Tower becomes the pre-eminent symbol. But
whereas today revolution and the commodity, political activism and
technological novelty, responsibility and 'post-modernist' hedonism are
a rigid binary opposition we can hardly think our way out of, for the
early-twentieth-century metropolis they fruitfully interbreed: mass-
production is 'democratic', technology sweeps away vestigial feudal
survivals, and socialism will liberate a dynamism that capitalism fetters.
Hence it is that Anderson speaks of 'the gaiety of the first cars and
movies', and John Berger has movingly labelled the Cubists 'the last
optimists in Western art. . . . They painted the good omens of the
modern world.'[39] These immigrants from 'provincial' cultures bring with
them a memory of precapitalist social relations which it seems the latest
cutting edge of capitalist innovation is likely to restore almost by itself:
Picasso's African masks and Delaunay's Eiffel Tower between them
short-circuit the entire bourgeois epoch.

But if Williams has now 'diachronized' Modernism, must he not
'synchronize' it too? To be sure, it no longer runs seamlessly from
Wordsworth's urban vertigo in Book VI of *The Prelude* to our own day,
but pertains to 'the imperial and capitalist metropolis as a specific histor-
ical form'; but what then becomes of the Modernism/avant-garde

distinction – which was certainly already operative, though not yet theorized, when Williams reissued *Drama from Ibsen to Eliot* as *Drama from Ibsen to Brecht* in 1968? In Chapter Two of *The Politics of Modernism* that distinction itself appears to be a diachronic one, a matter of 'fully oppositional' artistic groups succeeding merely 'self-defensive' ones. Yet this theory will not bear probing too closely: if Brecht's major work postdates *The Waste Land* (1922), the achievements of Cubism, Expressionism, Italian and Russian Futurism all substantially precede it. 'Language and the Avant-Garde' formulates the issue differently. Here the distinctiveness of the avant-garde, beyond its national differences, is held to reside in its challenge to 'not only the art institutions but the institution of Art or Literature itself'; and behind this phrasing we can sense the presence of Peter Bürger's *Theory of the Avant-Garde*, of which there is (as far as I know) no explicit discussion in Williams's oeuvre.

Bürger's project parallels Williams's to the extent that he too is concerned to move beyond internal–formal analysis of avant-garde arte-facts (represented for him by Lukács and Adorno); but whereas Williams then investigates formations of production, Bürger's interest is in what we might term 'formations of reception'. Works of art are not, he argues, 'received as single entities, but within institutional frame-works and conditions that largely determine the function of the works.'[40] In Bürger's view, the avant-garde itself has arrived at this insight, rebel-ling not against a specific preceding style (as had all previous innovators) but against the very mode of reception, the 'institutionalized discourse about art', of bourgeois society. Central to that formation of reception is the category of *autonomy*, practically instituted by the shift from patron-age to the literary market in the eighteenth century and then theorized as the 'disinterestedness' of aesthetic judgement in Kant's Third Critique. Euphoric liberation in the first instance, autonomy soon condemns art to a social impotence which is progressively internalized in the artefact itself. Moral contents with their residual social purposiveness dwindle, and art has nothing to talk about except its obligation, within autonomy, to say nothing; 'institutional frame and content coincide', as Bürger puts it. But at this point in the late nineteenth century, with the 'aesthetic' constituted as a zone of experience in its own right, art-as-institution is ripe for its avant-garde dislodgement. Internally, the *anti*-organicist work rips apart a key category that had sealed art off from any social function; externally, the avant-garde shifts the very sites of aesthetic reception from gallery or museum to streets, factory or pub. Its project can be summed up in a single phrase: 'to reintegrate art into the praxis of life.'

Bürger aims to move from immanent analysis to the social function of

art, but his version of function, it must be admitted, is a notably 'inter-
nalist' one; apart from a few initial gestures towards a sociology of the
literary market, there is little concreteness to his account of the 'crisis' of
bourgeois art. What we witness rather, in his Hegelian framework, are
the mutations of a self-evolving dynamic system, what he at one point
terms 'the full unfolding of the phenomenon of art'. The 'metropolitan-
immigrant' moment of urban modernity, the second industrial revolu-
tion and October 1917 are minor historical hiccoughs which barely
disturb the elegant geometry of Bürger's bloodless categories. Moreover,
Bürger has considerable reservations about the destruction of autonomy
status for art; along with its social ineffectuality, he argues, its potential
critical distance is also lost, after which it degenerates into mass-cultural
crassness or Stalinist conformity, the dystopian 'reintegrations' of West
and East. Yet he cannot explain, within the terms of his system, why this
should be so.

It is here above all that Williams's cultural materialism is turned to
good account. Locating the social basis of the avant-gardes in the dissi-
dent bourgeoisie, Williams can show both how precarious the overlap of
social revolution and the 'revolution of the word' always was and how,
in some ways, the avant-garde actually anticipated the new post-1945
capitalist order. It was capitalism, not Futurism or Surrealism, that
successfully integrated life and art in a new phase in which the commod-
ity no longer feared culture because it had already incorporated it, was
more aesthetic signifier than humdrum use-value. The new technologies,
so inspirational for some avant-gardes, already announced this reinte-
gration, though Anderson is of course right in stressing their contempor-
ary social indeterminacy. With the motor car, telephone, radio,
aeroplane, with the new advertising and the 'Northcliffe Revolution',
capital prepared to colonize leisure, culture and the psyche. Practically
effecting what the avant-gardists only dreamed, capitalism may even
have owed a direct debt to the former's artefacts and technologies. Film
may be the archetypal Modernist medium, but even so resolute an anti-
'technological determinist' as Williams has to concede in 'Cinema and
Socialism' that it evinces a certain 'symmetry' with its latter mass-
cultural exploitation; 'the road to Hollywood was then in one sense
inscribed.' Or take the products of the Weimar Bauhaus or the buildings
of Le Corbusier. Was their 'new sobriety' truly a 'progressive' abandon-
ment of Expressionist hysteria and utopian-socialist vapourings in the
name of Communist efficacy and streamlined technological mass-
modernity, or did it not rather adumbrate a bleached capitalist function-
alism that had no place for Nature, subjectivity or dream? The
reintegration of art and praxis envisaged by William Morris was to take
place in the labour process, in the expressive creative freedom of the

artisan; there could be no more radical challenge to capitalist work relations. But the reintegration offered us by 'late' capitalism takes effect at the level of the *consumer*, closing the gap between aesthesis and use-value in commodities that then present themselves to the 'sovereign individual' in whose name, in Williams's view, much of the avant-garde revolt was launched. In Morris's utopia, with breathtaking logic, there simply *are* no works of art; the 'aesthetic' has been dissolved *in toto* into labour. Avant-garde artefacts, committed to some such reintegration, none the less remain precisely *artefacts*, even in their maximum dissonance and fragmentation; they remain somehow in the grip of the very aesthetic logic they were seeking to shatter, as Bürger's description of them as the 'self-criticism' of bourgeois art (rather than positive alternative to it) also seems to suggest. Hence it is, as Williams concludes sombrely in *Culture*, that 'avant-garde formations, developing specific and distanced styles within the metropolis, at once reflect and compose kinds of consciousness and practice which became increasingly relevant to a social order itself developing in the directions of metropolitan and international significance beyond the nation-state and its borders.'[41]

Of all the European avant-gardes it seems to have been Expressionism that most engaged Williams throughout his lifetime, producing the films that meant most to him as a student and remaining central, in its difficult break with Naturalism, to his later dramatic preoccupations. And yet it is Futurism, Italian and Russian, which dominates this volume of late meditations on the avant-garde. To ask why this should be so at once takes us to *The Politics of Modernism* as contemporary polemic and intervention. The linkage here is the work of Bertolt Brecht, though this was certainly not yet clear to Williams as *Ibsen to Eliot* turned into *Ibsen to Brecht*. Yet even here the shape of dissensions to come is adumbrated. In the mid 1950s the European tours of Brecht's Berliner Ensemble laid the groundwork of his subsequent massive domination of radical cultural theory and practice. In Paris, Roland Barthes was 'set on fire' (*incendié*) by a performance of *Mother Courage* and the passages of Brechtian dramatic theory printed in the programme. His magazine *Théâtre Populaire* had been calling for a drama that would treat social and political issues, and now it had found it; the defences of Brecht which Barthes then wrote were collected alongside work on Robbe-Grillet and semiology in the influential *Critical Essays* of 1964. The rigours of Theory in Althusser's *For Marx* (1965) were lightened by one chapter on aesthetics – 'The "Piccolo Teatro": Bertolazzi and Brecht' – and Althusser went on to generalize the Brechtian theory of *Entfremdung* to *all* art in his 'Letter on Art in Reply to André Daspre' (1966). In August 1956 the Berliner Ensemble played *Mother Courage, The*

Caucasian Chalk Circle and *Trumpets and Drums* at the Palace Theatre, London, and Brecht's long ascendency over British radical culture had begun. More important to us than the manifestations of this in the theatre itself (of which Williams regarded John Arden's *Sergeant Musgrave's Dance* as the key instance) is the form it took in cultural theory – often mediated, of course, by Barthes and Althusser themselves. A few famous instances must suffice: Stephen Heath published 'Lessons from Brecht' and Colin MacCabe 'Realism and the Cinema: Notes on some Brechtian Theses' in *Screen* in 1974; Terry Eagleton wrote a play, *Brecht and Company*, in 1979, and hardly a recent book of his has been without its chapter on the German playwright. Moreover, a whole series of books, including Catherine Belsey's *Critical Practice* and Anthony Easthope's *Poetry as Discourse*, whose avowed masters are Althusser, Lacan and Macherey, remain in the grip of the Brechtian problematic. Eagleton has presented his *Walter Benjamin* as a 'shift in direction', almost a *coupure épistémologique*, after his intensively Althusserian *Criticism and Ideology*, and the former book is certainly a lot more fun to read than the latter; but then a move from Althusser/ Macherey to Benjamin/Brecht is in fact more of a 'return to origins' than any kind of theoretical break.

At the very start of this 'Brecht epoch' Raymond Williams recorded major reservations. The burden of his critique in *Drama from Ibsen to Brecht* is that the 'complex seeing' which Brecht desiderates must be achieved 'not in the spectator but in the play', not as a mere set of presentational techniques of *Verfremdung* but as a dramatic 'convention' embodied in the work's own deep structure. And what he finds *in* that structure is more a 'dramatic negative' or Bürger-style self-criticism of the Naturalist tradition than its positive supersession. Brecht's work retains 'the characteristic poles of Expressionism', isolated individual versus total system, even though it also stands Expressionism on its head in locating the positive reference in the objective rather than inner world. But 'the dramatic form is not oriented to growth', Brecht 'is hardly interested at all in intermediate relationships.'[42] What was taken from Brecht in the burgeoning British cult of his work was in Williams's view quite other than this. Reduced to 'a new method of staging', Brechtian drama could be represented as 'the enthronement of the critical spectator. For many people it was and has remained very difficult to detach this position, which they immediately underwrote because it was where they wanted to live themselves, from the actual dramatic actions.'[43] And the Brechtian opposition of empathy and active detachment at once had a hefty weight of further theoretical baggage deposited on its shoulders: Lacan's dualism of Imaginary and Symbolic, Barthes's 'readerly' versus 'writerly' texts in *S/Z*, Althusser's distinction between

ideology and science, Marxist and Freudian theories of fetishism – all of which adds up to that theoretical formation which Easthope has recently dubbed 'British Post-Structuralism'.[44]

Verfremdung, by now, was the name of the game. The 'classic realist' text confirmed the subject in a position of ideological plenitude, papering over social and psychic contradictions; the avant-garde text, packed chock-a-block with alienation-effects, would disrupt and disseminate such fixities. And a good job it could, since there seemed little else with the power to do so. Ideology in its Althusserian version expanded to devour the entire terrain of lived experience – which only the dessicating algorithms of Theory or the 'internally distantiating' violence of the Modernist work could break free of. By which time this 'fashionable form of Marxism', in Williams's bitter words, had made 'the whole people, including the whole working class, mere carriers of the structures of a corrupt ideology'.[45] One could assemble from *Politics and Letters* a whole chrestomathy of remarks in which Williams, with an attractively unbuttoned anger not found in the more abstract critique of structuralist Marxism in *Marxism and Literature*, tackles this 'new idealism'; but what matters to us here is his later attempt to trace the genealogy of this formation. The thrust of cultural materialism had already been to situate Brecht's alienation-theory within the general dislocations and defeat, and then his own actual exile, after Hitler's rise to power; Brecht thus remains (to borrow a phrase applied to Peter Owen in *Fight for Manod*) 'within alienation analysing alienation'. Already it is clear that there could be no easy wholesale transfer of such methods to the utterly different British situation of the 1960s.

The identification of Modernism as a specific moment within the social form of the metropolis allows this analysis to be pressed further. Brechtian estrangement derived from Russian Formalist 'defamiliarization', and Formalism in its turn, as the rediscovered work of Mikhail Bakhtin and his associates now allowed Williams to see, was the theorization of Futurism in its earliest phase, that 'precisely violent but empty and unaffiliated moment' as he describes it in 'The Uses of Cultural Theory'. Lukács's own critique of modernism could then be 'Bakhtinized', as Williams does in picking out a phrase from Lukács's great commination of Expressionism to apply to the dilemmas of contemporary British political theatre:

> it will become more and more necessary to distinguish between genuinely innovative vitality – a unique resource for the bitter period ahead – and what Lukács, writing of a somewhat comparable phase, called an 'empty dynamism'. Some of the emphases on the vitality of live theatre as such, and then the too easy contrast with 'the box', seem to me to need reconsideration with this distinction in mind.[46]

In viewing *Caligari* and *Metropolis* now, Williams remarks in *Politics and Letters*, 'what I feel is "here comes the sixties". . . . There is . . . much the same interesting confusion in the sixties and the twenties of a kind of formalist radicalism and a socialist radicalism, which for historical reasons had got mixed up together. Eventually the two had and will have again to be separated.'[47]

Empty dynamism, of which Futurism is of course a much purer instance than Expressionism, has its theoretical (i.e. ideological) grounding in those Modernist 'absolutes' of metropolitan perception that Williams discusses in Chapter Two: the eternally new which is, in the very rhythms of the commodity itself, the eternal recurrence of the same. Far from being able to 'situate' Modernism, it is the latter's most distinctive product, thereby reducing so much left cultural theory since 1968 to what Franco Moretti terms a 'hermeneutic vicious circle . . . little more than a left-wing "apology of Modernism"'.[48] Funded by a merely 'negative energy', such avant-gardisms scatter when faced with the question Williams poses in his Afterword to *Modern Tragedy* when 'in a sobering second stage . . . what we want to become, rather than what we do not now want to be' becomes a crucial issue (this is, in effect, a return to Michael Orrom's critique of montage in *Preface to Film*). For one kind of formalist radicalism, these two questions are one: desire can only be defined negatively, differentially, it can be achieved in no settled relationship. But with this claim the avant-garde has regressed behind Naturalism itself; for Ibsen in his major phase had articulated the limits, the 'tragedy', of any such individualist or dissident-bourgeois project of liberation. From *Ghosts* on, the would-be avant-gardiste is shown to bear the substance of the old rejected world untranscendably within him or herself. But if, as in structuralist Marxism, the dynamic radicalism of shock-aesthetics is linked to a grand overarching vision of structural determination, then we have arrived at a specifically modernist structure of feeling; for as in *Ulysses* or *The Waste Land* the jolting montage of our line-by-line progress is held in check by the stately mythic substructures of the literary or social text.

The shape of a cultural present beyond such dead-end modernisms and their ratifying cultural theories remains, as Williams notes intermittently in this work, obscure. I have cited Williams's claim that 'the period of conscious "modernism" is ending', but if we turn back to his television reviewing of the late sixties and early seventies we can trace the very moment when this sense of Modernism's demise comes through, as a sudden shock or rupture in the texture of experience rather than as assured theoretical claim. Watching the BBC dramatization of *Roads to Freedom* and relating it to work by Huxley and Bergman, he writes:

the received high art, of the modern era, is of this other cold, neutral kind. I have reacted against it, so strongly, over a generation, that I was surprised to find myself thinking that the Sartre work, now, had become fixed and past, but also that one could see it more clearly. I felt there was no need to fight it, any more than one need fight Wycherley. It is no road to freedom, in any but a negative sense. There's a different, historical feeling: that is done and over, and is there to be looked at. It stands very like a monument of, and to, the end of an era: distant, solid, cold.[49]

In the event, of course, by that Brechtian voodoo I have charted above, Modernism was able for another decade or so to sustain a grisly afterlife in cultural theory and its associated aesthetic production. But if, in a more substantial sense, it *was* superseded, what was replacing it, what were the contours and politics of a new, putatively 'post-modern' moment? Two questions are condensed here, descriptive and prescriptive: how was late capitalism at large pushing beyond its high-modernist moment, but then also how should *we*, socialist critics *of* that order, sketch an active culture beyond the ambivalences of Modernism itself? Two questions, but a single political motif – populism – and a single cultural technology – television – are at the centre of Williams's reflections on them. Much of what we now dub post-modernism is, in his view, simply a continuation of Modernism, the old defamiliarizing forms and gestures launched from the old metropolitan centres but now tolerated and even actively cultivated by the very bourgeoisie they had once scandalized, the old formations now integrated into a capitalism which had itself mutated in their own 'paranational' direction.

What is distinctive in post-modernism, however, is that *populist* impulse effectively captured in the title of Tom Wolfe's *From Bauhaus to Our House* or in Andy Warhol's turning T.S. Eliot's apocalyptic baked beans tin in *The Waste Land* into his own *100 Campbell's Soup Cans*: the antiseptic, elitist, directive high-cultural impulse of Modernism assailed in the name of the warmer, more creaturely world of the mass culture where most of us actually live most of the time. For the more garish manifestations of this trend Williams evinced little patience; of New York Pop Art and its 'depriving objects of their functions', he once coldly remarked that it merely confirmed 'the pattern of the settlement: old orders and young pseudo-freedoms'.[50] And yet the value of the post-modernist populist impulse at least could not readily be rejected; indeed, it is in a sense at the heart of the very project of the 'cultural studies' which Williams in the early sixties invented. In 'Cinema and Socialism' below he returns once more to the question of the 'popular' – a category which had to be vindicated against its high-Modernist or Althusserian detractors but simultaneously rescued from its post-modernist or, later, Thatcherite exploiters. His novel *The Volunteers* is

itself consonant with this post-modernist drive, inhabiting and rework-
ing, rather than turning its back on in Eliotic scorn (George *or* T.S.), the
mass-cultural genres of political thriller or detective fiction; and by
common critical consent achieving considerable success in the process.
But aesthetic populism of this kind must itself become a formational
rather than merely formal matter, a shift in the social relations of
cultural forms rather than a pure act of individual authorial volition. Or
as Williams put the point in a discussion of the mass-genres of television,
'in this necessarily popular form the social basis of the fiction must be
popular: a life seen and experienced from inside, rather than by profes-
sional visitors.'[51] At which point he and a populist post-modernism still
(as its name suggests) secretly, guiltily in thrall to the very Modernism it
claimed to have surpassed, decisively part company. For Warhol's soup
cans work *only* if you remember the Twilight-of-the-West frisson of
Eliot's own; their vitality is simply his mandarinism inverted, and is
indeed bending back towards the classic technopastoralisms of Futurism
itself.

 We have by now already begun to trespass into the second, *pre*scrip-
tive question posed by the 'end' of Modernism: how might a socialist or
genuinely popular culture push beyond the frozen antinomies of Rilke
and radio, Proust and popcorn, high modernity and mass junk? This was
in a sense Georg Lukács's own cultural project. For it could be shown
that his version of reflectionist aesthetics did not so much annul avant-
garde shock-effects as decentre them, exposing their true nature as mere
'first-stage radicalism' (to borrow Williams's description of *Culture and
Society*). In contrast to the passive photography of Naturalism,
Lukácsian realism is an active 'uncovering' or 'penetrating' of the imme-
diately perceptible network of social relations; a reflectionism as active
in its metaphors as this, clearly, is more a version *of* defamiliarization
than its blunt rejection. Yet Lukács's sense of the new exploratory
relationships which might be found beyond this necessary aggressive
ground-clearing phase then notoriously falls victim to realist cultural
nostalgia. Raymond Williams's own major recommendation here would
seem to be: *television*, which he claims has the capacity to renew the
'naturalist project' in ways the minority theatres, however experimental
and socially aware, do not. In this at least he remains faithful to the very
avant-garde to which he addresses so many hard remarks in *The Politics
of Modernism*. His 'Cinema and Socialism' stringently examines the
argument or hope that new cultural technologies are inherently populist
or even radical – a position eloquently represented by Benjamin's 'Work
of Art in the Age of Mechanical Reproduction'; and few of the myths
attached to that early euphoria survive his searching scrutiny. Yet in the
early 1960s he himself seems to have seen television in Bürgerian terms,

as a possible break with the 'institutionalized discourse about art' or auratic mode of reception in bourgeois society, providing vast audiences as relaxed and 'distracted' as those boxing or racing cycling fans that Brecht himself saw as the model for an ideal theatre audience. Repeating the avant-garde project in this sense, regressing behind it to naturalism in its recreation of a window onto the external world from an enclosed living room, advancing decisively beyond it into the new cultural relations of the 'transmitting metropolis', television as a medium evokes in Williams all the ambivalence that the city crowd did for Baudelaire or film for Walter Benjamin; and its role in his general cultural thought remains to be fully studied. It is true that his judgements on it hardened in the 1970s, to the point where some of its popular genres and, above all, the formal techniques of its advertising could come to seem the last resting-place of the more negative dimensions of the original modernist project; dislocating and fragmenting objects, bodies and identities to the point where its subjects became available for reinscription by the imperatives of a cosmopolitan consumerism – buy this! own that! And yet even during this period of bleaker assessments of the new medium, it is noteworthy that the two political 'heroes' of Williams's later novels – Lewis Redfern in *The Volunteers* and Jon Merritt in *Loyalties* – emerge precisely *from* television.

I have said that, though it was Expressionism that aesthetically formed Williams, it is Futurism that preoccupies his final meditations on modernism. But we then need to stress how little, relatively, the 'high-tech' dimensions of Futurism feature in his account. What chiefly comes through in Williams's discussions of it is the theme of *irrationalism* – as if the early Expressionist stress on primeval forces (*Baal*) or the later Surrealist emphasis on the unconscious were being substantially imported into it; or as if, within Futurism itself, Khlebnikhov rather than Marinetti or Mayakovsky were its major representative. 'There is this decisive difference', Williams writes below, 'between appeals to the tradition of reason and the new celebration of creativity which finds many of its sources in the irrational.' The context of this remark is a contrast between Leninist and Marinettian models of revolution; it registers an unease with the former without by any means amounting to an endorsement of the latter. Yet we are moving here towards an account of the politics of Modernism which runs somewhat athwart the 'official' line of Williams's volume. According to the latter, the avant-garde is a dissident–bourgeois formation whose formalist and/or libertarian radicalism could at best relate to the working class only in that mode of 'negative identification' first theorized in *Culture and Society*; if its cultural sociology remained to be worked out in full, its yield of political

insight none the less seemed unlikely to be high. But the 'sub-text' of *The Politics of Modernism* runs the case rather differently: Leninism and the avant-garde are now the dissociated halves of an integral lived politics, a New Left 'third space' between reform and revolution that remains to be invented in full. The claim often emerges as trope rather than argument, in Williams's persistent juxtaposition or montage of the two forces. *Modern Tragedy* was already an instance of this, where a play on Stalin and meditations on the Bolshevik Revolution as tragedy sit uneasily side by side with a powerful critique of the modes of Modernist drama from Ibsen onwards. And such effects are reproduced on a smaller scale in this book, in the vignettes of the Workers Commune celebration of Strindberg or of Lenin (perhaps apocryphally) at his desk in Zürich listening to a Dada cabaret wafting across from the other side of the Spiegelgasse. 'Is Dada something of a mark and gesture of a counterplay to Bolshevism?' Williams quotes Hugo Ball as asking.

Years before, in *Culture and Society*, Williams had cited Lenin's claim in *What Is To Be Done?* that 'the working class, exclusively by its own effort, is able to develop only trade-union consciousness',[52] which he had seen as founded on precisely the mass civilization/minority culture dualism of Modernism itself. (Lenin's remark is also alluded to in *Second Generation*, where the whole triangular relation of Harold and Kate Owen and Arthur Dean is an implicit riposte to it.) But a reason so divorced from experience – its later guise would be Althusserian Theory – threatens to become the baneful 'abstract revolutionary will' of *Modern Tragedy*, reproducing within socialism the 'dominative' relation to Nature and others characteristic of capitalism. Modernism had already been a resource of sorts against such domination: Ibsen had shown both the actual impossibility (*Ghosts*) and the disastrous human consequences (*The Wild Duck*) of the abstract will, evincing an almost Burkean sense of the organic textures of 'community' that must be defended against the predations of 'planning' from above. And in Williams's later work the avant-garde seems to generalize this function of Ibsen within his thinking, becoming yoked (once stripped of its technicist euphorias) with romantic anti-capitalism in general. Of both movements, many hard political questions remain to be asked – of both the sources and final destinations of the irrational forces here invoked. But then these are open questions, to be asked anew of each specific case: the sanguinary history of Fascist unreason remains a sombre warning but not a final interdict on reason's probing of its own frontiers.

They are not open, however, for the Communist Emma Broase in *Loyalties*: 'subjectivity before politics', she snorts dismissively, 'it's the whole postwar rot'.[52] Williams himself inclines to attribute the 'rot' of a subjectivist post-1950 Western avant-garde to 'what can be seen as a

failure in that most extreme political tendency – the Bolshevik variant of socialism – which had attached itself to the ideas and projects of the working class.' Criticizing Michael Löwy's brisk dismissal of the 'diffuse anti-capitalism' of pre-1914 Germany in *Georg Lukács: from Romanticism to Bolshevism*, he argues that 'Bolshevism, in this perspective, looks rather less like a solution than a short-cut both to new possibilities and some of the old problems.'[54] The avant-garde's attempted reintegration of art and social praxis, whether understood as the factoring into aesthetic production of the body that both classicism and realism had excluded, or as the shifting of the sites of aesthetic reception from gallery to factory, thus comes to stand in Williams's thought as a figure for an integration of theory and practice, revolutionary doctrine and actual working-class experience, more intimate than Lenin's 'top-down' formulations of the issue allow for. True, there is much in Lenin's own work that points to a closer imbrication of the two. Even in *What Is To Be Done?*, only a page or two before the 'trade-union consciousness' passage, he suggests that 'the "spontaneous element", in essence, represents nothing more nor less than consciousness in an *embryonic form*', and the book contains the famous defence of a Marxist's 'right to dream' that would have warmed the heart of William Morris.[55] But still, overall, the avant-garde in some of its manifestations at least might remedy that 'Bolshevik rejection of utopian thought' which Williams notes in *Towards 2000.*[56]

There are at last then two almost incompatible views of Modernism and the avant-garde in this book: most advanced outpost of bourgeois dissidence, it is also on occasion the potential 'warm current' (in Ernst Bloch's phrase) of an excessively scientific socialism. In 'Theatre as a Political Forum' Raymond Williams speaks of 'the only important question: that of the *alternative* directions in which a continuing bourgeois dissidence might go.' Important, certainly, yet not necessarily more crucial, or more poignant, than that of the 'alternative directions' in which his own assessments of the avant-garde would go: a tension both troubling and indispensable, a truly productive ambivalence which will now never finally be resolved out in one direction or another; the cultural theorist in his sixties, after his own realist 'detour' in mid-career, once again as fascinated by the whole extraordinary Modernist project as the boy of eighteen at Cambridge.

Tony Pinkney
Trent Polytechnic, Nottingham

I would like to thank Perry Anderson for his illuminating comments on an earlier draft of this introduction.

Notes

1. Letter to the editor, 14 January 1988.
2. Cited by Francis Mulhern in 'Living "the work"', *The Guardian*, 29 January 1988.
3. 'The Estranging Language of Post-Modernism', *New Society*, 16 June 1983, p. 439. Throughout this book, in accordance with the logic of Williams's developing argument, Modernism as a specific historical phenomenon (located, say, between 1880 and 1930) is given in upper-case, while modernism as a general, often ideological, theory of what it *means* to be 'modern' has been given in lower-case.
4. *The Country and the City*, Frogmore, St Albans, 1975, pp. 281–2.
5. Umbro Apollonio, ed., *Futurist Manifestos*, London, 1973, p. 21.
6. Gilles Deleuze and Felix Guattari, *Anti-Oedipus: Capitalism and Schizophrenia* New York 1977, p. 2.
7. T.S. Eliot, 'The Metaphysical Poets', *Selected Essays*, Third Enlarged Edition, London, 1951, p. 289.
8. A fuller account would offer a more nuanced version of Sartre, whose literary criteria remain directly political in a way that Lukács's do not ('commitment' rather than 'realism') and who had more positive things to say about Modernist experimentation, particularly in poetry, than the author of *The Meaning of Contemporary Realism*; but it is Lukács's rather than Sartre's 1848 that has on the whole carried the day, often drawing the latter into its theoretical orbit.
9. Roland Barthes, *Writing Degree Zero*, New York 1968, p. 60.
10. Cited in Jonathan Culler, *Barthes*, London, 1983, p. 29.
11. See my 'Nineteenth-Century Studies: As They Are and As They Might Be', *News from Nowhere* no. 2, October 1986, pp. 38–55.
12. *Modern Tragedy*, London 1966, pp. 13–14.
13. See my 'Raymond Williams and Modernism', in Terry Eagleton, ed., *Raymond Williams: Critical Debates*, forthcoming 1989.
14. *Politics and Letters: interviews with New Left Review* London 1979, pp. 45–6.
15. *Keywords: A Vocabulary of Culture and Society*, London 1976, p. 10.
16. *Problems of Materialism and Culture*, London 1980, p. 241.
17. Richard Hoggart, *The Uses of Literacy*, Harmondsworth 1958, pp. 192, 247, 235.
18. Review of Lukács, *The Meaning of Contemporary Realism*, in *The Listener* 28 March 1963, p. 385; 'From Scott to Tolstoy', in *The Listener*, 8 March 1962, pp. 436–7.
19. *The Long Revolution*, Harmondsworth 1965, p. 299.
20. 'My Cambridge', in Ronald Hayman, ed., *My Cambridge*, London, 1977, p. 60.
21. Raymond Williams and Michael Orrom, *Preface to Film*, London, 1954, p. 101.
22. *The Country and the City*, p. 290.
23. *Preface to Film*, p. 84.
24. *Second Generation*, London 1988, p. 233.
25. *The Country and the City*, pp. 290–1.
26. Walter Benjamin, *Illuminations*, edited by Hannah Arendt, Glasgow, 1973, pp. 239, 164, 177.
27. Cited in Benjamin, *Illuminations*, p. 167.
28. 'A City and its Writers', *The Guardian*, 30 August 1973, p. 12.
29. Benjamin, *Illuminations*, p. 196.
30. *The Country and the City*, pp. 260, 190.
31. *The Country and the City*, p. 268.
32. Marshall Berman, *All That Is Solid Melts Into Air: The Experience of Modernity*, London 1983, p. 25.
33. 'A City and its Writers', *The Guardian*, 30 August 1973, p. 12.
34. *The Country and the City*, p. 335.
35. *Culture* London 1981, p. 84. Williams has occasionally implied that Naturalism too has a metropolitan basis, dramatically confined as it is to 'that representative room, above a capital city', *Drama from Ibsen to Brecht*, London 1973, p. 374.

36. Perry Anderson, 'Modernity and Revolution', *NLR* 144, March–April 1984, p. 105.

37. *The Country and the City*, p. 338.

38. *The Country and the City*, p. 278.

39. John Berger, *The Success and Failure of Picasso*, London 1980, pp. 70-71. For a more detailed account of 'the revitalization of the giant cities from the 1890s', see *Metropolis: 1890–1940*, edited by Anthony Sutcliffe, London 1984.

40. Peter Bürger, *Theory of the Avant-Garde*, Manchester 1984, p. 12.

41. *Culture*, p. 84.

42. *Drama from Ibsen to Brecht*, Harmondsworth 1973, pp. 318, 330–1.

43. *Politics and Letters*, p. 216.

44. See his *British Post-Structuralism Since 1968*, London 1988 and my review in *THES*, 30 September 1988.

45. *Problems in Materialism and Culture*, p. 241.

46. 'Radical Drama', *New Society*, 27 November 1980, p. 432.

47. *Politics and Letters*, pp. 232–3.

48. Franco Moretti, 'The Spell of Indecision', in *Signs Taken for Wonders: Essays in the Sociology of Literary Forms*, London 1988, p. 240.

49. *Raymond Williams on Television: Selected Writings*, edited by Alan O'Connor, London 1989), p. 124, 12 December 1970.

50. Ibid. p. 68, 10 July 1969.

51. Ibid. p. 82, 27 November 1969.

52. V.I. Lenin, *What Is To Be Done?*, Peking 1978, p. 38; cited in *Culture and Society: 1780–1950*, London 1958, p. 283.

53. *Loyalties*, London 1985, p. 185.

54. 'What Is Anti-Capitalism?', *New Society*, 24 January 1980, p. 189.

55. *What Is To Be Done?*, pp. 37, 211–12.

56. *Towards 2000*, London 1985, p. 12.

1

When Was Modernism?

This lecture was given as one of an annual series at the University of Bristol founded by a former student at the University and subsequent benefactor. Raymond gave it on 17 March 1987, and this version is reconstructed from my brief notes and his even briefer ones. It is worth adding that while he spoke on that occasion in unhesitating, delicate and sinewy prose – the unmistakable and, where necessary, rousing Williams style – his notes are merely composed of jottings and very broad headings ('Metropolis' 'Exiles' '1840s or 1900–1930' etc). Down the lefthand margin are timings in ten-minute intervals: he finished according to plan exactly at fifty minutes.

I cannot hope in my version to have caught his voice accurately, but the trenchancy and relevance of one of the last public lectures he gave are not in doubt. Post-modernism for him was a strictly ideological compound from an enemy formation, and long in need of this authoritative rebuttal. This was a lecture by the 'Welsh European' given against a currently dominant international ideology.

Fred Inglis

My title is borrowed from a book by my friend Professor Gwyn Williams: *When Was Wales?* That was a historical questioning of a problematic history. My own inquiry is a historical questioning of what is also, in very different ways, a problem, but that is also a now dominant and misleading ideology.

'Modern' begins to appear as a term more or less synonymous with 'now' in the late sixteenth century, and in any case used to mark the period off from medieval *and* ancient times. By the time Jane Austen

was using it with a characteristically qualified inflection she could define
it (in *Persuasion*) as 'a state of alteration, perhaps of improvement', but
her eighteenth-century contemporaries used 'modernize' 'modernism'
and 'modernist', without her irony, as indicating updating and improve-
ment. In the nineteenth century it began to take on a more largely
favourable and progressive ring; Ruskin's *Modern Painters* was
published in 1846, and Turner becomes the type of modern painter for
his demonstration of the distinctively up-to-date quality of truth-to-
nature. Very quickly, however, 'modern' shifts its reference from 'now'
to 'just now' or even 'then', and for some time has been a designation
always going into the past with which 'contemporary' may be contrasted
for its presentness. 'Modernism' as a title for a whole cultural movement
and moment has then been retrospective as a general term since the
1950s, thereby stranding the dominant version of 'modern' or even
'absolute modern' between, say, 1890 and 1940. We still habitually use
'modern' of a world between a century and half a century old. When we
note that in English at least (French usage still retaining some of the
meaning for which the term was coined) 'avant-garde' may be indiffer-
ently used to refer to Dadaism seventy years after the event or to recent
fringe theatre, the confusion both willed and involuntary which leaves
our own deadly separate era in anonymity becomes less an intellectual
problem and more an ideological perspective. By its point of view, all
that is left to us is to become post-moderns.

Determining the process which fixed the moment of Modernism is a
matter, as so often, of identifying the machinery of selective tradition. If
we are to follow the Romantics' victorious definition of the arts as
outriders, heralds, and witnesses of social change, then we may ask why
the extraordinary innovations in social realism, the metaphoric control
and economy of seeing discovered and refined by Gogol, Flaubert or
Dickens from the 1840s on, should not take precedence over the
conventionally Modernist names of Proust, Kafka, or Joyce. The earlier
novelists, it is widely acknowledged, make the latter work possible; with-
out Dickens, no Joyce. But in excluding the great realists, this version of
Modernism refuses to see how they devised and organized a whole
vocabulary and its structure of figures of speech with which to grasp the
unprecedented social forms of the industrial city. By the same token, in
painting, the Impressionists in the 1860s also defined a new vision and a
technique to match in their rendering of modern Parisian life, but it is of
course only the Post-Impressionists and the Cubists who are situated in
the tradition.

The same questions can be put to the rest of the literary canon and
the answers will seem as arbitrary: the Symbolist poets of the 1880s are
superannuated by the Imagists, Surrealists, Futurists, Formalists and

others from 1910 onwards. In drama, Ibsen and Strindberg are left behind, and Brecht dominates the period from 1920 to 1950. In every case in these oppositions the late-born ideology of modernism selects the later group. In doing so, it aligns the later writers and painters with Freud's discoveries and imputes to them a view of the primacy of the subconscious or unconscious as well as, in both writing and painting, a radical questioning of the processes of representation. The writers are applauded for their denaturalizing of language, their break with the allegedly prior view that language is either a clear, transparent glass or a mirror, and for making abruptly apparent in the very texture of their narratives the problematic status of the author and his authority. As the author appears in the text, so does the painter in the painting. The self-reflexive text assumes the centre of the public and aesthetic stage, and in doing so declaratively repudiates the fixed forms, the settled cultural authority of the academies and their bourgeois taste, and the very necessity of market popularity (such as Dickens's or Manet's).

These are indeed the theoretic contours and specific authors of 'modernism', a highly selected version of the modern which then offers to appropriate the whole of modernity. We have only to review the names in the real history to see the open ideologizing which permits the selection. At the same time, there is unquestionably a series of breaks in all arts in the late nineteenth century: breaks, as we noted, with forms (the three-decker novel disappears) and with power, especially as manifested in bourgeois censorship – the artist becomes a dandy or an anti-commercial radical, sometimes both.

Any explanation of these changes and their ideological consequences must start from the fact that the late nineteenth century was the occasion for the greatest changes ever seen in the media of cultural production. Photography, cinema, radio, television, reproduction and recording all make their decisive advances during the period identified as Modernist, and it is in response to these that there arise what in the first instance were formed as defensive cultural groupings, rapidly if partially becoming competitively self-promoting. The 1890s were the earliest moment of the movements, the moment at which the manifesto (in the new magazine) became the badge of self-conscious and self-advertising schools. Futurists, Imagists, Surrealists, Cubists, Vorticists, Formalists and Constructivists all variously announced their arrival with a passionate and scornful vision of the new, and as quickly became fissiparous, friendships breaking across the heresies required in order to prevent innovations becoming fixed as orthodoxies.

The movements are the products, at the first historical level, of changes in public media. These media, the technological investment which mobilized them, and the cultural forms which both directed the

investment and expressed its preoccupations, arose in the new metropolitan cities, the centres of the also new imperialism, which offered themselves as transnational capitals of an art without frontiers. Paris, Vienna, Berlin, London, New York took on a new silhouette as the eponymous City of Strangers, the most appropriate locale for art made by the restlessly mobile emigré or exile, the internationally anti-bourgeois artist. From Apollinaire and Joyce to Beckett and Ionesco, writers were continuously moving to Paris, Vienna and Berlin, meeting there exiles from the Revolution coming the other way, bringing with them the manifestos of post-revolutionary formation.

Such endless border-crossing at a time when frontiers were starting to become much more strictly policed and when, with the First World War, the passport was instituted, worked to naturalize the thesis of the *non*-natural status of language. The experience of visual and linguistic strangeness, the broken narrative of the journey and its inevitable accompaniment of transient encounters with characters whose self-presentation was bafflingly unfamiliar, raised to the level of universal myth this intense, singular narrative of unsettlement, homelessness, solitude and impoverished independence: the lonely writer gazing down on the unknowable city from his shabby apartment. The whole commotion is finally and crucially interpreted and ratified by the City of Emigrés and Exiles itself, New York.

But this version of Modernism cannot be seen and grasped in a unified way, whatever the likenesses of its imagery. Modernism thus defined *divides* politically and simply – and not just between specific movements but even *within* them. In remaining anti-bourgeois, its representatives either choose the formerly aristocratic valuation of art as a sacred realm above money and commerce, or the revolutionary doctrines, promulgated since 1848, of art as the liberating vanguard of popular consciousness. Mayakovsky, Picasso, Silone, Brecht are only some examples of those who moved into direct support of Communism, and D'Annunzio, Marinetti, Wyndham Lewis, Ezra Pound of those who moved towards Fascism, leaving Eliot and Yeats in Britain and Ireland to make their muffled, nuanced treaty with Anglo-Catholicism and the celtic twilight.

After Modernism is canonized, however, by the post-war settlement and its accompanying, complicit academic endorsements, there is then the presumption that since Modernism is *here* in this specific phase or period, there is nothing beyond it. The marginal or rejected artists become classics of organized teaching and of travelling exhibitions in the great galleries of the metropolitan cities. 'Modernism' is confined to this highly selective field and denied to everything else in an act of pure ideology, whose first, unconscious irony is that, absurdly, it stops history

dead. Modernism being the terminus, everything afterwards is counted out of development. It is *after*; stuck in the post.

The ideological victory of this selection is no doubt to be explained by the relations of production of the artists themselves in the centres of metropolitan dominance, living the experience of rapidly mobile emigrés in the migrant quarters of their cities. They were exiles one of another, at a time when this was still not the more general experience of other artists, located as we would expect them to be, at home, but without the organization and promotion of group and city – simultaneously located *and* divided. The life of the emigré was dominant among the key groups, and they could and did deal with each other. Their self-referentiality, their propinquity and mutual isolation all served to represent the artist as necessarily estranged, and to ratify as canonical the works of radical estrangement. So, to *want* to leave your settlement and settle nowhere like Lawrence or Hemingway, becomes presented, in another ideological move, as a normal condition.

What has quite rapidly happened is that Modernism quickly lost its anti-bourgeois stance, and achieved comfortable integration into the new international capitalism. Its attempt at a universal market, trans-frontier and transclass, turned out to be spurious. Its forms lent themselves to cultural competition and the commercial interplay of obsolescence, with its shifts of schools, styles and fashion so essential to the market. The painfully acquired techniques of significant *dis*connection are relocated, with the help of the special insensitivity of the trained and assured technicists, as the merely technical modes of advertising and the commercial cinema. The isolated, estranged images of alienation and loss, the narrative discontinuities, have become the easy iconography of the commercials, and the lonely, bitter, sardonic and sceptical hero takes his ready-made place as star of the thriller.

These heartless formulae sharply remind us that the innovations of what is called Modernism have become the new but fixed forms of our present moment. If we are to break out of the non-historical fixity of *post*-modernism, then we must search out and counterpose an alternative tradition taken from the neglected works left in the wide margin of the century, a tradition which may address itself not to this by now exploitable because quite inhuman rewriting of the past but, for all our sakes, to a modern *future* in which community may be imagined again.

2

Metropolitan Perceptions and the Emergence of Modernism

It is now clear that there are decisive links between the practices and ideas of the avant-garde movements of the twentieth century and the specific conditions and relationships of the twentieth-century metropolis. The evidence has been there all along, and is indeed in many cases obvious. Yet until recently it has been difficult to disengage this specific historical and cultural relationship from a less specific but widely celebrated (and execrated) sense of 'the modern'.

In the late twentieth century it has become increasingly necessary to notice how relatively far back the most important period of 'modern art' now appears to be. The conditions and relationships of the early-twentieth-century metropolis have in many respects both intensified and been widely extended. In the simplest sense, great metropolitan aggregations, continuing the development of cities into vast conurbations, are still historically increasing (at an even more explosive rate in the Third World). In the old industrial countries, a new kind of division between the crowded and often derelict 'inner city' and the expanding suburbs and commuter developments has been marked. Moreover, within the older kinds of metropolis, and for many of the same reasons, various kinds of avant-garde movement still persist and even flourish. Yet at a deeper level the cultural conditions of the metropolis have decisively changed.

The most influential technologies and institutions of art, though they are still centred in this or that metropolis, extend and indeed are directed beyond it, to whole diverse cultural areas, not by slow influence but by immediate transmission. There could hardly be a greater cultural contrast than that between the technologies and institutions of what is still mainly called 'modern art' – writing, painting, sculpture, drama, in

37

minority presses and magazines, small galleries and exhibitions, city-centre theatres – and the effective output of the late-twentieth-century metropolis, in film, television, radio and recorded music. Conservative analysts still reserve the categories 'art' or 'the arts' to the earlier technologies and institutions, with continued attachment to the metropolis as the centre in which an enclave can be found for them or in which they can, often as a 'national' achievement, be displayed. But this is hardly compatible with a continued intellectual emphasis on their 'modernity', when the actual modern media are of so different a kind. Secondly, the metropolis has taken on a much wider meaning, in the extension of an organized global market in the new cultural technologies. It is not every vast urban aggregation, or even great capital city, which has this cultural metropolitan character. The effective metropolis – as is shown in the borrowing of the word to indicate relations between nations, in the neo-colonial world – is now the modern transmitting metropolis of the technically advanced and dominant economies.

Thus the retention of such categories as 'modern' and 'Modernism' to describe aspects of the art and thought of an undifferentiated twentieth-century world is now at best anachronistic, at worst archaic. What accounts for the persistence is a matter for complex analysis, but three elements can be emphasized. First, there is a factual persistence, in the old technologies and forms but with selected extensions to some of the new, of the specific relations between minority arts and metropolitan privileges and opportunities. Secondly, there is a persistent intellectual hegemony of the metropolis, in its command of the most serious publishing houses, newspapers and magazines, and intellectual institutions, formal and especially informal. Ironically, in a majority of cases, these formations are in some important respects residual: the intellectual and artistic forms in which they have their main roots are for social reasons – especially in their supporting formulations of 'minority' and 'mass', 'quality' and 'popular' – of that older, early-twentieth-century period, which for them is the perennially 'modern'. Thirdly and most fundamentally, the central product of that earlier period, for reasons which must be explored, was a new set of 'universals', aesthetic, intellectual and psychological, which can be sharply contrasted with the older 'universals' of specific cultures, periods and faiths, but which in just that quality resist all further specificities, of historical change or of cultural and social diversity: in the conviction of what is beyond question and for all effective time the 'modern absolute', the defined universality of a human condition which is effectively permanent.

There are several possible ways out of this intellectual deadlock, which now has so much power over a whole range of philosophical, aesthetic and political thinking. The most effective involve contempor-

ary analysis in a still rapidly changing world. But it is also useful, when faced by this curious condition of cultural stasis – curious because it is a stasis which is continually defined in dynamic and experientially pre- carious terms – to identify some of the processes of its formation: seeing a present beyond 'the modern' by seeing how, in the past, that speci- fically absolute 'modern' was formed. For this identification, the facts of the development of the city into the metropolis are basic. We can see how certain themes in art and thought developed as specific responses to the new and expanding kinds of nineteenth-century city and then, as the central point of analysis, see how these went through a variety of actual artistic transformations, supported by newly offered (and competitive) aesthetic universals, in certain metropolitan conditions of the early twentieth century: the moment of 'modern art'.

It is important to emphasize how relatively old some of these appar- ently modern themes are. For that is the inherent history of themes at first contained within 'pre-modern' forms of art which then in certain conditions led to actual and radical changes of form. It is the largely hidden history of the conditions of these profound internal changes which we have to explore, often against the clamour of the 'universals' themselves.

For convenience I will take examples of the themes from English literature, which is particularly rich in them. Britain went through the first stages of industrial and metropolitan development very early, and almost at once certain persistent themes were arrived at. Thus the effect of the modern city as a crowd of strangers was identified, in a way that was to last, by Wordsworth:

> O Friend! one feeling was there which belonged
> To this great city, by exclusive right;
> How often, in the overflowing streets,
> Have I gone forward with the crowd and said
> Unto myself, 'The face of every one
> That passes by me is a mystery!'
>
> Thus have I looked, nor ceased to look, oppressed
> By thoughts of what and whither, when and how,
> Until the shapes before my eyes became
> A second-sight procession, such as glides
> Over still mountains, or appears in dreams.
> And all the ballast of familiar life,
> The present, and the past; hope, fear; all stays,
> All laws of acting, thinking, speaking man
> Went from me, neither knowing me, nor known.[1]

What is evident here is the rapid transition from the mundane fact that the people in the crowded street are unknown to the observer – though we now forget what a novel experience that must in any case have been to people used to customary small settlements – to the now characteristic interpretation of strangeness as 'mystery'. Ordinary modes of perceiving others are seen as overborne by the collapse of normal relationships and their laws: a loss of 'the ballast of familiar life'. Other people are then seen as if in 'second sight' or, crucially, as in dreams: a major point of reference for many subsequent modern artistic techniques.

Closely related to this first theme of the crowd of strangers is a second major theme, of an individual lonely and isolated within the crowd. We can note some continuity in each theme from more general Romantic motifs: the general apprehension of mystery and of extreme and precarious forms of consciousness; the intensity of a paradoxical self-realization in isolation. But what has happened, in each case, is that an apparently objective milieu, for each of these conditions, has been identified in the newly expanding and overcrowded modern city. There are a hundred cases, from James Thomson to George Gissing and beyond, of the relatively simple transition from earlier forms of isolation and alienation to their specific location in the city. Thomson's poem 'The Doom of a City' (1857) addresses the theme explicitly, as 'Solitude in the midst of a great City':

> The cords of sympathy which should have bound me
> In sweet communication with earth's brotherhood
> I drew in tight and tighter still around me,
> Strangling my lost existence for a mood.[2]

Again, in the better-known 'City of Dreadful Night' (1870), a direct relationship is proposed between the city and a form of agonized consciousness:

> The City is of Night, but not of Sleep;
> There sweet sleep is not for the weary brain;
> The pitiless hours like years and ages creep,
> A night seems termless hell. This dreadful strain
> Of thought and consciousness which never ceases,
> Or which some moment's stupor but increases,
> This, worse than woe, makes wretches there insane.[3]

There is direct influence from Thomson in Eliot's early city poems. But more generally important is the extension of the association between isolation and the city to alienation in its most subjective sense: a range

from dream or nightmare (the formal vector of 'Doom of a City'), through the distortions of opium or alcohol, to actual insanity. These states are being given a persuasive and ultimately conventional social location.

On the other hand, alienation in the city could be given a social rather than a psychological emphasis. This is evident in Elizabeth Gaskell's interpretation of the streets of Manchester in *Mary Barton*, in much of Dickens, especially in *Dombey and Son*, and (though here with more emphasis on the isolated and crushed observer) in Gissing's *Demos* and *The Nether World*. It is an emphasis drawn out and formally argued by Engels:

> . . .They crowd by one another as though they had nothing in common, nothing to do with one another. . . . The brutal indifference, the unfeeling isolation of each in his private interest becomes the more repellent and offensive, the more these individuals are crowded together, within a limited space. And, however much one may be aware that this isolation of the individual, this narrow self-seeking is the fundamental principle of our society everywhere, it is nowhere so shamelessly barefaced, so self-conscious as just here in the crowding of the great city. The dissolution of mankind into monads . . . is here carried out to its utmost extremes.[4]

These alternative emphases of alienation, primarily subjective or social, are often fused or confused within the general development of the theme. In a way their double location within the modern city has helped to override what is otherwise a sharp difference of emphasis. Yet both the alternatives and their fusion or confusion point ahead to observable tendencies in twentieth-century avant-garde art, with its at times fused, at times dividing, orientations towards extreme subjectivity (including subjectivity as redemption or survival) and social or social/cultural revolution.

There is also a third theme, offering a very different interpretation of the strangeness and crowding and thus the 'impenetrability' of the city. Already in 1751 Fielding had observed:

> Whoever considers the Cities of London and Westminster, with the late vast increases of their suburbs, the great irregularity of their buildings, the immense numbers of lanes, alleys, courts and bye-places, must think that had they been intended for the very purpose of concealment they could not have been better contrived.[5]

This was a direct concern with the facts of urban crime, and the emphasis persisted. The 'dark London' of the late nineteenth century, and particularly the East End, were often seen as warrens of crime, and one

important literary response to this was the new figure of the urban
detective. In Conan Doyle's *Sherlock Holmes* stories there is a recurrent
image of the penetration by an isolated rational intelligence of a dark
area of crime which is to be found in the otherwise (for specific physical
reasons, as in the London fogs, but also for social reasons, in that teem-
ing, mazelike, often alien area) impenetrable city. This figure has
persisted in the urban 'private eye' (as it happens, an exact idiom for the
basic position in consciousness) in cities without the fogs.

On the other hand, the idea of 'darkest London' could be given a
social emphasis. It is already significant that the use of statistics to
understand an otherwise too complex and too numerous society had
been pioneered in Manchester from the 1830s. Booth in the 1880s
applied statistical survey techniques to London's East End. There is
some relation between these forms of exploration and the generalizing
panoramic perspectives of some twentieth-century novels (Dos Passos,
Tressell). There were naturalistic accounts from within the urban
environment, again with an emphasis on crime, in several novels of the
1890s, for example, Morrison's *Tales of Mean Streets* (1894). But in
general it was as late as the 1930s, and then in majority in realist modes,
before any of the actual inhabitants of these dark areas wrote their own
perspectives, which included the poverty and the squalor but also, in
sharp contradiction to the earlier accounts, the neighbourliness and
community which were actual working-class responses.

A fourth general theme can, however, be connected with this explicit
late response. Wordsworth, interestingly, saw not only the alienated city
but new possibilities of unity:

> among the multitudes
> Of that huge city, oftentimes was seen
> Affectingly set forth, more than elsewhere
> Is possible, the unity of men.[6]

What could be seen, as often in Dickens, as a deadening uniformity,
could be seen also, in Dickens and indeed, crucially, in Engels, as the
site of new kinds of human solidarity. The ambiguity had been there
from the beginning, in the interpretation of the urban crowd as 'mass' or
'masses', a significant change from the earlier 'mob'. The masses could
indeed be seen, as in one of Wordsworth's emphases, as:

> slaves unrespited of low pursuits,
> Living amid the same perpetual flow
> Of trivial objects, melted and reduced
> To one identity . . .[7]

But 'mass' and 'masses' were also to become the heroic, organizing words of working-class and revolutionary solidarity. The factual development of new kinds of radical organization within both capital and industrial cities sustained this positive urban emphasis.

A fifth theme goes beyond this, but in the same positive direction. Dickens's London can be dark, and his Coketown darker. But although, as also later in H.G. Wells, there is a conventional theme of escape to a more peaceful and innocent rural spot, there is a specific and unmistakable emphasis on the vitality, the variety, the liberating diversity and mobility of the city. As the physical conditions of the cities were improved, this sense came through more and more strongly. The idea of the pre-industrial and pre-metropolitan city as a place of light and learning, as well as of power and magnificence, was resumed with a special emphasis on physical light: the new illuminations of the city. This is evident in very simple form in Le Gallienne in the 1890s:

> London, London, our delight,
> Great flower that opens but at night,
> Great city of the midnight sun,
> Whose day begins when day is done.
>
> Lamp after lamp against the sky
> Opens a sudden beaming eye,
> Leaping a light on either hand
> The iron lilies of the Strand.[8]

It is not only the continuity, it is also the diversity of these themes, composing as they do so much of the repertory of modern art, which should now be emphasized. Although Modernism can be clearly identified as a distinctive movement, in its deliberate distance from and challenge to more traditional forms of art and thought, it is also strongly characterized by its internal diversity of methods and emphases: a restless and often directly competitive sequence of innovations and experiments, always more immediately recognized by what they are breaking from than by what, in any simple way, they are breaking towards. Even the range of basic cultural positions within Modernism stretches from an eager embrace of modernity, either in its new technical and mechanical forms or in the equally significant attachments to ideas of social and political revolution, to conscious options for past or exotic cultures as sources or at least as fragments *against* the modern world, from the Futurist affirmation of the city to Eliot's pessimistic recoil.

Many elements of this diversity have to be related to the specific cultures and situations within which different kinds of work and position were to be developed, though within the simpler ideology of modernism

this is often resisted: the innovations being directly related only to themselves (as the related critical procedures of formalism and structuralism came to insist). But the diversity of position and method has another kind of significance. The themes, in their variety, including as we have seen diametrically opposite as well as diverse attitudes to the city and its modernity, had formerly been included within relatively traditional forms of art. What then stands out as new, and is in this defining sense 'modern', is the series (including the competitive sequence) of breaks in form. Yet if we say only this we are carried back inside the ideology, ignoring the continuity of themes from the nineteenth century and isolating the breaks of form, or worse, as often in subsequent pseudo-histories, relating the formal breaks to the themes as if both were comparably innovative. For it is not the general themes of response to the city and its modernity which compose anything that can be properly called Modernism. It is rather the new and specific location of the artists and intellectuals of this movement within the changing cultural milieu of the metropolis.

For a number of social and historical reasons the metropolis of the second half of the nineteenth century and of the first half of the twentieth century moved into a quite new cultural dimension. It was now much more than the very large city, or even the capital city of an important nation. It was the place where new social and economic and cultural relations, beyond both city and nation in their older senses, were beginning to be formed: a distinct historical phase which was in fact to be extended, in the second half of the twentieth century, at least potentially, to the whole world.

In the earliest phases this development had much to do with imperialism: with the magnetic concentration of wealth and power in imperial capitals and the simultaneous cosmopolitan access to a wide variety of subordinate cultures. But it was always more than the orthodox colonial system. Within Europe itself there was a very marked unevenness of development, both within particular countries, where the distances between capitals and provinces widened, socially and culturally, in the uneven developments of industry and agriculture, and of a monetary economy and simple subsistence or market forms. Even more crucial differences emerged between individual countries, which came to compose a new kind of hierarchy, not simply, as in the old terms, of military power, but in terms of development and thence of perceived enlightenment and modernity.

Moreover, both within many capital cities, and especially within the major metropolises, there was at once a complexity and a sophistication of social relations, supplemented in the most important cases – Paris, above all – by exceptional liberties of expression. This complex and

open milieu contrasted very sharply with the persistence of traditional social, cultural and intellectual forms in the provinces and in the less developed countries. Again, in what was not only the complexity but the miscellaneity of the metropolis, so different in these respects from traditional cultures and societies beyond it, the whole range of cultural activity could be accommodated.

The metropolis housed the great traditional academies and museums and their orthodoxies; their very proximity and powers of control were both a standard and a challenge. But also, within the new kind of open, complex and mobile society, small groups in any form of divergence or dissent could find some kind of foothold, in ways that would not have been possible if the artists and thinkers composing them had been scattered in more traditional, closed societies. Moreover, within both the miscellaneity of the metropolis – which in the course of capitalist and imperialist development had characteristically attracted a very mixed population, from a variety of social and cultural origins – and its concentration of wealth and thus opportunities of patronage, such groups could hope to attract, indeed to form, new kinds of audience. In the early stages the foothold was usually precarious. There is a radical contrast between these often struggling (and quarrelling and competitive) groups, who between them made what is now generally referred to as 'modern art', and the funded and trading institutions, academic and commercial, which were eventually to generalize and deal in them. The continuity is one of underlying ideology, but there is still a radical difference between the two generations: the struggling innovators and the modernist establishment which consolidated their achievement.

Thus the key cultural factor of the modernist shift is the character of the metropolis: in these general conditions, but then, even more decisively, in its direct effects on form. The most important general element of the innovations in form is the fact of immigration to the metropolis, and it cannot too often be emphasized how many of the major innovators were, in this precise sense, immigrants. At the level of theme, this underlies, in an obvious way, the elements of strangeness and distance, indeed of alienation, which so regularly form part of the repertory. But the decisive aesthetic effect is at a deeper level. Liberated or breaking from their national or provincial cultures, placed in quite new relations to those other native languages or native visual traditions, encountering meanwhile a novel and dynamic common environment from which many of the older forms were obviously distant, the artists and writers and thinkers of this phase found the only community available to them: a community of the medium; of their own practices.

Thus language was perceived quite differently. It was no longer, in the old sense, customary and naturalized, but in many ways arbitrary

and conventional. To the immigrants especially, with their new second common language, language was more evident as a medium – a medium that could be shaped and reshaped – than as a social custom. Even within a native language, the new relationships of the metropolis, and the inescapable new uses in newspapers and advertising attuned to it, forced certain productive kinds of strangeness and distance: a new consciousness of conventions and thus of changeable, because now open, conventions. There had long been pressures towards the work of art as artefact and commodity, but these now greatly intensified, and their combined pressures were very complex indeed. The preoccupying visual images and styles of particular cultures did not disappear, any more than the native languages, native tales, the native styles of music and dance, but all were now passed through this crucible of the metropolis, which was in the important cases no mere melting pot but an intense and visually and linguistically exciting process in its own right, from which remarkable new forms emerged.

At the same time, within the very openness and complexity of the metropolis, there was no formed and settled society to which the new kinds of work could be related. The relationships were to the open and complex and dynamic social process itself, and the only accessible form of this practice was an emphasis on the medium: the medium as that which, in an unprecedented way, defined art. Over a wide and diverse range of practice, this emphasis on the medium, and on what can be done in the medium, became dominant. Moreover, alongside the practice, theoretical positions of the same kind, most notably the new linguistics, but also the new aesthetics of significant form and structure, rose to direct, to support, to reinforce and to recommend. So nearly complete was this vast cultural reformation that, at the levels directly concerned – the succeeding metropolitan formations of learning and practice – what had once been defiantly marginal and oppositional became, in its turn, orthodox, although the distance of both from other cultures and peoples remained wide. The key to this persistence is again the social form of the metropolis, for the facts of increasing mobility and social diversity, passing through a continuing dominance of certain metropolitan centres and a related unevenness of all other social and cultural development, led to a major expansion of metropolitan forms of perception, both internal and imposed. Many of the direct forms and media processes of the minority phase of modern art thus became what could be seen as the common currency of majority communication, especially in films (an art form created, in all important respects, by these perceptions) and in advertising.

It is then necessary to explore, in all its complexity of detail, the many variations in this decisive phase of modern practice and theory. But it is

also time to explore it with something of its own sense of strangeness and distance, rather than with the comfortable and now internally accommodated forms of its incorporation and naturalization. This means, above all, seeing the imperial and capitalist metropolis as a specific historical form, at different stages: Paris, London, Berlin, New York. It involves looking, from time to time, from outside the metropolis: from the deprived hinterlands, where different forces are moving, and from the poor world which has always been peripheral to the metropolitan systems. This need involve no reduction of the importance of the major artistic and literary works which were shaped within metropolitan perceptions. But one level has certainly to be challenged: the metropolitan interpretation of its own processes as universals.

The power of metropolitan development is not to be denied. The excitements and challenges of its intricate processes of liberation and alienation, contact and strangeness, stimulation and standardization, are still powerfully available. But it should no longer be possible to present these specific and traceable processes as if they were universals, not only in history but as it were above and beyond it. The formulation of the modernist universals is in every case a productive but imperfect and in the end fallacious response to particular conditions of closure, breakdown, failure and frustration. From the necessary negations of these conditions, and from the stimulating strangeness of a new and (as it seemed) unbonded social form, the creative leap to the only available universality – of raw material, of medium, of process – was impressively and influentially made.

At this level as at others – 'modernization' for example – the supposed universals belong to a phase of history which was both creatively preceded and creatively succeeded. While the universals are still accepted as standard intellectual procedures, the answers come out as impressively as the questions determine. But then it is characteristic of any major cultural phase that it takes its local and traceable positions as universal. This, which Modernism saw so clearly in the past which it was rejecting, remains true for itself. What is succeeding it is still uncertain and precarious, as in its own initial phases. But it can be foreseen that the period in which social strangeness and exposure isolated art as only a medium is due to end, even within the metropolis, leaving from its most active phases the new cultural monuments and their academies which in their turn are being challenged.

Notes

1. William Wordsworth, *The Prelude*, VII, in *Poetical Works*, edited by De Selincourt and Darbishire, eds, London 1949, p. 261.

2. A. Ridler, ed., *Poems and Some Letters of James Thomson*, London 1963, p. 25.

3. Ibid., p. 180.

4. Friedrich Engels, *The Condition of the Working Class in England in 1844*, translated by F.K. Wischnewetzky, London, 1934, p. 24.

5. Henry Fielding, *Inquiry into the Cause of the Late Increase in Robbers*, 1751, p. 76.

6. Wordsworth, p. 286.

7. Ibid., p. 292.

8. C. Trent, *Greater London*, London 1965, p. 200.

3

The Politics of the
Avant-Garde

In January 1912 a torchlight procession, headed by members of the
Stockholm Workers' Commune, celebrated the sixty-third birthday of
August Strindberg. Red flags were carried and revolutionary anthems
were sung.

No moment better illustrates the contradictory character of the poli-
tics of what is now variously (and confusingly) called the 'Modernist
movement or the 'avant-garde'. In one simple dimension the acclam-
ation of Strindberg is not surprising. Thirty years earlier, presenting
himself, rhetorically, as the 'son of a servant', Strindberg had declared
that in a time of social eruption he would side with those who came,
weapon in hand, from below. In a verse contrasting Swartz, the inventor
of gunpowder – used by kings to repress their peoples – with Nobel, the
inventor of dynamite, he wrote:

> You, Swartz, had a small edition published
> For the nobles and the princely houses!
> Nobel! you published a huge popular edition
> Constantly renewed in a hundred thousand copies.[1]

The metaphor from publishing makes the association between the
radical, experimental, popular writer and the rising revolutionary class
explicit. Again, from 1909, he had returned to the radical themes of his
youth, attacking the aristocracy, the rich, militarism and the conservative
literary establishment. This association of enemies was equally charac-
teristic.

Yet very different things had happened in the intervening years. The
man who had written: 'I can get quite wild sometimes, thinking about

49

the insanity of the world', had gone on to write: 'I am engaged in such a revolution against myself, and the scales are falling from my eyes.'[2] This is the transition which we shall come to recognize as a key movement in modern art, and which already in 1888 enabled Nietzsche to write of Strindberg's play *The Father*: 'It has astounded me beyond measure to find a work in which my own conception of love – with war as its means and the deathly hatred of the sexes as its fundamental law – is so magnificently expressed.'[3] Strindberg confirmed the mutual recognition: 'Nietzsche is to me the modern spirit who dares to preach the right of the strong and the wise against the foolish, the small (the democrats).'[4] This is still a radicalism, and indeed still daring and violent. But it is not only that the enemies have changed, being identified now as those tendencies which had hitherto been recognized as liberating: political progress, sexual emancipation, the choice of peace against war. It is also that the old enemies have disappeared behind these; indeed it is the strong and the powerful who now carry the seeds of the future: 'Our *evolution* . . . wants to protect the strong against the weak species, and the current aggressiveness of women seems to me a symptom of the regress of the race.'[5] The language is that of Social Darwinism, but we can distinguish its use among these radical artists from the relatively banal justifications of a new hard (lean) social order by the direct apologists of capitalism. What emerges in the arts is a 'cultural Darwinism', in which the strong and daring radical spirits are the true *creativity* of the race. Thus there is not only an assault on the weak – democrats, pacifists, women – but on the whole social and moral and religious order. The 'regress of the race' is attributed to Christianity, and Strindberg could hail Nietzsche as 'the prophet of the overthrow of Europe and Christendom'.[6]

We have then to think again of the torches and red flags of the Workers' Commune. It is important, in one kind of analysis, to trace the shifts of position, and indeed the contradictions, within complex individuals. But to begin to understand the more general complexities of the politics of the avant-garde, we have to look beyond these singular men to the turbulent succession of artistic movements and cultural formations which compose the real history of Modernism and then of the avant-garde in so many of the countries of Europe. The emergence of these self-conscious, named and self-naming groups is a key marker of the movement in its widest sense.

We can distinguish three main phases which had been developing rapidly during the late nineteenth century. Initially, there were innovative groups which sought to protect their practices within the growing dominance of the art market and against the indifference of the formal academies. These developed into alternative, more radically innovative

groupings, seeking to provide their own facilities of production, distribution and publicity; and finally into fully oppositional formations, determined not only to promote their own work but to attack its enemies in the cultural establishments and, beyond these, the whole social order in which these enemies had gained and now exercised and reproduced their power. Thus the defence of a particular kind of art became first the self-management of a new kind of art and then, crucially, an attack in the name of this art on a whole social and cultural order.

It is not easy to make simple distinctions between 'Modernism' and the 'avant-garde', especially as many uses of these labels are retrospective. But it can be taken as a working hypothesis that Modernism can be said to begin with the second type of group – the alternative, radically innovating experimental artists and writers – while the avant-garde begins with groups of the third, fully oppositional type. The old military metaphor of the vanguard, which had been used in politics and in social thought from at latest the 1830s – and which had implied a position within a general human progress – now was directly applicable to these newly militant movements, even when they had renounced the received elements of progressivism. Modernism had proposed a new kind of art for a new kind of social and perceptual world. The avant-garde, aggressive from the beginning, saw itself as the breakthrough to the future: its members were not the bearers of a progress already repetitiously defined, but the militants of a creativity which would revive and liberate humanity.

Thus, two years before the Workers' Commune homage to Strindberg, the Futurists had published their manifestos in Paris and Milan. We can catch clear echoes of the Strindberg and Nietzsche of the 1880s. In the same language of cultural Darwinism, war is the necessary activity of the strong, and the means to the health of society. Women are identified as special examples of the weak who hold back the strong. But there is now a more specific cultural militancy: 'Take up your pickaxes, your axes and hammers, and wreck, wreck the venerable cities, pitilessly. Come on, set fire to the library shelves. Turn aside the canals to flood the museums. . . . So let them come, the gay incendiaries with charred fingers. . . . Here we are! Here we are!'[7] The directions are more particular, but we can remember, as we listen to them, Strindberg's celebration of dynamite in 'a huge popular edition'. Except that his violence had been linked with those 'who came, weapon in hand, from below': a central and traditional image of revolution. There is a significant difference in the Futurist commitment to what looks, at first glance, like the same movement: 'We will sing of great crowds excited by work, by pleasure and by riot . . . the multicoloured, polyphonic tides of revolution.'[8] Anyone with an ear for the nuances of talk of revolution, down to

our own time, will recognize the change, and recognize also the
confused and confusing elements of these repeated calls to revolution,
many of which, in the pressures of subsequent history, were to become
not only alternatives but actual political antagonists.

The direct call to political revolution, based in the workers' move-
ments, was rising through just this period. The Futurist call to destroy
'tradition' overlaps with socialist calls to destroy the whole existing social
order. But 'great crowds excited by work, by pleasure and by riot', 'the
multicoloured polyphonic tides of revolution': these, while they can
appear to overlap, are already – especially with the advantage of hind-
sight – a world away from the tightly organized parties which would use
a scientific socialism to destroy the hitherto powerful and emancipate
the hitherto powerless. The comparison bears both ways. Against the
single track of proletarian revolution there are the 'multicoloured, poly-
phonic tides'. 'Great crowds excited . . . by riot' carries all the ambigui-
ties between revolution and carnival. Moreover, and crucially, though its
full development is later, there is the decisive difference between appeals
to the tradition of reason and the new celebration of creativity which
finds many of its sources in the irrational, in the newly valued uncon-
scious, and in the fragments of dreams. The social basis which had
appeared to fuse when the Workers' Commune honoured Strindberg – a
writer who had intensively explored these unconscious sources – could
now be equally strongly contrasted: the organized working class with its
disciplines of party and union; the cultural movement with its mobile
association of free and liberating, often deliberately marginal,
individuals.

What was 'modern', what was indeed 'avant-garde', is now relatively
old. What its works and language reveal, even at their most powerful, is
an identifiable historical period, from which, however, we have not fully
emerged. What we can now identify in its most active and creative years,
underlying its many works, is a range of diverse and fast-moving artistic
methods and practices, and at the same time a set of relatively constant
positions and beliefs.

We have already noticed the emphasis on creativity. This has prece-
dents, obviously, in the Renaissance, and later in the Romantic Move-
ment when the term, at first thought blasphemous, was invented and
heavily used. What marks out this emphasis in both Modernism and the
avant-garde is a defiance and finally violent rejection of tradition: the
insistence on a clean break with the past. In both the earlier periods,
though in different ways, there was a strong appeal to *revival*: the art
and learning, the life of the past, were sources, stimuli of a new creativ-
ity, against an exhausted or deformed current order. This lasted as late
as that alternative movement of the Pre-Raphaelites – a conscious

modernism of its day; the present and the immediate past must be rejected, but there is a farther past, from which creativity can revive. What we now know as Modernism, and certainly as the avant-garde, has changed all this. Creativity is all in new making, new construction: all traditional, academic, even learned models are actually or potentially hostile to it, and must be swept away.

It is true that, as in the Romantic Movement, with its appeal to the folk art of marginal peoples, there is also a sidelong reference. Art seen as primitive or exotic but creatively powerful – and now within a developed imperialism available from much wider sources, in Asia and in Africa – is in several different movements, within this turbulent creative range, taken not only as exemplary, but as forms that can be woven into the consciously modern. These appeals to the 'Other' – in fact highly developed arts of their own places – are combined with an underlying association of the 'primitive' and the 'unconscious'. At the same time, however, and very marked in the competition between these movements, there is a virtually unprecedented emphasis on the most evident features of a modern urban industrialized world: the city, the machine, speed, space – the creative engineering, *construction* of a future. The contrast with the central Romantic emphases on spiritual and natural creativity could hardly be more marked.

Yet also, and decisive for its relations with politics, the range of new movements was operating in a very different social world. To the emphases on creativity and on the rejection of tradition we must add a third common factor: that all these movements, implicitly but more often explicitly, claimed to be anti-bourgeois. Indeed 'bourgeois', in all its rich range of meanings, turns out to be a key to the many movements which claimed to be its opposite. Schools and movements repeatedly succeeded each other, fused or more often fragmented in a proliferation of *isms*. Within them individuals of marked singularity pursued their apparently and in some ways authentically autonomous projects, readily linked by the historian but often directly experienced as isolated and isolating. Very diverse technical solutions were found, in each of the arts, to newly emphasized problems of representation and narration, and to ways beyond what came to be seen as these constrictions of purpose and form. For many working artists and writers, these working consider-ations – the actual methods of their art – were always uppermost in their minds; indeed they could sometimes be isolated as evidence of the singularity and purity of art. But whichever of these ways was taken there was always a single contrast to it. Hostile or indifferent or merely vulgar, the bourgeois was the mass which the creative artist must either ignore and circumvent, or now increasingly shock, deride and attack.

No question is more important to our understanding of these once

modern movements than the ambiguity of 'bourgeois'. The underlying ambiguity is historical, in its dependence on the variable class position from which the bourgeois was seen. To the court and the aristocracy the bourgeois was at once worldly and vulgar, socially pretentious but hidebound, moralistic and spiritually narrow. To the newly organizing working class, however, not only the individual bourgeois with his combination of self-interested morality and self-serving comfort, but the bourgeoisie as a class of employers and controllers of money, was at centre stage.

The majority of artists, writers and intellectuals were in none of these fixed class positions. But in different and variable ways they could overlap with the complaints of each other class against the bourgeois reckoning of the world. There were the dealers and booksellers who, within the newly dominant cultural market, were treating works of art as simple commodities, their values determined by trading success or failure. Protests against this could overlap with the Marxist critique of the reduction of labour to a traded commodity. Alternative and oppositional artistic groups were defensive attempts to get beyond the market, distantly analogous to the working-class development of collective bargaining. There could thus be at least a negative identification between the exploited worker and the exploited artist. Yet one of the central points of their complaint against this treatment of art was that creative art was more than simple labour; its cultural and spiritual or then its aesthetic values were especially outraged as the commodity reduction took hold. Thus the bourgeois could also be seen, simultaneously or alternatively, as the vulgar, hidebound, moralistic and spiritually narrow figure of the aristocratic complaint.

There are innumerable variations on these essentially distinguishable complaints against the bourgeoisie. How each mix or variation came out politically, depended, crucially, on differences in the social and political structures of the many countries within which these movements were active, but also, in ways often very difficult to analyse, on the proportions of the different elements in the anti-bourgeois positions.

In the nineteenth century the element derived from the aristocratic critique was obviously much stronger, but it found a metaphorical form of its own, which was to survive, pathetically, into the twentieth century, to be taken up by even the most unlikely people: the claim, indeed the assertion, that the artist was the authentic aristocrat; had indeed to be, in the spiritual sense, an aristocrat if he was to be an artist. An alternative vocabulary gathered behind this assertion, from Arnold's culturally superior 'remnant' to Mannheim's vitally uncommitted intelligentsia, and more individually in the proposition – eventually the cult – of 'the genius' and 'the superman'. Naturally the bourgeoisie and its world were

objects of hostility and contempt from such positions, but the assertion did not have to be made very often to extend to a wholesale condemnation of the 'mass' that was beyond all authentic artists: now not only the bourgeoisie but that ignorant populace which was beyond the reach of art or hostile to it in vulgar ways. Any residue of an actual aristocracy could at times be included in this type of condemnation: worldly barbarians who were offensively mistaken for the true creative aristocrats.

On the other hand, as the working-class, socialist and anarchist movements developed their own kind of critique, identifying the bourgeoisie as the organizers and agents of capitalism and thus the specific source of the reduction of all broader human values, including the values of art, to money and trade, there was an opportunity for artists to join or support a wide and growing movement which would overthrow and supersede bourgeois society. This could take the form of a negative identification between the artists and workers, each group being practically exploited and oppressed; or, though more rarely, a positive identification, in which artists would commit themselves, in their art and out of it, to the larger causes of the people or of the workers.

Thus within what may at first hearing sound like closely comparable denunciations of the bourgeois, there are already radically different positions, which would lead eventually, both theoretically and under the pressure of actual political crisis, not only to different but to directly opposed kinds of politics: to Fascism or to Communism; to social democracy or to conservatism and the cult of excellence.

This synchronic range has, moreover, to be complemented by the diachronic range of the actual bourgeoisie. In its early stages there had been an emphasis on independent productive and trading enterprise, free of the constraints of state regulation and both privilege and precedent, which in practice closely accorded with the life situation and desires of many artists, who were already in precisely this position. It is not really surprising that so many artists – including, ironically, at later stages of their careers, many avant-garde artists – became in this sense good and successful bourgeois: at once attentive to control of their own production and property, and – which mattered more in public presentation – ultimate apotheoses of that central bourgeois figure: the sovereign individual. This is still today the small change of conventional artistic self-presentation.

Yet the effective bourgeoisie had not stopped at these early stages. As it gathered the fruits of its free and independent production it placed a heavy emphasis on the rights of accumulated (as distinct from inherited) property, and thus on its forms of settlement. Though in practice these were interlocked in variable ways with older forms of property and settlement in state and aristocracy, there was a distinctive emphasis on

the morality (rather than only the brute fact) of property and order.

A particular instance, of great importance to Modernism and the avant-garde, is what came to be called the *bourgeois family*. The actual bourgeois family was not the inventor of propertied marriage, nor of the inclusion within it of male domination over women and children. The bourgeois initiative within these established feudal forms had been an emphasis on personal feeling – at first derided as sentimental – as the proper basis for marriage, and a related emphasis on the direct care of children. The fusion of these ideas of the family with the received forms of property and settlement was a hybrid rather than a true bourgeois creation.

Yet, by the time of Modernism, the contradictions of this hybrid were increasing. The emphasis on personal feeling was quickly developed into an emphasis on irresistible or even momentary desire, which it would be a thwarting of humanity to suppress. The care of children could be resented as an irksome form of control. And the repression of women, within a restrictive social system, was increasingly challenged. Nor is it any reduction of the nature of these developments to note how much more vigorous they became as the bourgeoisie moved, by its very economic success, into more funded forms. The economic constraints by which the older forms had maintained practical control were loosened not only by general changes in the economy and by the availability of new (and especially professional) kinds of work, but by a cruder consideration: that the son or daughter of a bourgeois family was financially in a position to lay claim to new forms of liberation, and in a significant number of cases could actually use the profits of the economic bourgeoisie to lead political and artistic crusades against it.

Thus the growing critique of the bourgeois family was as ambiguous as the more general critique of the bourgeois as such. With the same vigour and confidence as the first bourgeois generations, who had fought state and aristocratic monopolies and privileges, a new generation, still in majority by practice and inheritance bourgeois, fought, on the same principle of the sovereign individual, against the monopoly and privilege of marriage and family. It is true that this was most vigorous at relatively young ages, in the break-out to new directions and new identities. But in many respects a main element of modernism was that it was an authentic avant-garde, in personal desires and relationships, of the successful and evolving bourgeoisie itself. The desperate challenges and deep shocks of the first phase were to become the statistics and even the conventions of a later phase of the same order.

Thus what we have observed synchronically in the range of positions covered by the anti-bourgeois revolt we observe also, diachronically, within that evolution of the bourgeoisie which in the end produced its

own successions of distinctively bourgeois dissidents. This is a key element of the politics of the avant-garde, and we need especially to remember it as we look at forms which seem to go beyond politics or indeed to discount politics as irrelevant. Thus there is a position within the apparent critique of the bourgeois family which is actually a critique and rejection of all social forms of human reproduction. The 'bourgeois family', with all its known characteristics of property and control, is often in effect a covering phrase for those rejections of women and children which take the form of a rejection of 'domesticity'. The sovereign individual is confined by any such form. The genius is tamed by it. But since there is little option for celibacy, and only a limited option (though taken and newly valued, even directly associated with art) for homosexuality, the male campaign for liberation is often associated, as in the cases of Nietzsche and Strindberg, with great resentment and hatred of women, and with a reduction of children to elements of struggle between incompatible individuals. In this strong tendency, liberation translates desire as perpetually mobile: it cannot, in principle, be achieved in a settled relationship or in a society. Yet at the same time the claims of human liberation, against forms of property and other economic controls, are being much more widely made, and increasingly – for that is the irony of even the first phase – by women.

Thus we have seen that what is new in the avant-garde is the aggressive dynamism and conscious affront of claims to liberation and creativity which, through the whole Modernist period, were in fact being much more widely made. We have now to look at the variable forms of its actual intersections with politics. These cover, in effect, the whole political range, though in the great majority of cases there is a strong movement towards the new political forces which were breaking beyond old constitutional and imperial politics, both before the war of 1914–18 and with much greater intensity during and after it. We can briefly identify some of the main strands.

There was, first, a strong attraction to forms of anarchism and nihilism, and also to forms of revolutionary socialism which, in their aesthetic representation, had a comparably apocalyptic character. The contradictions between these varying kinds of attachment were eventually to be obvious, but there was a clear initial linkage between the violent assault on existing conventions and the programmes of anarchists, nihilists and revolutionary socialists. The deep emphasis on the liberation of the creative individual took many towards the anarchist wing, but especially after 1917 the project of heroic revolution could be taken as a model for the collective liberation of all individuals. Hostility to the war and to militarism also fed this general tendency, from the Dadaists to the Surrealists, and from the Russian Symbolists to the Russian Futurists.

On the other hand, the commitment to a violent break with the past, most evident in Futurism, was to lead to early political ambiguities. Before 1917 the rhetoric of revolutionary violence could appear congruent with the Italian Futurists' explicit glorification of violence in war. It was only after 1917, and its consequent crises elsewhere, that these came to be fully distinguished. By then two Futurists, Marinetti and Mayakovsky, had moved in quite opposite directions: Marinetti to his support for Italian Fascism; Mayakovsky to his campaigning for a popular Bolshevik culture. The renewed rhetoric of violent rejection and disintegration in the Germany of the 1920s produced associations within Expressionism and related movements which by the end of the decade, and then notably with the coming of Hitler, led different writers to positions on the extreme poles of politics: to both Fascism and Communism.

Within these varying paths, which can be tracked to relatively explicit political stations, there is a very complex set of attachments which could, it seems, go either way. It is a striking characteristic of several movements within both Modernism and the avant-garde that rejection of the existing social order and its culture was supported and even directly expressed by recourse to a simpler art: either the primitive or exotic, as in the interest in African and Chinese objects and forms, or the 'folk' or 'popular' elements of their native cultures. As in the earlier case of the 'medievalism' of the Romantic Movement, this reach back beyond the existing cultural order was to have very diverse political results. Initially the main impulse was, in a political sense, 'popular': this was the true or the repressed native culture which had been overlain by academic and establishment forms and formulas. Yet it was simultaneously valued in the same terms as the exotic art because it represented a broader human tradition, and especially because of those elements which could be taken as its 'primitivism', a term which corresponded with that emphasis on the innately creative, the unformed and untamed realm of the pre-rational and the unconscious, indeed that vitality of the naive which was so especially a leading edge of the avant-garde.

We can then see why these emphases went in different political directions as they matured. The 'folk' emphasis, when offered as evidence of a repressed popular tradition, could move readily towards socialist and other radical and revolutionary tendencies. One version of the vitality of the naive could be joined with this, as witness of the new kinds of art which a popular revolution would release. On the other hand, an emphasis on the 'folk', as a particular kind of emphasis on 'the people', could lead to very strong national and eventually nationalist identifications, of the kind heavily drawn upon in both Italian and German Fascism.

Equally, however, an emphasis on the creativity of the pre-rational

could be coopted into a rejection of all forms of would-be rational politics, including not only liberal progressivism but also scientific socialism, to the point where, in one version, the politics of action, of the unreflecting strong, could be idealized as necessarily liberating. This was not, of course, the only conclusion from an emphasis on the pre-rational. The majority of the Surrealists in the 1930s moved towards resistance against Fascism: of course as an active, disrupting resistance. There was also a long (and unfinished) interaction between psychoanalysis, increasingly the theoretical expression of these 'pre-rational' emphases, and Marxism, now the dominant theoretical expression of the revolutionary working class. There were many attempted fusions of the revolutionary impulse in both, both generally and in particular relation to a new sexual politics which both derived from the contested early Modernist sources. There was also, however, an eventual rejection of all politics, in the name of the deeper realities of the dynamic psyche; and, within this, one influential strand of option for *conservative* forms of order, seen as offering at least some framework of control for the unruly impulses both of the dynamic psyche and of the pre-rational 'mass' or 'crowd'.

The diverse movements which went in these different and opposed directions continued to have one general property in common: all were pioneering new methods and purposes in writing, art and thought. It is then a sober fact that, for this very reason, they were so often rejected by mainstream political forces. The Nazis were to lump left, right and centre Modernists together as *Kulturbolschewismus*. From the middle and late 1920s, the Bolsheviks in power in the Soviet Union rejected virtually the same range. During the Popular Fronts of the 1930s there was a reassembly of forces: Surrealists with social realists, Constructivists with folk artists, popular internationalism with popular nationalism. But this did not outlast its immediate and brief occasion, and through the war of 1939–45 separate directions and transformations were resumed, to reappear in further brief alliances in the postwar years and especially, with what seemed a renewal of the original energies, in the 1960s.

Within the range of general possibilities it mattered greatly what was happening in the different countries in which the avant-garde movements were based, or in which they found refuge. The true social bases of the early avant-garde were at once cosmopolitan and metropolitan. There was rapid transfer and interaction between different countries and different capitals, and the deep mode of the whole movement, as in Modernism, was precisely this mobility across frontiers: frontiers which were among the most obvious elements of the old order which had to be rejected, even when native folk sources were being included as elements or as inspiration of the new art. There was intense competition but also

radical coexistence in the great imperial capitals of Paris, Vienna, Berlin, and Petersburg, and also, in more limited ways, in London. These concentrations of wealth and power, and of state and academy, had each, within their very complexities of contact and opportunity, drawn towards them those who most opposed them. The dynamics of the imperialist metropolis were, then, the true bases of this opposition, in ways that have already been explored in the volume *Unreal City*.[9]

This was to happen again, but in essentially different ways, after the shocks of the 1914–18 war and the Russian Revolution. Paris and Berlin (until Hitler) were the new major centres, but the assembly now was not only of pioneering artists, writers and intellectuals seeking contact and solidarity in their multiplicity of movements, but to a much greater extent of political exiles and emigrés: a movement later to be repeated, with an even greater emphasis, in New York.

Thus there is a certain structural continuity within the changing situations of the metropolitan capitals. Yet, wherever the artists might be, or settle, the quite new political crises of the post-1917 world produced a diversity different in kind from the mobile and competitive diversity of the years before 1914. Thus the Russian Modernists and avant-gardists were in a country which had passed through revolution and civil war. Blok, in *The Twelve*, could write a late Symbolist poem of twelve Red Army soldiers led by Christ through a storm towards the new world. Mayakovsky could move from the liberated detachment of *A Cloud in Trousers* (1915) to *Mystery Buffo* (1918), acclaiming the revolution, and later, after the official rejection of Modernist and avant-garde art, to the satirical observation of the supposed new world in *The Bedbug* (1929). These are examples among many, in the turbulence of those years, when the relation between politics and art was no longer a matter of manifesto but of difficult and often dangerous practice.

The Italian Futurists had a very different but comparable experience. The earlier rhetoric had led them towards Fascism, but its actual manifestation was to impose new tests, and varieties of accommodation and reservation. In the Weimar Republic there was still an active and competitive diversity, with the current running strongly against bourgeois culture and its forms. But while Piscator could move from the Spartakus League to the Proletarian Theatre, the poet Tucholsky, verifying a point in our earlier analysis, could declare that 'one is bourgeois by predisposition, not by birth and least of all by profession':[10] bourgeois, that is to say, not as a political but as a spiritual classification. The eventual crisis of the end of the Republic and the Nazi rise to power forced a polarization which can be summarily represented, among writers who had been closely involved with Expressionism, by Brecht on the revolutionary Left and Gottfried Benn on the Fascist Right.

In countries in which during this period there was no radical change of power in the state, the effects, though no less complex, were often less dramatic. There was a notable rallying of Surrealist writers to the anti-Fascist cause in France, but there, as in Britain, it was possible to sustain a certain political solidarity against war and against Fascism within a diversity of literary movements and cultural principles. In the Popular Front period, also, that element of the original avant-garde position which had rejected official cultural institutions and sought new – and in some instances, as in the early Soviet Union, new *popular* – audiences for more open kinds of art, was widely emphasized. There was the leftist tendency of the Auden and Isherwood plays, borrowing from German Expressionism; but there was also an avant-garde colouring in the social-realist and documentary film and theatre movements, offering to break from fixed fictional forms and enclosed bourgeois institutions.

Also in Britain, however, there was a significantly different tendency, in which literary Modernism moved explicitly to the right. Wyndham Lewis's Vorticism, a version of Futurism, developed idiosyncratically, but Pound's characteristically total avant-garde position ended in Fascism, and Yeats's version of the 'people', sustained at first by a broad and diverse movement, became a right-wing nationalism. The most interesting because most influential case is that of Eliot, seen from the 1920s to the 1940s as the key modernist poet. Eliot developed what can now be seen as an Ancient-and-Modern position, in which unceasing literary experiment moved towards a conscious elite, and in which an emphasis on tradition (so distinct from earlier Modernist and avant-garde rejections of the past) was offered as in effect subversive of an intolerable because shallow and self-deceiving (and in that sense still *bourgeois*) social and cultural order.

The war of 1939–45 brought an end to many of these movements and transformed most of the earlier positions. Yet, though it requires separate analysis, the period since 1945 shows many of the earlier situations and pressures, and indeed many – though, at their most serious, altered – recurrences of position and initiative. Two new social factors have then to be noted, since continuities and similarities of technique, affiliation and manifesto can too easily be isolated in a separated aesthetic history: itself one of the influential forms of a postwar cultural modernism which had observed the complexity of the many political crises.

First, the avant-garde, in the sense of an artistic movement which is simultaneously both a cultural and political campaign, has become notably less common. Yet there are avant-garde political positions from the earliest stages – dissident from fixed bourgeois forms, but still as *bourgeois* dissidents – which can be seen as a genuine vanguard of a truly modern international bourgeoisie which has emerged since 1945.

The politics of this New Right, with its version of libertarianism in a dissolution or deregulation of all bonds and all national and cultural formations in the interest of what is represented as the ideal open market and the truly open society, look very familiar in retrospect. For the sovereign individual is offered as the dominant political and cultural form, even in a world more evidently controlled by concentrated economic and military power. That it can be offered as such a form, in such conditions, depends partly on that emphasis which was once, within settled empires and conservative institutions, so challenging and so marginal.

Secondly, especially in the cinema, in the visual arts, and in advertising, certain techniques which were once experimental and actual shocks and affronts have become the working conventions of a widely distributed commercial art, dominated from a few cultural centres, while many of the original works have passed directly into international corporate trade. This is not to say that Futurism, or any other of the avant-garde movements, has found its literal future. The rhetoric may still be of endless innovation. But instead of revolt there is the planned trading of spectacle, itself significantly mobile and, at least on the surface, deliberately disorientating.

We have then to recall that the politics of the avant-garde, from the beginning, could go either way. The new art could find its place either in a new social order or in a culturally transformed but otherwise persistent and recuperated old order. All that was quite certain, from the first stirrings of Modernism through to the most extreme forms of the avant-garde, was that nothing could stay quite as it was: that the internal pressures and the intolerable contradictions would force radical changes of some kind. Beyond the particular directions and affiliations, this is still the historical importance of this cluster of movements and of remarkable individual artists. And since, if in new forms, the general pressures and contradictions are still intense, indeed have in many ways intensified, there is still much to learn from the complexities of its vigorous and dazzling development.

Notes

1. Quoted in O. Lagercrantz, *August Strindberg*, London 1984, p. 97.
2. Ibid., p. 122.
3. Quoted in M. Meyer, *August Strindberg*, London 1985, p. 205.
4. Ibid.
5. Ibid.
6. Ibid.

7. U. Apollonio, ed., *Futurist Manifestos*, London 1973, p. 23.

8. Ibid., p. 22.

9. Edward Timms and David Kelley, eds, *Unreal City: Urban Experience in Modern European Literature and Art*, Manchester 1985.

10. See A. Phelan, 'Left-wing Melancholia', in A. Phelan, ed., *The Weimar Dilemma*, Manchester 1985.

4

Language and the
Avant-Garde

As to the dialogue: I have rather broken with tradition in not making my characters catechists who sit asking foolish questions in order to elicit a smart reply. I have avoided the mathematically symmetrical construction of French dialogue and let people's brains work irregularly, as they do in actual life, where no topic of conversation is drained to the dregs, but one brain receives haphazard from the other a cog to engage with. Consequently my dialogue too wanders about, providing itself in the earlier scenes with material which is afterwards worked up, admitted, repeated, developed, and built up, like the theme in a musical composition.[1]

Again:

My souls (characters) are conglomerations from past and present stages of civilization; they are excerpts from books and newspapers, scraps of humanity, pieces torn from festive garments which have become rags – just as the soul itself is a piece of patchwork.[2]

I take these descriptions of intention in writing from an unarguably Modernist playwright who was moreover often seen, in the movements of the avant-garde, as a precedent: August Strindberg. Yet the descriptions occur in what is in effect his manifesto of Naturalism, and this is my point in quoting them: as a challenge to certain tendencies in applied linguistics, and to forms of literary analysis seemingly derived from them, which have appropriated a selective version of Modernism, and within this an internal and self-proving definition of the avant-garde, as a way of ratifying their own much narrower positions and procedures.

The most serious consequence of this appropriation is that what are actually polemical positions, some of them serious, on language and

65

writing, can pass, however ironically, as historical descriptions of actual movements and formations: the summations *Modernism* and *avant-garde* are, in most uses, obvious examples. For suppose we say, conventionally, that Modernism begins in Baudelaire, or in the period of Baudelaire, and that the avant-garde begins around 1910, with the manifestos of the Futurists, we can still not say, of either supposed movement, that what we find in them is some specific and identifiable position about language, or about writing, of the kind offered by subsequent theoretical or pseudo-historical propositions.

Even at their most plausible – in a characteristic kind of definition by negative contrast, where the main stress is put on a common rejection of the representational character of language and thence of writing – there is not only an astonishing reduction of the diversity of actually antecedent writing practices and theories of language, but a quite falsely implied identification of actual Modernist and avant-garde writing – with convenient slippages between the two loose terms – as based on attitudes to language which can be theoretically generalized, or at least made analogous, to what, borrowing the classifications, are themselves offered as modernist or avant-garde linguistic and critical positions and methodologies.

My challenge in quoting Strindberg, in his Naturalist manifesto, is that he was evidently putting forward a version of character – as a 'conglomeration', an 'excerpt', 'pieces torn' and 'scraps' – which has been widely seen as characteristic of Modernist writing and indeed of more general theory, together with a method of irregular writing, 'built up like the theme in a musical composition', also widely identified as 'modernist', which are yet quite unmistakably based on an affiliation to, even a desire to represent, actual social processes: 'I have . . . let people's brains work irregularly, *as they do in actual life*'. One is even reminded of Ibsen's words, when he decided to abandon dramatic verse and cultivate 'the very much more difficult art of writing the genuine, plain language spoken in real life.'[3] 'My desire was to depict human beings and therefore I would not make them speak the language of the gods': Ibsen, who, if it is a question of movements, was so influential on Joyce.[4]

I am not of course saying that Modernism was a Naturalism, though dramatic Naturalism was indeed one of its major early manifestations. But I am saying, certainly of Modernism, and even, where I shall concentrate, of the avant-garde, that actual positions and practices are very much more diverse than their subsequent ideological presentations, and that we shall misunderstand and betray a century of remarkable experiments if we go on trying to flatten them to contemporary theoretical and quasi-theoretical positions.

For the present analysis I am accepting the conventional deli_eation of the avant-garde as a complex of movements from around 1910 to the late 1930s. In real practice there are no such convenient break-points. What is almost the only distinguishing feature, and even then incompletely, is less a matter of actual writing than of successive formations which challenged not only the art institutions but the institution of Art, or Literature, itself, typically in a broad programme which included, though in diverse forms, the overthrow and remaking of existing society. That certainly cuts it off from later formations which continued its technical practices, and its accompanying aggressiveness marks at least a change in tone from earlier formations which had pioneered some of its methods and which, in at least some cases, had comparably broad social and even political intentions. Within the irregularities and overlaps of any cultural history – its repeated co-presence of various forms of the emergent with forms of the residual and the dominant – that definition of period and type has a working usefulness.

Yet we cannot then jump to its farthest manifestations: to the phonetic poems and the automatic writing, and the body language of the Theatre of Cruelty. What we have, instead, to distinguish is a set of tendencies, in writing, which in this place and that had specific but in no way inevitable outcomes. Thus the movement of verbal composition towards what was seen as the condition of music has no predestined outcome in Dada. The movement of verbal composition towards the creation of what were seen as images has no predestined outcome in Imagist verses. Rather, in the diverse movements which are summarized as Modernism or as the avant-garde, we have to look at radical differences of practice within what can be seen, too hastily, as a common orientation, and then relate both practices and orientation to certain uses and concepts of language and writing which historically and formally belong to neither.

The central issue may be that which was defined, ideologically, by Shklovsky, as 'the resurrection of the word'.[5] At the level of summary, this idea is often now used as a core definition of literary Modernism, and is further associated with certain interpretations of the 'sign' in linguistics. Yet it was Shklovsky's colleague among the early Russian Formalists, Eikhenbaum, who wrote that 'the basic slogan uniting the initial group was the emancipation of the word from the shackles of the philosophical and religious tendencies with which the Symbolists were possessed.'[6] The local observation is just, yet it was precisely the Symbolists who had most clearly introduced the new emphasis on the intrinsic value of the poetic word. A word seen in this way was not a signal to something beyond it, but a signifier in its own material properties which, by its poetic use, embodied, rather than expressed or represented, a

value. It is then true that this value, for the Symbolists, was of a particular kind: the poetic word as the ideoglyph of mystery or of myth. In some later tendencies of this sort, for example the Acmeists or the Yeats of the Dancer plays, this embodiment of the poetic word is refracted through existing literary or legendary material, a more specialized and often more exotic manifestation of the more general – and much older – use of classical myth and literature as a source of symbolic, self-valuable units of meaning. We can then go on to see the Formalist 'resurrection' or 'emancipation' of the word as a secularization, a demystification, of the 'poetic word' of the Symbolists. What was being proposed instead was still a specific 'literary language', but now defined in terms of the word as empirical phonetic material. Yet it was then not simply the specific ideological freight of the Symbolist 'poetic word' that was being rejected, but, so far as possible, not only its ideological but any or all of its received semantic freight: the poetic word then being not simply a grammatical unit but available in what came to be called a 'transrational sound image'.

Moreover this was always a matter of practice. In the early years of the century, partially in Apollinaire and more directly in the poems which became known as *bruitiste*, verse composed as pure sound was being written in several European languages. The eventual outcome, along this very specialized line of development, was the phonetic poem, evident among some of the Futurists but more especially in Dadaism. In 1917, following a common earlier analogy, Hugo Ball wrote that 'the decision to let go of language in poetry, just like letting go of the object in painting, is imminent', and he had indeed just written his *Gadji Beri Bimba*. His own account of its public reading is instructive:

> I began in a slow and solemn way
> *gadji beri bimba glandridi launa lonni cadori . . .*
> It was then that I realized that my voice, lacking other
> possibilities, was adopting the ancestral cadence of priestly
> laments, that style of chanting the mass in the
> catholic churches of East and West:
> *zimzim urallala zimzim urallala zimzim zanzibar*
> *zimzall zam.*[7]

Moreover it was done to drums and bells.

There is a sense in which the most extreme practitioners of these new theories of language and writing are markedly more acceptable than the contemporary makers of formulae. For what was being tested in practice, even where tested to destruction, was actually a major element of very old as well as very new kinds of verbal performance. The relapse to the rhythms of the mass in the middle of an outraging Dadaist spec-

tacle is not only funny; it is, like the sudden locating appearance of Zanzibar, a reminder of how deeply constituted, socially, language always is, even when the decision has been made to abandon its identifiable semantic freight.

For of course the use of material sound and of rhythm, in both general communication and the many forms of drama, narrative, lyric, ritual and so on, is in no way a Modernist discovery and is, moreover, never reducible, in another direction, to simplified accounts of meaning in language. From the Welsh *cynghanedd* to medieval alliterative verse it has been an element not only of practice but even of rules. In less ordered forms it has been virtually a constant component of many different kinds of oral composition and of writing, from dramatic blank verse to the nonsense-poem (that significantly popular nineteenth-century English form which certain phonetic poems much resemble). What is different, in some Modernist and avant-garde theory and practice, is the attempt to rationalize it for specific ideological purposes of which the most common – though it has never been more than an element of these movements – is the deliberate exclusion or devaluing of all or any referential meaning.

We have already seen, in Hugo Ball, the false analogy with renunciation of the 'object' in painting. A true analogy would have been a decision by painters to give up paint. But we must go beyond these pleasantries to the substantial case which is at the root of so many of these diverse movements and indeed of some of their predecessors. This case is primarily historical, underlying the diverse formations and practices, but also underlying many of the developments in the study of language which, at an altogether later stage, are now used to interpret or recommend them. Yet the complexity of this history – indeed that which makes it history – is evident at once if we abstract and then offer to construe the substantial position from which so many of these initiatives were made. Indeed the difficulty of formulating it is, in a real sense, its history.

If I say, for example, as so many of these writers did, that language should be creative, as against its contemporary condition, I can be reasonably certain, given a sufficient diversity of audience, of being understood as saying at least seven different things: not only because of the manifold possibilities of 'creative' but because the 'contemporary condition' has been historically understood as at least one of the following: a state of active repression of human possibilities; a state of antiquated discourse and composition; a state in which language is dulled and exhausted by custom and habit or reduced to the merely prosaic; a state in which everyday, ordinary language makes literary composition difficult or impossible; a state in which a merely instru-

mental language blocks access to an underlying spiritual or unconscious reality; a state in which a merely social language obstructs the most profound individual expression. There are probably other variants and accompaniments, as there are certainly other slogans. But the extraordinary historical generalization of what may – indeed I think must – still be grasped as the underlying position is too important to allow any intellectual retreat. What is being argued, in these diverse ways, leading to so many diverse formations and practices, has to be not summarized but explored.

It is only in one special outcome of this argument, in one part of Modernism and a rather larger part of the avant-garde, that the difficulties and tensions are in effect collapsed. This is in the (themselves varied) attempts either to dispense with language altogether, as too hopelessly compromised and corrupted by this or that version of its condition, or, failing that, to do what Artaud proposed, 'substituting for the spoken language a different language of nature, whose expressive possibilities will be equated to verbal language.'[8] In straight terms this is vaudeville, but more practically we can see that a key element in both Modernism and the avant-garde was a deliberate running-together, cross-fertilization, even integration of what had been hitherto seen as different arts. Thus the aspiration to develop language towards the condition of music, or towards the immediacy and presence of visual imagery or performance could, if it failed (as it was bound to) in its original terms, be taken on into music or painting or performance art, or, significantly, into film of an avant-garde kind. These developments, however, go beyond the present argument. For though Apollinaire apostrophized 'man in search of a new language to which the grammarian of any tongue will have nothing to say',[9] and looked forward to the time when 'the phonograph and the cinema having become the only forms of "print" in use, poets will have a freedom unknown up till now',[10] he continued for his own part in his own written compositions. Even Artaud, much later in this development, continued to write, if only, as he claimed, for illiterates, years after he had conceived, in the Theatre of Cruelty, a kind of dramatic performance in which bodily presence and action, a dynamic of movement and image, would take decisive priority over what remained of dramatic language: an initiative which has been continued and even in some respects – ironically even in commercial cinema – generalized.

Thus we can return to the underlying history of direct positions in the practice of language, in relation to that almost neutral term, the 'contemporary condition'. 'Almost neutral', since for the Symbolists, for example, the so-called condition was not contemporary but permanent, though acute in the crises of their time. This is, incidentally, a way in

which, with a certain effect of paradox, the Symbolists can be distinguished from one main sense of modernism. Their ways of writing verse were new, often radically so, but it was less among them than among their very different contemporaries, the Naturalists, that there came the familiar challenging rhetoric of the new, the *modern*, which required a new art: new bottles for this new wine, as Strindberg put it in his arguments for Naturalism.[11] The idealist substratum of Symbolism was the belief that the world transmitted by the senses – but then by all the senses and most profoundly in synaesthesia – should be understood as revealing a *spiritual* universe. The Symbolist poem would then be an enabling form of such revelation, a mode of realized *correspondance* in Baudelaire's sense, in which the 'poetic word' becomes a verbal symbol, at once material in embodiment and metaphysical in its revelation of a spiritual but still sensual reality.

This concept was related, linguistically, to ideas of the 'inner form' of a word – indeed its internal creative capacity – as defined, for example, by Potebnia. It was often supported from the established idea of the distinctive 'inner forms' of languages, corresponding to the inner life of their speakers, as argued as early as Humboldt. This 'inner form' had then to be, as it were, discovered, released, embodied in the 'poetic word': and especially then by poets: the basis for speaking, as they did, of a 'literary language'. Within this whole concept these are already, one can say, distinguishable metaphysical and historical bearings: distinguishable but in practice ordinarily fused and confused. For the intention is metaphysical but the occasion can still be defined as the 'contemporary', or in that loose grand way the 'modern', crisis of life and society.

Characteristically, in the Symbolists, as clearly in Baudelaire and again in Apollinaire, this form of poetic revelation involved a fusion of present synaesthetic experience with the recovery of a nameable, tangible past which was yet 'beyond' or 'outside' time. And versions of this form of practice have continued to be important in many works which do not formally carry the specific marks of Symbolism as an identifiable historical movement. It is evident, for example, in the visionary and legendary Yeats and, in a different way, in Eliot, who is so often taken, in English, as the exemplary Modernist poet but who in this respect, as in others, can be more precisely defined, in an idealist as well as a historical sense, as quintessentially Ancient and Modern.

And we have then only to go across from that whole tendency to the Futurists, with their wholesale rejection of any trace of the past, indeed, as Marinetti put it, with their campaigning 'modernolatry', to know the profound disjunctions which the usual summary of Modernism papers over. For now 'literary language', and indeed the whole institution and

existing practice of literature, were the shackles which these heralds of
the new time must break. Not an 'inner form' but the 'freedom' of words
is what is now celebrated, for they are to be hurled in the shock of action
or of play against a sclerotic literary or social order. To be sure there still
can be appeal to primeval energies against the decayed forms. This goes
on into the Expressionists. It is a main theme of Brecht's *Baal.*

But there are also more specific changes in the handling of language;
for example, Khlebnikov's use of his studies of the linguistic history of
words to propose a form of release in the coming of new verbal forms,
as in the famous poem the 'Incantation to Laughter', where the whole
composition is a series of variations on the Russian word *smekh* =
laughter. Mayakovsky's 'A Cloud in Trousers' in a broader way offers to
break up, in a single operation, the habitual expectations, collocations
and connections of both existing poems and existing perceptions. Signi-
ficantly, it was from this Futurist practice that the early Formalists
derived their concepts not only of the word as grammatical unit – the
linguistic element of their arguments – but as a 'transrational sound
image' – the literary element or potential. This can be connected –
though not by direct influence – with the bruitiste poems and with the
phonetic poems of Dada, but it was to have much longer and wider
though perhaps equally surprising effects.

For there is already an underlying dichotomy in this understanding of
'the word'. Whether as 'grammatical unit' or as 'transrational sound
image' it can be projected in two quite different directions: on the one
hand towards active composition, in which these units are arranged and
combined, by conscious literary strategies or devices, into works; or, on
the other hand, taking an ideological cue from 'transrational', into
procedures much resembling traditional accounts of 'inspiration', in
which the creative act occurs beyond the 'ordinary self', and more
substantial, more original, energies are tapped.

It is interesting to reflect on the itinerary of this latter conception:
from metaphysical notions of literal possession by gods or spirits in the
moment of true utterance, through the conventional personifications of
inspiring muses of great predecessors, ancestor poets, into the Romantic
version of creative access to the new all-purpose personification of
Nature, and finally – or is it finally? – to creative access to 'the uncon-
scious'. Certainly we have to notice how commonly, in later Modernism
and in sectors of the avant-garde, both idealist notions of the 'life force'
(as in Bergson) and psychoanalytic notions of the unconscious (as
derived from Freud but perhaps more commonly from Jung) functioned
in practice as modernized versions of these very old assumptions and
processes.

The most relevant example, in avant-garde practice, is of course the

'automatic writing' of the Surrealists, which was based on one, or
perhaps several, of the positions about language and its contemporary
condition which we have identified. 'Everyday' and 'ordinary' language,
or sometimes 'the language of a decadent bourgeois society', blocked
true creative activity, or (for another different formulation was also
employed) prevented us embodying – almost one can say 'representing'
– the true process of thought. Thus Breton had said, in a still general
way: 'words are likely to group themselves according to particular affin-
ities, recreating the world in accordance with its old pattern at any
moment.'[12] But this still broad position was sharpened to a more sweep-
ing rejection: 'we pretend not to notice that . . . the logical mechanism of
the sentence appears more and more incapable of releasing the
emotional shock in man which actually gives some true value to his
life.'[13] And so to 'automatic writing': 'a pure psychic automatism by
which one proposes to express, either verbally or in writing, or in any
other way, the real functioning of thought: dictation by thought, in the
absence of any control exercised by reason, and without any aesthetic or
moral consideration.'[14] The terms of this rhetoric, confused and confus-
ing as they ought to be seen, are now in many ways naturalized: that
highly specific 'thought'/'reason' dichotomy, for example. Yet one can
look back on 'automatic writing', for all the meagreness of its actual
results, with a certain respect for its ambitions of practice, as distinguish-
able from its much looser though more suggestive ideological context.
For language was being simultaneously identified with the blocking of
'true consciousness' and, to the extent that it could emancipate itself
from its imprisoning everyday forms and, beyond that, from the received
forms of 'literature', as itself the medium of the idealized 'pure
consciousness'.

One way out of this contradiction was the move to Surrealist film, but
most writers stayed in the double position and then of course at once
encountered the obvious and ominous question of 'communication'.
Theoretically it might have been said that if psychic automatism could
reach 'the real functioning of thought' it would be transparently, even
universally, communicable, yet the means of psychic automatism were,
in practice, if not alienating, at least distancing. Artaud could go on to
say: 'The break between us and the world is well established. We speak
not to be understood, but to our inner selves.'[15] Thus the purpose of
writing (as we have since often heard) is not communication but illumin-
ation (a contrast which seems necessarily to modify the second term to
self-illumination). There can be an emphasis – which indeed became a
culture – on the experience itself, rather than on any of the forms of
embodying or communicating it.

Automatic writing had been achieved, by the internal account, in

somnambulist or trance-like states: drugs were one group of means to this state; several varieties of esoteric, mystical and transcendental philosophy another. Breton himself distinguished the poetic process as empirical; it did not 'presuppose an invisible universe beyond the network of the visible world.' Yet this older form of contrast – which would hold as a distinction, one way or the other, as late as the Symbolists – was now insignificant, within the ideological substitution of 'the unconscious' which could comfortably embrace 'reality' and 'hidden reality', 'experience' and 'dream', 'neurosis' and 'madness', 'psychic trace' and 'primal myth', in a dazzling shift of new and old concepts which could be selected as purpose served.

What came through, at its most serious, were unforeseen yet convincing or at least striking collocations, but this much more often in visual imagery than in language. The presumptive dismissal of 'everyday' content found a later rationalization, for example in Adorno, in the idealization of form as authentic – art-defining – image. But there was also a broad highway into the process rather than the product: the drug-experience as such; the esoteric and the occult as direct, but not artistic, practices; the support looked for in mystical philosophies becoming the new practice of the meditative and transcendental rather than the 'poetic' or 'creative' word.

That was one general way, later dividing, from the proposition of the transrational sound-image. Within Surrealist practice, for all the specificity of its forms, there was still construction through, if not from, the word. The other general way took construction in language more directly, but then again in diverse ways.

For the Expressionists, in writing, the emphasis was not on transcending contradictions – as in Breton's remark that 'Surrealism would have liked nothing better than to allow the mind to jump the barrier raised by contradictions such as action-dream, reason-madness, and sensation-representation'[16], but on raising them to a principle of form: sharply polarized states of mind, angrily polarized social positions, whose conflict was then the dynamic of truth. The discursive language which they identified in Naturalism – whether as reflection or discussion of a situation or problem, or as the social process which Strindberg had defined as the irregular engagement of minds or which Chekhov had realized in his writing of failures of communication, that negative group which yet, as a group, shared a social situation of which they needed to speak and which others should see and understand – all that kind of writing of speech was rejected, within the polar contradictions, for what is in effect the language of the cry, the exclamation.

In its early stages especially, the Expressionist word is indeed 'trans-rational', but for conflict rather than access. The idea of primeval energy

in the cry is again evident, and in some later Expressionist work – in Toller and Brecht, for example – the cry is a consciously liberating, indeed revolutionary moment: the cry can become a shout or the still inarticulate cry a protest; that cry which fights to be heard above the news bulletins, the headlines, the false political speeches of a world in crisis; even the cry which can become a slogan, a fixed form, to shout as a means to collective action. That direction in language sought, in its own terms, to intervene in the social process and to change reality by struggle. It is then at most a distant cousin of the 'transrational sound-image', though some relationship is there.

Yet this is one more case in which a specific and specializing development of actual writing practices cannot usefully be reduced to the general propositions about language which, in their own but different terms, were becoming influential. Thus we can see some relationship between certain versions of the 'poetic word' or the 'transrational sound-image' and certain modern linguistic definitions of the 'sign': indeed 'sign', as a term, with its available free associations to 'icon' or 'ideogram' or some visual representation, sometimes points us that way, and we can usefully recall Saussure's hesitations about it, since it can blur the necessary choice between 'sign' as *signifier*, a unit within an autonomous language system, and 'sign' in its very combination of 'signifier' and 'signified' as pointing both ways, to the language-system and to a reality which is not language.[17] But that is a question within the distinctive area of linguistics, and there is little point – indeed there is some obvious danger – in assimilating one or other version of the linguistic sign to the specific – and in fact diverse – concepts of the sound-image that were available to certain strategies in writing.

Thus, if we look back to the early Formalists, we find a failure to resolve this problem as it passes from linguistic definition to literary analysis or recommendation. To understand the word as empirical phonetic material is indeed a basis for a strategy of 'defamiliarization' or 'estrangement', and it is true that exclusion of received or indeed any semantic content opens possibilities of semantic exploration as well as our old friends the phonetic poem or its upstart cousin, cross-cultural assonance: 'jung and easily freudened'.

Yet the Formalist position, as it came through into an influential tendency in literary theory, was a disastrous narrowing of the very facts to which it pointed. It became tied to rejections of what were called 'content' and 'representation', and even more damagingly of 'intention', which actually missed the point of active literary uses of the very quality that Voloshinov called 'multiaccentual', an inherent semantic openness, corresponding to a still active social process, from which new meanings and possible meanings can be generated, at least in certain important

classes of words and sentences.[18]

Yet even that was still a linguistic proposition. The Formalists, though tying their linguistic position to certain kinds of literary practice – kinds heavily influenced by the practice of Futurism though most of their illustrative examples were from much earlier works and, of course, from folk-tales – limited the true potential of the position by a characteristic error. Under the spell of their own selected examples, of valued but highly specific uses, they forgot that every act of composition in writing, indeed every utterance, at once moves into specific processes which are no longer in that way open: which indeed, as acts, even in the most seemingly bizarre cases, necessarily have 'content' and 'intention' and which may, in any of many thousands of ways, even in these terms 'represent'. To retain the useful abstraction of basic linguistic material, which is properly the ground of linguistic analysis, in arguments which offer to deal with what is already and inevitably a wide range of practices, in which that material is for this and that purpose being used, has been to misdirect several generations of analysts and even, though fewer in number, some writers.

And perhaps, finally, there is more than a wide range of practices; perhaps, through the many complications, overlaps and uncertainties, there have been, through this period of active innovation and experiment, two fundamental directions which we can at least provisionally distinguish.

We can begin by noticing the two active senses of 'modern' in this context: 'modern' as a historical time, with its specific and then changing features; but 'modern' also as what Medvedev and Bakhtin, criticizing it, called 'eternal contemporaneity', that apprehension of the 'moment' which overrides and excludes, practically and theoretically, the material realities of change, until all consciousness and practice are 'now'.

From the first sense, with its grasp of changes that were factually remaking society (a grasp that was of course variable, selecting this or that group of features, in this or that movement), a sense of the future, and then properly of an avant-garde, was extensively derived. From the second sense there was, and is, something else: a generalization of the human condition, including generalizations of both art and language, and through them of consciousness. The 'modern', in this sense, is then either a set of conditions which allow this universal condition to be at last recognized, after the tied ideologies of earlier times, or else, as in the earliest movements, a set of circumstances in which the universal and true nature of life is especially threatened by a modernity which must be opposed or evaded: a modernism, as so often, against modernity: not an *avant* but an *arrière* garde: the literally reactionary tendency which should have culminated in Eliot.

Correspondingly there appear to be two basic contradictory attitudes towards language: that which, engaging with received form and the possibilities of new practice, treats language as material in a social process; and that other which, as in several avant-garde movements, sees it as blocking or making difficulties for authentic consciousness: 'the need for expression . . . born from the very impossibility of expression';[19] or what Artaud seems to mean when he writes: 'my thought abandons me at every step – from the simple fact of thought to the external fact of its materialization in words.'[20]

Each of these positions is, we can say, a modernism; but we can then also say that while the first is modernist in both theory and practice, the latter is modernist in practice, but in its underlying theory, its finally intransigent idealism, at best a finding of new terms for the 'ineffable': even anti-theological, anti-metaphysical terms for that same 'ineffable', as they would of course now have to be.

The same basic contrast, within modernism, is evident in the forms of specification of 'the modern' itself: on the one hand those forms which engage with history and with specific social formations; on the other hand those which point to certain general features, approvingly or disapprovingly: features which then function in effect as 'background' to the foregrounded 'creative act'. Thus we are told, in an enumeration, of the facts of the city, of new technology, of changes in work and in class, of the weakening and collapse of traditional faiths, and so on, for the listing can be endless. Yet any or all of these probable features has to be seen as having influenced whole populations, whole social processes, whereas Modernism and the avant-garde, in any of their forms, have never involved, as producers or as publics, more than minorities; often very small minorities. To be sure there is an internal way of meeting this objection: that while 'mass life' may flow this way or that, the significant movements are always those of minorities. That conceit has been heard from embattled innovators, where it is understandable, to privileged and even institutionalized groups, which when they are also attaching themselves to an avant-garde become absurd.

What matters, still, is not general features but specification. Certainly the city is relevant, and specifically the city as a metropolis. It is a very striking feature of many Modernist and avant-garde movements that they were not only located in the great metropolitan centres but that so many of their members were immigrants into these centres, where in some new ways all were strangers. Language, in such situations, could appear as a new kind of fact: either simply as 'medium', aesthetic or instrumental, since its naturalized continuity with a persistent social settlement was unavailable; or, of course, as system: the distanced, even the alien fact. Moreover, these cities had become the capitals of imperi-

alism. The old hegemony of capital over its provinces was extended over
a new range of disparate, often wholly alien and exotic, cultures and
languages. The evolutionary and family versions of language which were
the basis of language studies in the period of formation of nation-states
and confederacies were then replaced by studies of universal systems
within which specificities were either, as in much literary practice,
exotica, or were the local, momentary, and superficial features of more
fundamental structures.

There was then both gain and loss: new possibilities of analysis
beyond the naturalized forms; new kinds of false transfer of these
analytic positions to practice and recommendations for practice. Within
these specific conditions, various formations emerged; in political aspir-
ations to a corresponding universality – the revolutionary groups; or in
reactionary redoubts, preserving a literary language in either of its forms
– a pure national language or a language of authenticity against the
banalities or repressions of everyday language use.

But finally, and still much the most difficult to analyse, there were the
formations of certain special innovations, and these most marked – to
use shorthand for what would need to be a very complex socio-historical
analysis – in three types of group: those who had come to the metropolis
from colonized or capitalized regions; those who had come from what
were already linguistic borderlands, where a dominant language
coexisted with the practice or the memory of an older native language;
and those who came as exiles – an increasingly important kind of form-
ation – from rejecting or rejected political regimes. For in each of these
cases, though in interestingly different ways, an old language had been
marginalized or suppressed, or else simply left behind, and the now
dominant language either interacted with its subordinate for new
language effects or was seen as, in new ways, both plastic and arbitrary:
an alien but accessible system which had both power and potential yet
was still not, as in most earlier formations, however experimental, the
language or the possible language of a people but now the material of
groups, agencies, fractions, specific works, its actual society and complex
of writers and game-players, translators and signwriters, interpreters and
makers of paradoxes, cross-cultural innovators and jokers. The actual
social processes, that is to say, involved not only an Apollinaire, a Joyce,
an Ionesco, a Beckett, but also, as Joyce recognized in Bloom, many
thousands of extempore dealers and negotiators and persuaders:
moreover not even, reliably, these as distinct and separate groups.

And indeed this was bound to be so, since the shift was occurring
within accelerating general processes of mobility, dislocation and para-
national communication which, over the decades, appeared to convert
what had been an experience of small minorities to what, at certain

levels, and especially in its most active sites and most notably in the United States, could be offered as a definition of modernity itself.

There was then a now familiar polarization, of an ideological kind: between on the one hand the 'old, settled' language and its literary forms and on the other hand the 'new, dynamic' language and its necessarily new forms. Yet at each of these poles there is a necessary distinction. The cultural forms of the 'old, settled' language (always, in practice, never settled, however old) were indeed, at one level, the imposed forms of a dominant class and its discourse. But this was never the only level. Uses of a language of connection and of forms of intended communication remained an emphasis and an intention of other social groups, in both class and gender, whose specific existence had been blurred or contained within the imposed 'national' forms. Similarly, the cultural forms of the 'new, dynamic' language were never only experimental or liberating. Within the real historical dynamics they could be, and were, notably and deliberately manipulative and exploiting. The widespread adoption and dilution of avant-garde visual and linguistic modes by advertising and publicity agencies is only the most evident example; overtly commercial paranational art includes many more interesting, if less obvious, cases. There is then a practical linkage of a selective definition of modernity with the asymmetries of political and economic domination and subordination. This cannot be rendered back to isolated formal or technical levels.

Thus what we have really to investigate is not some single position of language in the avant-garde or language in Modernism. On the contrary, we need to identify a range of distinct and in many cases actually opposed formations, as these have materialized in language. This requires us, obviously, to move beyond such conventional definitions as 'avant-garde practice' or 'the Modernist text'. Formal analysis can contribute to this, but only if it is firmly grounded in formational analysis.

Thus the 'multivocal' or 'polyphonic', even the 'dialogic', as features of texts, have to be referred to social practice if they are to be rigorously construed. For they can range from the innovatory inclusion of a diversity of voices and socio-linguistic relationships (as in that remarkable historical instance of English Renaissance popular drama, in an earlier period of dislocation and offered integration) to what is no more in effect, but also in intention, than the self-absorbed miming of others: a proliferation and false interaction of class and gender linguistic stereotypes from an indifferent and enclosing technical consciousness. The innovatory inclusion can be traced to its formation, but the isolated technique is more usually traceable to its agency, in direct or displaced domination. Similarly, the important inclusion, within a highly literate

and culturally allusive context, of the active range and body of the everyday vernacular has to be distinguished not only formally but formationally from that rehearsal and miming of what is known in the relevant agencies as *Vox Pop*: that linguistic contrivance for political and commercial reach and control. The polar instances may be relatively easy to distinguish, but the complex range between them demands very precise analysis: some of it made more difficult by the facts of indeterminacy between 'literary texts' and 'general cultural discourse' which ironically, but then with very different intentions, elements in the avant-garde had worked to bring about.

Moreover, and finally, the work can be done only if we begin moving beyond those received theoretical positions, in applied linguistics and derived forms of literary analysis, which have now to be seen as at many levels internal to these very processes; often, indeed, repeating, in what appear more formal ways, the operational manifesto phrases of specific avant-garde formations, though they offer to be independently explanatory of them and indeed of most other practices. Such positions are not collaborators in the necessary work but in effect agents of its indefinite – its 'eternally contemporary' – postponement. On the other hand the history and practice of these same general movements, reviewed to disclose in some new ways the profound connections between formations and forms, remain sources of inspiration and of strength.

Notes

1. August Strindberg, Preface to *Lady Julie*, in *Five Plays*, Berkeley, 1981, p. 71.
2. Ibid. p. 67.
3. Henrik Ibsen, *Collected Works*, W. Archer, ed., London 1906–8, VI, p. xiv.
4. Ibid.
5. V.B. Shklovsky, in Striedter and Sempel, eds, *Texte der Russischen Formalisten*, Munich 1972, II, p. 13.
6. B.M. Eikhenbaum, 'La théorie de la "méthode formelle"', in *Théorie de la littérature*, ed. and trans., Tzvetan Todorov, Paris, 1965, p. 39.
7. Cited in M. Sanouillet, *Dada à Paris*, Paris 1965, pp. 70 ff.
8. A. Artaud, *The Theatre and its Double*, New York 1958, p. 110.
9. G. Apollinaire, *Oeuvres complètes* volume III, edited by M. Décaudin, Paris 1965–66, p. 901.
10. G. Apollinaire, 'La Victoire', in *Calligrammes* (12th edn.), Paris, 1945.
11. Strindberg, p. 64.
12. A. Breton, *Manifestes du surréalisme*; Coll. Idées, 23, Paris 1963, p. 37.
13. A. Breton, *Point du jour*, Paris 1934, p. 24.
14. *Manifestes du surréalisme*, p. 109.
15. A. Artaud, *Oeuvres complètes*, Paris 1961, I, p. 269.
16. A. Breton, *Entretiens: 1913–1952*, Paris 1952, p. 283.
17. Cf. R. Godel, *Les sources manuscrites du 'Cours de linguistique générale' de F. de Saussure*, Geneva, Paris, 1957, p. 192.
18. V. Voloshinov, *Marxism and the Philosophy of Language*, New York 1973.
19. G. Picon, *L'Usage de la lecture*, Paris 1961, II, p. 191.
20. *Oeuvres complètes*, I, p. 20.

5

Theatre as a Political Forum

In neutral Zürich, in 1916, a cabaret of Dadaism –

> Gadji, beri bimba
> Gadji, beri bimba

– and similar items, deliberately meaningless words repeated slowly and solemnly, or bizarre disjunctions of a hated normality –

> The cows sit on telegraph poles
> and play chess

– was being performed in Number One, Spiegelgasse. One of the founders of Dada, Hugo Ball, recalled that at Number Six, Spiegelgasse,'directly across from us . . . there lived, if I am not mistaken, Herr Ulianov/Lenin. Every evening he must surely have heard our music-making and our tirades.' Ball went on to put this question: 'Is Dadaism something of a mark and gesture of a counterplay to Bolshevism? Does it oppose to the destruction and thorough settling of accounts the utterly quixotic, unpurposeful, incomprehensible side of the world? It will be interesting to see what happens.'[1] Indeed it has been, especially when we remember that Dada also, for a time, had a Revolutionary Central Committee and was proposing a new culture to include circuses and the use of Dada verse as a Communist state prayer.

In fact, within five years, in Lenin's Soviet Union, there was a revolutionary avant-garde theatre. Alexander Tairov was pioneering the extraordinarily influential Constructivist sets of scaffolding and platforms, and was using exaggerated make-up to emphasise theatricality. Vsevolod Meyerhold was moving drama and theatre away from what he

saw as trivial personalia towards the deliberately unindividual. Meanwhile Nikolai Okhlopkov was developing large open-air productions, intended to break down the conventional separation between actors and audiences. A similarly experimental vigour was evident also in Soviet film-making: in one direction moving out to crowds and actual locations and away from actors and sets; in another, controlling and planning the juxtaposition of images, in some versions as an identification of montage with the dialectic – shot A interacts with shot B to produce a new concept C. During the same years, in the turbulence of postwar Germany, Expressionist theatre and cinema were moving very actively in related avant-garde directions. And in England, too, D.H. Lawrence was writing: 'drama is enacted by symbolic creatures formed out of human consciousness: puppets if you like: but not human individuals. Our stage is all wrong, so boring in its personality.'[2] W.B. Yeats had already produced his *Plays for Dancers* on similar principles, influenced by the Japanese *Noh* theatre.

These developments could be described in a historical narrative. But that legendary, perhaps apocryphal moment in the Spiegelgasse gives a more truthful insight into the complex relations between avant-garde theatre and radical or revolutionary politics. More generally, in avant-garde art as a whole, comparable or at least negatively related innovations and technical experiments, founded on an angry rejection of bourgeois culture and its enclosed, personalized, reproductive works and institutions, contained within themselves profoundly different social principles and almost equally different conceptions even of the basic purposes of art. Ball's question is perceptive. There was indeed a counterplay between the conception of theatre which was associated with Bolshevik practice – a movement beyond bourgeois concepts of the sources of human action and a corresponding transformation of the relations between producers and audiences – and on the other hand the conception, as marked in Lawrence and Yeats as in what seems the special case of Dada, of forms of writing, acting and presentation which would explore, or as often simply assert, all that was 'unpurposeful, incomprehensible', not only in acknowledgement of this human dimension but in its acceptance, even its celebration.

The diversity of early Soviet experiments was in fact first reduced, then cut short, by political developments and eventually by repression, from the late 1920s. The central site of the whole remarkable history is then the Germany of the Weimar Republic, later ended by Hitler but continuing to be influential in exile in ways that come down to our own time.

We can best look at the early German experience through two figures: Ernst Toller and Erwin Piscator. There is then a later and very

significant climax in the changing work of Bertolt Brecht. Yet before we enter these details it is necessary to look more generally at the development of modernist drama before the crisis and new opportunities after 1917. The main reason for this is that the rhetoric of the avant-garde, characteristically rejecting even the immediate past, has survived into what appears to be scholarly and critical discussion, with deeply negative effects not only on the work of that earlier period but, more to the present point, on the understanding of the complex character of avant-garde theatre itself and especially its relations to politics.

One word sums up the diverse rejection: *naturalism*. There is hardly a new dramatic or theatrical movement, down to our own day, which fails to announce, in manifesto, programme note or press release, that it is rejecting or moving beyond 'naturalism'. And this is especially surprising since the overwhelming majority of theatrical works and productions continue, in relatively obvious senses, to be naturalist, or at least (for there can be a difference), naturalistic. To untie this tangle we must attend to its history.

The key moment, not surprisingly, is that most neglected period of dramatic and theatrical history in which bourgeois influence and bourgeois forms made their decisive appearance. In England, where this was early, this period is the mid-eighteenth century. Much can be missed if we interpret this new influence in terms only of its evident and at first crude morality and ideology. It is important that the bourgeoisie had moved from its earlier rejections of late feudal, courtly and aristocratic theatre – because of its inherently misleading fictions, its lewdness and amorality, its function as a mere distraction from the serious and the utilitarian – to positive interventions in its own image, sentimental and conformist as these undoubtedly were. But the most fundamental cultural history is always a history of forms, and what we actually find, as we examine this period in its long and slow lines of development towards our own century, is one of the two major transformations in the whole history of drama (the first was that of the Renaissance).

We can identify five factors of an immensely influential kind in all subsequent drama. First, there was the radical admission of the *contemporary* as legitimate material for drama. In the major periods of Greek and Renaissance drama the inherent choice of material was overwhelmingly legendary or historical, with at most some insertions of the contemporary at the margins of these distanced events. Second, there was an admission of the *indigenous* as part of the same movement; the widespread convention of an at least nominally exotic site for drama began to be loosened, and the ground for the now equally widespread convention of the *contemporary indigenous* began to be prepared. Third, there was an increasing emphasis on *everyday speech forms* as the

basis for dramatic language: in practice at first a reduction from the extraordinary linguistic range, including the colloquial, which had marked the English Renaissance, but eventually a decisive point of reference for the nature of all dramatic speech, formally rhetorical, choral and monological types being steadily abandoned. Fourth, there was an emphasis on *social extension*: a deliberate breach of the convention that at least the principal personages of drama should be of elevated social rank. As in the novel, this process of extension moved in stages, from the court to the bourgeois home, and then, first in melodrama, to the poor. Fifth, there was the completion of a decisive *secularism*: not, in its early stages, necessarily a rejection of, or indifference to, religious belief, but a steady exclusion *from the dramatic action* of all supernatural or metaphysical agencies. Drama was now, explicitly, to be a human action played in exclusively human terms.

The success of this major bourgeois intervention is easily overlooked just because it has been so complete. For the last two hundred years, and as clearly in the modernist and avant-garde theatres as in those of the successive mainline bourgeois establishments, these five factors have been fundamentally defining. What has then really to be traced is the string of variations and tensions within these norms, in different phases of experimental drama and theatre. We can then approach the question of the real nature of the avant-garde revolt against what is called 'bourgeois' drama and theatre.

For our present purpose the naturalist variation is decisive. It is true that 'naturalism' might be used as a summary of the effects of these five bourgeois factors, but historically this was not the way the term went. Late-nineteenth-century Naturalism, in practice, was the first phase of Modernist theatre. It was in many ways an intensification – in its period a shocking intensification – of the five factors, but in its immediate development it rested on a more specific base. At its centre was the humanist and secular – and, in political terms, liberal and later socialist – proposition that human nature was not, or at least not decisively, unchanging and timeless, but was socially and culturally specific.

There was always a decisive action and interaction between what was still residually called 'character' and a specific 'environment', physical and social. The new use of 'naturalism', as distinct from earlier broadly secular emphases, was formed by a new natural history, with a clear borrowing of language to describe the adaptation, or failure of adaptation, of old and new social and human types; and with an explicit emphasis on the evolutionary process, commonly seen as a struggle for existence, by which a new kind of life tried and as often failed to come through. Thus the best-known technical innovation of Naturalism – the building of 'lifelike' stage sets (though this had actually already been

pioneered in society drama as a form of luxurious display) – was now a dramatic convention in its own right. A real environment had to be reproduced on the stage because within this perspective an actual environment – a particular kind of room, particular furnishing, a particular relation to street or office or landscape – was in effect one of the actors: one of the true agencies of the action. This is especially clear in Ibsen; but in many subsequent plays and films this essential relationship is common, and is even taken for granted.

Thus real and often new social locations were put on stage, and within the same purpose there was ever more careful attention to the reproduction, within them, of everyday speech and behaviour. These new conventions passed ever more widely into drama as a whole, but it is then necessary to distinguish between what can still properly be called the Naturalist convention and what became, in the more general change, the naturalist habit. This is in practice a distinction between the Naturalist drama which was actually the first phase of Modernism, and that naturalist – or shall we now say 'naturalistic'? – accommodation to the norms of the orthodox culture. What is most clear in modernist Naturalism – from Ibsen through early Strindberg to Chekhov – is its challenging selection of the crises, the contradictions, the unexplored dark areas of the bourgeois human order of its time.

These challenges were met by furious denunciation. The new drama was low and vulgar or filthy; it threatened the standards of decent society by subversion or indifference to accepted norms. Plays which questioned prevailing conceptions of femininity, such as Ibsen's *Doll's House* and Strindberg's *Miss Julie*, provoked particular indignation. In this sense there is a direct continuity from modernist Naturalism to the work and reception of the avant-garde. Moreover their social bases are directly comparable, in that each is the work of dissident fractions of the bourgeoisie itself, which became grouped – especially from the 1890s – in new independent and progressive theatres.

Yet there was an early crisis within the chosen form of modernist Naturalism. Its version of the environment within which human lives were formed and deformed – the domestic bourgeois household in which the social and financial insecurities and above all the sexual tensions were most immediately experienced – was at once physically convincing and intellectually insufficient. Beyond this key site of the living room there were, in opposite directions, crucial areas of experience which the language and behaviour of the living room could not articulate or fully interpret. Social and economic crises in the wider society had their effects back in the living room, but dramatically only as reports from elsewhere, off-stage, or at best as things seen from the window or as shouts from the street. Similarly, crises of subjectivity – the

privacies of sexuality, the uncertainties and disturbances of fantasies and dreams – could not be fully articulated within the norms of language and behaviour which, for its central purposes, the form had selected.

This was an ironic result in a form which had gained its main energies from its selection and exposure of deep crises and hitherto dark areas. And in fact each of the three major Naturalist dramatists moved to continuing experiment to overcome these limitations. Ibsen and Chekhov used visual images beyond the room to suggest or define larger forces (*The Wild Duck, The Cherry Orchard*). Ibsen, in his last plays and especially in *When We Dead Awaken*, and Strindberg, from *The Road to Damascus* through *Dreamplay* to *Ghost Sonata*, actually inaugurated the methods, later known as Expressionism, which were to be main elements of the drama and theatre of the avant-garde. Here again, and centrally, the essential continuity between the thrust of modernist Naturalism and the campaigns of the avant-garde is historically evident.

There is then need for a further distinction. The drama of the living room had unreachable areas of experience in what must continue to be seen as two *opposite* directions. Theoretically there were then two choices. Either the drama could become fully public again, reversing the bourgeois evacuation of the sites of social power which had been a consequence of its rejection of the monopoly of rank. But where now would these sites of power be? Or the drama could explore subjectivity more intensively, drawing back from conscious representation and reproduction of public life in favour of the dramatization, by any available means, of what was taken to be an inner consciousness or indeed an unconscious. The key to the politics of avant-garde theatre is that both these very different directions were taken, of course with quite different results. The spurious unity which is conferred by what appears the common negative element – the 'rejection of naturalism', which by this stage could mean almost anything, including the respectable mainline accommodations of the unchallenging naturalist habit – has long concealed the only important question: that of the *alternative* directions in which a continuing bourgeois dissidence might go, and of the very different and ultimately transformed positions which were waiting at the end of each of these directions.

These alternative but at first overlapping directions are especially clear in German drama. Sternheim's *Scenes from Bourgeois Life* (trilogy, 1911–14) was a relatively simple form of bourgeois dissidence: scandals and shocks within the outwardly respectable. But in *Earth Spirit* (1895) and *Pandora's Box* (1904) by Frank Wedekind there was a more radical break: the bourgeois world is grotesque, haunted by dead customs and laws, choked by its self-repressions; but now this is chal-

lenged by an elementary life-force, primarily but not exclusively sexual, which will at once disrupt and liberate. One of the most influential consciously Expressionist plays, Kaiser's *From Morn to Midnight* (1916), showed, through twelve hours in the life of an absconding bank clerk, the insecurities and miseries of a conforming *petite bourgeoisie* breaking into petty revolt. Meanwhile Brecht, in *Baal* (written in 1918), selected the strong and ruthless individual, unafraid of social conventions, as a form of liberation of human nature and desire. The essential overlaps in what is customarily perceived as an avant-garde now seem very clear. There was at once a continuation, often by new methods, of the Naturalist project of exposing the dark places of bourgeois life, and a break to a new emphasis of the agency which will disrupt it, an elemental and uncontainable force identified primarily as an intense subjectivity.

It is then already insufficient to rest on the 'anti-bourgeois' definition: above all because other new work was moving in a quite different direction. Ernst Toller, in gaol for his part in the Bavarian Revolution of 1919, was writing *Man and the Masses* (1921). Erwin Piscator was moving from the Spartakus League to found the Proletarian Theatre as 'the stage of the revolutionary working man'. The two decisively different directions of what could be grouped as the avant-garde, and indeed more narrowly as Expressionism, can be seen in two contrasting statements of these years. Theodor Däubler wrote in 1919: 'Our times have a grand design: a new eruption of the soul! The I creates the world.'[3] Somewhat later, Piscator wrote: 'No longer is the individual with his private, personal fate the heroic factor of the new drama, but Time itself, the fate of the masses.'[4]

It is from these wholly alternative emphases that we can define, within the vigorous and overlapping experimental drama and theatre, the eventually distinguishable forms of 'subjective' and 'social' Expressionism. New names were eventually found for these avant-garde methods, mainly because of these differences and complications of purpose. What was still there in common was the refusal of reproduction: in staging, in language, in character presentation. But one tendency was moving towards that new form of bourgeois dissidence which, in its very emphasis on subjectivity, rejected the discourse of any public world as irrelevant to its deeper concerns. Sexual liberation, the emancipation of dream and fantasy, a new interest in madness as an alternative to repressive sanity, a rejection of ordered language as a form of concealed but routine domination: these were now seen, in this tendency, which culminated in Surrealism and Artaud's 'Theatre of Cruelty', as the real dissidence, breaking alike from bourgeois society and from the forms of opposition to it which had been generated within its terms. On the other

hand, the opposite, more political tendency offered to renounce the
bourgeoisie altogether: to move from dissidence to conscious affiliation
with the working class: in early Soviet theatre, Piscator and Toller,
eventually Brecht.

The concept of 'political theatre', for obvious reasons, is associated
mainly with the second tendency. But it would be wrong to overlook
altogether the political effects of the first tendency which, with an
increasing emphasis on themes of madness, disruptive violence and
liberating sexuality, came through to dominate Western avant-garde
theatre in a later period, especially after 1950. One element in this
domination has been what can be seen as a failure in that most extreme
political tendency – the Bolshevik variant of socialism – which had
attached itself to the ideas and projects of the working class. Postwar
history, and especially the Soviet experience, has made the brave early
affiliations evidently problematic. Yet, since both tendencies are still
active, and in changing proportions, it is important to identify them,
within the generalities of avant-garde theatre, at the point where they
most clearly began to diverge.

Piscator's production of *Fahnen* ('Flags') in 1924 is exemplary of that
movement in which 'our pieces were incitements with which we wished
to engage in living history and "act" politics.'[5] It was based on a bomb-
ing incident in Chicago after which four anarchists were hanged.
Described by Piscator as 'epic drama', it had fifty-six characters, in a
deliberately open, public action. There was a minimum of stage furni-
ture; playing areas were constructed and isolated by lighting, on a basis
of the scaffolding and platforms pioneered by Tairov in Constructivism,
and with further mechanical developments. Film excerpts and titles were
inserted in the action, and there could be direct audience address. The
whole emphasis was on a fluidity and simultaneity of otherwise
distanced actions; newsreels and radio announcements cut in to the
direct dramatization of an acted group.

This production can be directly related to Toller's *Hoppla!* of 1927.
The prologue shows a group of condemned revolutionaries in 1919,
waiting for execution; at the last moment one of them, Wilhelm Kilman,
is released, while the sentence on the others – including Kilman's friend
Karl Thomas – is commuted to a long term of imprisonment. The action
then switches to 1927. Thomas has just been released; meanwhile
Kilman has become prime minister. Thomas explores the altered politi-
cal world; in the end he is rearrested on a false charge, and commits
suicide.

The general history of these eight decisive years is projected by news-
reel extracts and titles, and by radio reports. The stage itself is a scaf-
folding divided into floors; any part of this structure can become a room

on which the action settles by lighting. At different times the structure is a hotel, asylum and prison. The successive scenes are of political, financial and sexual corruption; there is also sharp satire of a group of 'philosophical revolutionaries' intent on their own class-based forms of male sexual liberation. Karl Thomas, who has become a waiter, plans to shoot Kilman; but a student shoots the prime minister first.

Two main points arise from *Hoppla!* First, that it is a decisive reoccupation of that public space which the bourgeois domestic drama had evacuated. Moreover, its fluidity of scene and staging allows the virtually simultaneous presentation of otherwise separated and concealed areas of social action. The play invokes the widest possible contemporary history and then moves through more localized situations to exposure and confrontation.

Secondly, the reoccupation of this public space is accompanied by a dilution of substantial social relationships which modernist Naturalism had explored. The relationships in *Hoppla!* are sharp and diagrammatic: modes of presentation and analysis rather than of substantiation. Moreover, and this can be seen as an inner link with the subjectivist tendency, the revolutionary affiliation is primarily an exposure of the corruption of the bourgeois world – sexual as well as financial and political – against which the heroic individual struggles to act, but fails. It is relevant in this context that the decisive act is not a communal rising (as already, within Naturalism, in Hauptmann's *The Weavers* of the 1890s) but an individual assassination, within the militant anarchist tradition.

These points can be related to the changes of direction made by Brecht who, coming out of this theatrical world of the 1920s, at first with less clear political commitments, was to become the major practitioner of the drama and theatre of the political avant-garde.

The early Brecht, of *Baal* and *Drums in the Night*, is radical and anti-bourgeois within the subjectivist tendency; even the revolution in *Drums in the Night* is essentially a disconnected background to a subjective history. In a following phase, that of *Mahagonny* and *The Threepenny Opera*, the critique of specifically bourgeois society is more explicit and more vigorous, but the dominant mode of response is still a cynicism linked with individual accommodation and survival. There is a transition in *St Joan of the Stockyards* and especially in his adaptation of Gorki's *Mother*, where the elements of a positive and eventually collective response begin to come through. This is also the period of his deliberate movement away from the experimental bourgeois theatre towards a possible working-class theatre. This was a period, in the late 1920s, of intensified theatrical enterprise of this kind, in mass pageants, in street theatre, in performances in pubs and factories, and in the touring of such groups as the Red Shirts and the Red Rockets. Brecht, who had moved

much closer to Marxism, contributed his 'teaching plays'. The most significant of these, *The Measures Taken*, was performed by the Workers' Choirs in Berlin before a mainly working-class audience.

This phase was in fact the climax of what is, historically, a relatively unusual situation: the direct interaction of avant-garde theatre with a militant working-class movement which has found its appropriate cultural institutions. It is thus different in kind from the dissident bourgeois avant-garde working within dissident bourgeois minority theatres. Yet the change cuts both ways. There is movement beyond a knowing and self-regarding cynicism, and beyond ever wilder gestures of theatrical revolt within basically conformist institutions in unaltered social relationships. At the same time, the mediation of the new drama and new audiences through a party and a theory, at one level the sources of its strength, produced (as in *The Measures Taken*) a certain applied angularity, indeed a core of overbearing demonstration within what was consciously offered as a shared, participating exploration of the profound and authentic problems of struggle.

We cannot now say what would have happened if this whole development had not been aborted by the coming to power of the Nazis. An immensely self-confident cultural movement was overborne by political history. Shock and denunciation were replaced by repression and terror. It is within this experience of dislocation and defeat that the next and best-known phase of Brecht's work developed: one that is very significant for understanding the changing politics of avant-garde theatre. It is mainly within this situation, and from exile, that Brecht developed the new techniques of distancing and of 'estrangement' (a term which he probably took directly from early Russian Formalism). It is true that within the 'teaching plays' he had been moving towards the idea of the consciously participating, critical audience, but there was then still both an actual and a potential comradely public of that kind. Deprived of such a public, and having tried and largely failed to produce a drama which could confront contemporary Fascism directly, Brecht moved, both in technique and in choice of subject, towards new and deliberate forms of distance. In doing so, it happened that he cancelled two factors of the long development of bourgeois drama: the indigenous and the contemporary. This can be taken, in one perspective, as the radical break from 'naturalism' or 'realism': within avant-garde theory the two are conflated. But of course it is also the reconstruction, within the forced conditions of exile, of the determining social conditions of the original avant-garde: the chosen forms of the marginal artist, drawing away from reproduction of a contemporary world that is hostile to art.

The brilliance of Brecht's development of these forms is not to be doubted. *Mother Courage* and *Galileo* are the profoundly divided, even

self-dissolving figures of mature modernist Naturalism, now given broad and clear historical and ideological perspectives. *The Caucasian Chalk Circle* breaks new ground in moving towards the utopian elements of the fairytale, when an unlooked-for and literally impossible human justice prevails over the hard lines of necessity typically demonstrated in both myth and realism. In one direction there are the ambiguities of survival through defeat and destruction, in which positive consciousness is available only through critical response to the action, which the form invites but does not enforce. This has been brought out by productions of Brecht which – against his intention – have emphasized the self-interested virtues of survival. In another direction, whether in the songs of pleasure and defiance, or in the utopian realization of a rare and happy justice, the collective impulse survives and communicates.

It is in this kind of complex analysis, which corresponds to what Brecht himself described as his new method, that of 'complex seeing' of a multivalent and both dynamic and uncertain social process, that Brecht's significance must be defined. To abstract the specific methods, or the theoretical phrases attached to them, as determining forms without reference to their very specific and limiting social situation, is to confirm the actual development of the avant-garde, culturally and politically, towards a new aestheticism. By this means unresolvable social problems are bypassed in what seems an autonomous, self-dependent and self-renewing artistic enterprise. The often successful attempt to depoliticize Brecht, by bringing up the elements of cynical survival and unspecific liberation and playing down the firm attachments to a common condition and common struggle, is characteristic of that phase of accommodation and incorporation of the avant-garde which happened so widely, in the West, after 1950.

By contrast with developments in Germany, the English theatre of the twenties and thirties never acquired real political momentum. The dominating figure was Bernard Shaw; but his drama of ideas lacks the leading edge of formal innovation. For developments which run parallel (and may in part be indebted) to German Expressionism, we must turn first to Sean O'Casey, and then to Auden and Isherwood. O'Casey, after the distinctive realism of his Abbey Theatre plays, wrote in 1927 *The Silver Tassie*, which in its central sections is an attempt at a new form: the use of songs, slogans, reduced speech to express the alienation of war; a movement that is accomplished in the play as a whole by the transformation of the hero from popular football star to mutilated war victim.

Auden and Isherwood, in their plays, adapted elements of Expressionist theatre in combination with the more familiar forms of musical

comedy and pantomime. *The Ascent of F6* (1937) mixes motifs of social and psychological struggle. Caricatured figures from the political Establishment persuade an idealistic climber to conquer the haunted mountain 'F6' in the British colony of Sudoland, in order to impress the unruly natives. A downtrodden, gullible suburban family, speaking comic verse, acts as chorus. Although modernist techniques (like the split stage, where politicians, climbers, native monks and the British public unwittingly interact) help to underline the revolutionary tendency, the play's hybrid borrowings – from Symbolist as well as from Expressionist theatre – form an uneasy synthesis. The same disjunction is evident thematically in the attempt to combine Marxist and Freudian motifs – so characteristic of the avant-garde in this period. The climber, who disapproves of his tendentious mission, attempts to scale the mountain for more personal reasons – in order to win his mother's love. As he is dying, the figure of his mother appears as the shrouded divinity haunting the mountaintop. His dying fantasy is projected on stage in Expressionist fashion: his politician brother becomes a dragon, and masked Establishment figures enact a pantomime chess game. This mingling of popular and experimental forms, resulting in a Brechtian sense of alienation, provides a panoramic critique of the social order juxtaposed with the spiritual crisis of the failed idealist.

On the Frontier (1938) portrays two warring countries in which the troops mutiny and the workers revolt as they overcome their misguided mutual hostility (which is largely attributable to the press and radio). Again the revolutionary theme is highlighted by both music-hall caricature and Brechtian montage. The Fascist leader is a failed revolutionary, feeble and insane, who is manipulated by big business. And the warring families living on either side of the invisible 'frontier' (centre stage) respond unwittingly in ironic antiphony. But, in a significant shift of emphasis, the young lovers, who have been separated by the frontier throughout the play, affirm the supremacy of love, as they die. They have abjured their earlier pacifism to become respectively an insurgent and a nurse, in support of those who 'build the city where/ The will of love is done'. The lovers thus 'die to make man just/ And worthy of the earth'.[6] Despite this expression of faith in the justness of their cause, the effect of this ending is to eclipse the political impact of the popular rising, which had earlier been powerfully foregrounded by satirical newspaper readings in front of the curtain. The play ends on a note of lyrical individual lament.

These were the best-known English left plays of the 1930s, mainly because they were produced within the most effective cultural formation: that of the politically dissident bourgeoisie. Yet work of a different kind, seeking out working-class audiences and direct workers'

production, was also being done: not only through the agitational forms
of the living newspaper but over a range of methods, including recon-
structing popular history and contemporary social realism. This tend-
ency, often interrupted by its institutional weaknesses, has continued to
appear and has strengthened.

Yet it is on what has happened since to the cultural politics of the
self-conscious avant-garde that we must place our final emphasis. The
fragmented ego in a fragmented world has survived as a dominant struc-
ture of feeling. In the overlapping phases of Surrealist theatre, the
Theatre of Cruelty, the theatre of the Absurd and the theatre of 'non-
communication', distinct original strains of the avant-garde formation
have deepened and intensified. There is still an element of revolt in the
challenge to bourgeois society (later renamed 'mass society' or even
'society' as such, including, in a later phase, 'male patriarchal society')
on the grounds of its monopoly of consciousness: a monopoly typically
expressed in its forms of language and of representation.

The cutting edge of this critique can still move towards forms of more
general revolt (as in some examples of feminist theatre); but more
characteristically it settles in the attempted breakthrough to authentic
individual experience from below this standardized consciousness, or in
the very demonstration of the impossibility of any such break. There is
then a movement from presenting the bourgeois world as at once
domineering and grotesque to an insistence – in certain forms a satisfied
and even happy insistence – that changing this is impossible, is indeed
literally inconceivable while the dominant consciousness bears down.
This takes a special form in theatre in what is offered as a rejection of
language. If words 'arrest and paralyse thought' it may be possible, as
Artaud hoped, to substitute 'for the spoken language a different
language of nature, whose expressive possibilities will be equal to verbal
language':[7] a theatre of visual movement and of the body. In such ways,
the fixed forms of representation can be perpetually broken, not by
establishing new forms but by showing their persistent pressure and
tyranny. One main emphasis within this is to render all activity and
speech as illusory and to value theatre, in its frankly illusory character,
as the privileged bearer of this universal truth.

Yet what has to be said as we look at this latest and in practice diverse
theatre of the avant-garde is that it has also been, in its own ways, a
politics. It has continued to shock and to challenge. It has often illumi-
nated, with its own forms of sympathy, the dislocations, the disturb-
ances, the forms of what are accounted madness, which orthodox society
in all its political colours has crudely dismissed. At the same time, as in
the earliest subjectivism, it has often been profoundly equivocal about
violence, and has at times converted it to subjectivist spectacle and to

what are in effect cruel forms of pornography (the element of *male* liberation and rejection of women in the earliest subjectivism has been powerfully maintained). Further, in some of its most beguiling examples, from the genius of Beckett to the incoherent black comedies of the new boulevards, it has programmatically reduced the scale of human possibility and human action, coverting a dynamism of form which had flirted with a dynamic of action to a repetitious, mutually misunderstanding stasis of condition. These are not then the politics of an avant-garde, in any but the most limited sense, but, as was always possible (and as had happened earlier in Eliot, Yeats and Claudel), of an avant-garde as *arrière-garde*: the impossible, unacceptable condition now taken to be inevitable and requiring submission: a defeat rationalized by cancelling its human ground and moving first its theatre and then its politics elsewhere.

Notes

1. Quoted in F. Ewen, *Bertolt Brecht*, London 1970, p. 74.
2. D.H. Lawrence, *Sea and Sardinia*, London 1921, p. 189.
3. Quoted in Ewen, p. 174.
4. Quoted in Ewen, p. 151.
5. Quoted in Ewen, p. 149.
6. W.H. Auden and Christopher Isherwood, *The Ascent of F6*, and *On the Frontier*, London 1958, pp. 190–1.
7. A. Artaud, *The Theatre and its Double*, New York 1958, p. 110.

6

Afterword to *Modern Tragedy*

The voices came and were silenced; came again and were partly silenced; came again and . . .

In the years that have passed since I wrote *Modern Tragedy* there has been more than enough evidence of the centrality of its themes. At the point where I ended, with the children of the struggle facing its men turned to stone, an extraordinary history was about to begin. There was to be the liberation and repression of the Prague Spring. There were to be new voices, some desperate, some hysterical, some lucidly challenging, within the nominally post-revolutionary regimes. But the history was to be more than this. The children of an indifferent affluence were to become, for a decade, the children of struggle, above all in resistance to the violent assault on Vietnam. In 1965, at the beginning of those years, I argued that 'Korea, Suez, the Congo, Cuba, Vietnam, are names of our struggle'. That perspective was verified, and it came to include new names: Czechoslovakia, Chile, Zimbabwe, Iran, Kampuchea. The struggle to make such connections, as a way of resolving rather than confirming a general disorder, was remarkably widened and deepened. But there can also be no doubt that this extending and complex revolution, and the extended and very bitter resistance to it, have still to be seen in a tragic perspective. It is not only the weight of the continuing suffering. It is also the intricacy of the relations between action and consequence.

These are matters of contemporary history, to be specifically as well as generally addressed. What I here feel most need to add is a note on one particular cultural consequence. My central argument, it will be remembered, was on the deep relations between the actual forms of our history and the tragic forms within which these are perceived, articulated

95

and reshaped. What I have now to note is a strengthening of one of these forms, which in cultures like my own has become temporarily dominant and indeed, at times, overwhelming.

In its most general sense this can be expressed, simply, as a wide-spread loss of the future. It is remarkable how quickly this mood has developed. It can be observed most evidently in the very centres of orthodox opinion. In the early nineteen sixties, when I was writing *Modern Tragedy*, there were many voices of protest and warning, and some of despair, but the prevailing official mood was one of calmly and happily extending prospects: a managed affluence; managed consensus; managed and profitable transitions from colonialism; even managed violence, the 'balance of terror'. Some scraps of this repertory survive here and there, as electoral gestures. But the dominant messages from the centres are now again of danger and conflict, with accompanying calculations of temporary advantage or containment but also with deeper rhythms of shock and loss. Managed affluence has slid into an anxiously managed but perhaps unmanageable depression. Some political consensus has held but the social consensus underlying it has been visibly breaking down, and especially at the level of everyday life. Managed transitions from colonialism have been profitably achieved but are increasingly and fiercely being fought in a hundred fields. The balance of terror is still there, and is yet more terrifying, but its limited and enclosed stabilities are increasingly threatened by the surges of wider actions. It is then not surprising that the dominant messages are of danger and conflict, and that the dominant forms are of shock and loss.

Yet these rhythms are familiar in history. They can be traced, with some accuracy, to a dying social order and a dying class. The particular forms of that kind of tragedy, their kind of tragedy, are now everywhere around us. They are outnumbered, it is true, by alternative responses within the same structure of feeling. There is a seemingly endless flow of colourful retrospect, simple idealizations of a happy and privileged past, most of which are not even nostalgic – an attitude which predicates a present – but merely temporary alternatives to the pain of any kind of connection. There is also a flow, touching some real nerves, of a new and dangerous form of legitimated violence by the forces of order: the rationally penetrating detective and the exposed and unorthodox private eye have in the last ten years been largely replaced, in the dominant centres of mass dramatic production, by the hard police officer, indistinguishable physically and ethically from those he is hunting and punishing, but with the formal advantage that he is taken to be on the side of the law, of things as they are or should be. This connects explicitly with the harder political gestures, in this place and that becoming more than gestures, of a new and deliberate constitutional authori-

tarianism. These flows continue compulsively, but beyond their wistfulness or their stylish recklessness, disturbing even those to whom they are necessary, there is a graver, more authentic sound: the loss of hope; the slowly settling loss of any acceptable future.

When a social order is dying, it grieves for itself, but at that very time it might be expected that all those who have suffered under it can at last release quite opposite feelings: of relief, at least; or of confident reconstruction; or of rejoicing. And indeed we have heard all those voices, at a certain distance, and are glad to have heard them. But at the slow turning point of a culture like my own, in the very cultures that are the rich expressions of this lived and now dying order, our feelings are necessarily more intricate and more involved. These feelings are coming through in overlapping phases. This is the structural reality of the very active, very diverse but curiously decentred culture of our period. The phases then need description.

But first, there is no sharp break, inside those forms and feelings which are inherent in a dying order, between on the one hand its representatives and conscious supporters and on the other hand those who would welcome alternatives to it or are already its conscious opponents. The moment of sharp break, however temporally structured, would be the moment of revolution, and we are not yet at that; not yct, pcrhaps, even near it. While the old order is still powerful, even if visibly dying, it still exercises, even if in new forms, its many determinations. Thus the simple shock of disturbance, the relatively sudden but slowly settling loss of effective continued development, of general and even common perspectives that could be taken for granted, spreads at first, beyond values, through the whole of the culture. This indeed is inevitable, since the shock is not only to an abstract social order but to millions of lives that have been shaped to its terms. Thus a capitalist economic order is in the process of defaulting on its most recent contract: to provide full employment, extended credit and high social expenditure as conditions for a political consensus of support. Those who, like myself, have seen that consensus as damaging, as preventing or postponing until it is dangerously late any effective challenge to its destructive long-term priorities, must feel, at one level, relief that it is disintegrating, but must also feel, at more immediate and in that sense much deeper levels, the human costs of that default, which in the terms of just such an order will be paid more heavily by those being defaulted on than by the defaulters themselves. Millions will be thrown out of their expectations of work. Old and ravaged areas of heavy industrial exploitation, but more important the families and communities once decanted into them who have built and lived among their fallout, will be left exposed and hopeless as capital and calculation move away. Within the still function-

ing but now tightened system, the stresses of forced competitive
routines, the arbitrariness and where necessary the brutality of new
limits and new controls, all seem certain to increase. And this is to look
only at the period which we have already entered. Beyond it, and
especially at its inevitable breaking point, there has to be reasonable
assessment of the pains of any central disintegration, even one to be
followed by new construction, and an arguable but still relevant assess-
ment of that more violent resistance to disintegration, those still harsher
mutations of a desperate order, which could indeed then occur. Facing
such perspectives, we find ourselves modulating analysis with a sharp
awareness of pain, and qualifying projection with inescapable inti-
mations of danger. If it is not easy to distinguish such feelings from the
cries of the old order itself, it is still impossible to override them, while
we still think and feel in a world of real people.

Thus shock and loss have been common responses. But we must then
go beyond them to some crucial distinctions. Take the hardest first: the
discovery in ourselves, and in our relations with others, that we have
been more effectively incorporated into the deepest structures of this
now dying order than it was ever, while it was strong, our habit to think
or even suspect. Many of those, even, who had most clearly distanced
themselves from it, who had tried to live differently and to imagine
differently, and had in part succeeded, find now that unknown fibres,
unsuspected neural connections, exert their pressures, report their limits,
and can be broken, of course painfully, only by rigorous and relentless
self-examination and new relationships. To succeed, even partly, in this
fundamental reordering is then painful as well as liberating. To find
ourselves stuck at some point in this process, as in the most general
sense, if to varying extents, we all inevitably are, is to know quite new
kinds of shock. And where this interacts, as it is now doing, with situ-
ations for which we have more familiar descriptions – the sheer duration
of the struggle for alternatives; the repeated postponements of hope,
through which, nevertheless, new commitments to effort must be made;
the intricate and difficult relations between a generation that seems and
really is tired and a younger, more vigorous generation that seems and
really is inexperienced – then the elements not only of shock and loss
but of some familiar and some new forms of tragedy are already widely
and actively present.

The hardest because perhaps the nearest kind? For of course other
kinds are more evident. Just as elements of this perceived and pressing
incorporation, in these new circumstances, run back to elements of the
tragic form developed by Ibsen, so, but much more directly, there are
significant and major continuities from the form of private tragedy
developed by Strindberg. Indeed this is one of the leading ways in which

disturbance, shock and loss have been mediated. There has been an extraordinary re-emphasis of conditions of breakdown and of what is now an ambivalent madness. Simple continuities, and especially that perception of essentially isolated persons meeting not in relationships but in inevitable and basic struggles, have, though widely evident, remained more completely within the received form. But some tendencies in radical pyschoanalysis have underwritten a newly conventional association between such breakdowns and violent struggles and a qualified condition of society: in fact, centrally, an emphasis on the repressive family, or a repressive form of family, as the nuclear element of a false and repressive kind of society. In this it is different from an earlier subjective expressionism, in which breakdown and madness were also related to specific social conditions; but these, more typically, were such general facts as war and exploitation. This relatively new form of radical private tragedy requires emphasis. It is becoming even more important in its specific articulation of the repression of women, which in another tendency can be seen within a whole social structure and crisis, but which in this tendency is embedded in, or reduced to, a version of basic and inevitable primal conflict. There are many shifting lines in this now intensely developing area, but there is still a clear theoretical distinction, not always made within the dramatic adaptations of radical psychoanalysis, between a primary and therefore inevitable condition of destructive personal or sexual conflict, and a qualified recognition of such conflicts, not diminishing their actual intensity but exploring their connections with alterable social conditions. We can take as examples of such connections the reproduction, within families and marriages, of brutalities, exploitations, or simply tensions, which are primarily generated in the whole social order; or, in another perspective, the use made of the family or of marriage by the reproductive social order for purposes of discipline, adaptation, prepared inequalities or postponed satisfactions. Disturbance, shock and loss have been memorably expressed from both these general positions. Merely rhetorical collocations, as of a violent marriage and the nuclear bomb, have also been abundant. Historically the important point is that the unaltered form of private tragedy, with its assumptions of irreducible primal conflict, belongs both generally and conventionally in the old and dying order. It is always from such positions that immediate and urgent experience is universalized as necessary, just as, in blander mood, existing social relations are universalized as necessary. The effect, both here and in some specific impressions of the alternative mode, is in any case to distance, override or convert to mere abstraction any hope of the future (the conventional exclusion of children from these versions, or their reduction to mere objects of struggle, is one evident form of this). It is

thus consonant with the new specificities of the contemporary perception of tragedy.

Connected with this form, but very different in tone and convention, is another development, which again has a precedent – in the early work of Brecht – but is now much more widespread. This is the conversion of shock, loss and disturbance to conscious insult and a deliberately perverse exposure. Of course much of this belongs directly to the old order, which can both use degradation as a means of adaptation and control – if we are as filthy as this ('and we are') there is no point in anything else – and, more publicly, in the mode of spectacle, use degradation as diversion, the pastime of calloused nerves. But there is also something not too easily separable from this in some radical work, and this at its best – for the worst is merely ephemeral – is the old twist: 'a raw chaotic resentment, a hurt so deep that it requires new hurting, a sense of outrage which demands that people be outraged.' There have indeed been some dangerous moments of this kind, as in the radical or pseudo-radical 'theatre of cruelty'. Inevitably a mixed and unstable form, it is still, in this period as in some of its equally disturbed predecessors, a plausible temporary alternative to the modes of either tragedy or comedy.

Yet there is again, beyond this, a deeper kind of degradation which now belongs, specifically, to a contemporary tragic form. In the later work of Beckett there has been so consistent a reduction and degradation of all forms of human life that it is reasonable, even after noting the precedents, to speak of a new form. It is a long if traceable way from Strindberg's *Ghost Sonata* to Beckett's *Endgame* or *Breath*. The internal coherence and dramatic power of Beckett only force the recognition. Here, very purely and starkly, are the last cries of a dying world, overwhelmed by convictions of insignificance and of guilt. In a general state of shock, it is perhaps understandable that even this ultimate reduction and degradation should have been so widely received. Its universal claim can be overlooked, or abstractly qualified, while the powerful detail meshes with the specific reductions and degradations of the time. But what is much more serious than its particular reception is the degree of adaptation to it. There can be endless false traffic, as well as some genuine confusion, between notions of a doomed and contemptible species, of a hopeless and played-out civilization, of a guilty and dying class, and of a displaced and alienated sensibility. General controversy between all these versions of the character of a recognized moment is of course necessary and urgent. But the specific and deliberate absoluteness of this late Beckett form allows, as dramatic image, no space for anything but surrender or adaptation. It not only kills hope, it sets out to kill it. It lingers with the powerful affection of genius on the last commu-

nicable moments of its death. Reducing the drama itself from character and action to puppet images and the inarticulate cries of a moment of pain, it completes, more deeply than could at all have been foreseen, the long and powerful development of bourgeois tragedy.

That is an icy peak in the drama of our period. But it is, for that very reason, though significant not dominant. What has really come through as dominant is another form which I analysed as a specific variation, but which is now so general as to be almost defining. When I analysed the development of the group as victim in Chekhov, noting the new form of his dramatic writing and its powerful creation of a position of stalemate, I had not yet fully arrived at the explanatory concept which is now necessary. For the drama of Chekhov is, fundamentally, the drama of a *negative group*, and it is here, in our own time, that we can see most clearly the basic connections between a form of history and a dramatic form. This involves, as it happens, a basic mutation of tragedy, in that the tragic event is no longer of any of the earlier kinds, and its development no longer runs back either to a public world or to a private feeling. The fact and source of tragedy are now, centrally, the inability to communicate. People still assemble or are assembled, meet or collide. A given collectivity is in this way taken for granted. But it is a collectivity that is only negatively marked. A common condition is suspected, intimated, glanced at but never grasped. The means of sociality and of positive relationship are fundamentally discounted, but not as actual isolation; merely as effective isolation within what is still unavoidable physical presence. This group or that group exists, but always negatively. There is no effective identity either within it or outside it. And this is not some imitation; it is a worked form. The skills of dramatic composition, within this dominant form, are now employed to render, that is to say produce, a negative incommunicability which is then presented to be overheard.

Now it should be clear that this form, and the ideas and feelings that it mediates, have long roots. One element of it is recognizable as early as Wordsworth in London, in the historically new 'crowd of strangers' within which identity is threatened. It was powerfully dramatized by Chekhov and by Pirandello and by their recognizable successors. Its conditions have often been analysed, most notably by Sartre with his crucial concept of 'seriality'. What can now reasonably be said to be new is that it has become a commonplace. It is no longer a vigorous challenge to the artificialities, the evasions, the false completeness of conventionally theatrical or everyday talk. On the contrary it has ingested all these, as the means to its own style. It is not a recognition of the passable or unpassable limits of communication; it is, so to say, the enunciation and construction of limits. Resting inertly on what has become a commonplace, catching with an easy indolence the passing traumas of specific

failures, it both reflects and builds a social model which is the last end of hope; for if we cannot, under any conditions, speak or try to speak fully to each other, that is the real end. And this, past what is often its light or glancing surface, is its bearing as tragic form. Painful or terrible events impinge on it arbitrarily; with a necessary arbitrariness. For through its deliberately dissolving language, its widely developed and often dominant theatrical repertoire of the gestures of failure and of turning away, it can trace no action to its motive or consequence, no joy or pain to its source, but instead (which is worse than doing nothing) hint at anything or everything, imply, become complicit. It is often said, in a misplaced defence of this form, that its function as a negative group, its radical communication of the limits of communication, is an authentic condition of late capitalist or bourgeois society. But what has also to be said is that it is a reliable condition of remaining indefinitely inside just such a society. It is not now the desperate but the wry end of hope. The sense of tragedy, which had already entered the bloodstream, now enters the whole neural system, where it can then even, of course, be played with, often with dazzling intricacy. And this last event is the clue to its place in the structure of feeling of our period. There is a very specific modulation of the conviction of impending disaster, and of the effective end of hope, in this abstracted delight, even this fashionable pleasure, in playing the last clever tunes. Nothing, or nothing much, can be said, while we sail on (the image of the *Titanic* approaching the iceberg is very widely retailed) towards disaster. But we can play doomed verbal games, or talk past each other, in the ephemeral negative groups which human society has become.

But is not the end of hope the very root of tragedy? This book was written, against specific ideological pressures in Cambridge, and against the wider pressures of a dominant period of a culture, to break down that rhetorical question to the historical and continuing diversity of tragic theory and practice. That sense of diversity, of authentic tragic variations, is still my main emphasis, as the pressures towards simplification and reduction have continued to work through. But there is now this difference: that there is what seems to me a much wider gap between the realized and demonstrated historical and cultural diversity and the now apparently blank page of the future. The very forms of our struggle for a future, under conditions only partly and at times quite indistinctly of our own making, have entered, as I argued and as subsequent history has confirmed, a tragic dimension. But for much longer than now seems reasonable or even possible, we have endured disorder, and entered the struggle against disorder, with very simple convictions of the kind of future order towards which this struggle was directed. This trap has now been sprung.

Not, of course, for the first time. There were specifically tragic histor-ical moments, of this general kind, in the late nineteen twenties, in the late nineteen thirties, and in the early and middle nineteen fifties. A foreseen future was falsified, and the consequence lent tragic depth to what were already the pains of struggle. The overwhelming historical example was of course what happened to the Russian Revolution. I see now, rereading *Modern Tragedy*, how much of that specific experience was still shaping my ideas, and not only explicitly. It is an experience that still reverberates, in an ageing generation and in other generations, as its details are relentlessly documented. To try to evade that experi-ence remains unforgiveable. But I have felt in myself, and noticed very clearly in others, a kind of fixing of vision on that intense and terrible experience which induces – and by many is intended to induce – a very deep stasis. Its sheer magnitude and importance can come to cancel the dynamics of what is now, after all, a very long and extended history. There are then moments, readily recognizable to an analyst of dramatic forms, when the real events of the Stalinist terror come to function as a dumb show, to be ritually and statically displayed before each new act and scene. It is certainly impossible to respect those who will not look, or who say merely that they have seen it before, just as it is impossible not to despise those who attempt to cover that tragic history with mere apologetics. But I find it also increasingly difficult to respect all those who gaze so fixedly on this scene that they fail to notice, in any adequate way, the turbulent actions that have begun and are continuing else-where. By the very fact of isolating that terrible moment they begin the conversion of an action into a dumb show. And this process is quite radically connected with one deep form of the tragedy of non-communi-cation.

It is not only that caught in struggles elsewhere, demanding active attention and engagement, people can be ritually terrified by the unceas-ing production of the dumb show. It is that while that action, even in its most vivid and speaking forms, preoccupies our ideas and our feelings, there is not enough left in us to live where we are, except in the reduced forms of stasis and incommunicability. Certainly the experience of Stalinism has radically reduced the confidence of many of those who are most actively confronting the destructive and dying order of imperialism and capitalism. But it seems to be false to believe that the observable loss of hope, the felt loss of a future in our own time, can be merely rendered back to those other events. In some morbid cases this may indeed be so. But in many cases it has become an evasion, of a kind common in tragic actions, of our own real situations and relations. Many vigorous and admirable people, in new kinds of dramatic production, are now attempting to counter the stasis with active discovery and re-

discovery of alternative real pasts. There have been significant and understandable new connections with periods of our own popular struggles, and especially with some of the most heroic and invigorating periods. But this also, while incomparably better than the forms of reduction and stasis, can sometimes be seen as one of the more active forms of the loss of a future. For there is a sense in which the reproduction of struggle is not primarily, whatever may be claimed, a production of struggle. The few real cases of forms of dramatic *connection* of past and present and future struggles are not only exceptionally valuable in themselves; they allow us to see the difference between this and mere reproduction.

Tragedy can inhere in so many shapes of the historical process: in the failed revolution; in the deep divisions and contradictions of a time of shock and loss; in the deadlock or stalemate of a blocked and apparently static period. But it is in the overlap of the last two of these areas, in cultures like my own, that we now find ourselves. The forms of deadlock and much more commonly of stalemate are now being intensively practised, in deepening modes of reduction and stasis (ironically, sometimes as proud alternatives to realism, which they damagingly are; or, more plausibly, to Naturalism, which while it was usually static, though hardly ever as fundamentally static as some of these new forms, was never, in the central sense, reduced, but at its best was always extending, exploring and inquiring). The forms of division and contradiction are also now extensively practised, but in majority in ways that confirm and stabilize, wryly specify or rhetorically universalize, the very forms of division and contradiction to which they are addressed.

It is here that the loss of a future is most keenly felt. It has been argued that it is time now to move from a tragic to a utopian mode, and there is some strength in this; it is a classical form of invigoration and hopeful protest; it is also, at any time, a necessary mode of one area of social thought. But it is not, when we look into it, a question of this or that prescription. The fact is that neither the frankly utopian form, nor even the more qualified outlines of practicable futures, which are now so urgently needed, can begin to flow until we have faced, at the necessary depth, the divisions and contradictions which now inhibit them.

This can be done, of course, in other than tragic modes: by theoretical analysis of the most general kind, and by many kinds of specific analysis and action. Without these it is difficult to believe that we could ever gather the materials to find our ways beyond the present and paralysing sense of loss. It is easy to gather a kind of energy from the rapid disintegration of an old, destructive and frustrating order. But these negative energies can be quickly checked by a sobering second stage, in which what we want to become, rather than what we do not now want to

be, remains a so largely unanswered question. To the significant degree that our reasons for not answering or trying to answer this question are connected with the now painful divisions and contradictions – as painful to try to shift as to experience – it seems inevitable that a tragic stress must still be made, but in that form which follows the whole action and which is thus again profoundly dynamic.

This is of course much easier to project than to do, but it is in fact far from easy, under current pressures and limits, even to project it. Yet one immediately available way of creating some conditions for its projection, and perhaps for its performance, is now, as when I was first writing, to push past the fixed forms in the only way that is possible, by trying to understand their intricate and diverse formations, and then to see, through and beyond them, the elements of new dynamic formations.

7

Cinema and Socialism

The first audiences for cinema were working-class people in the great cities of the industrialized world. Among the same people, in the same period, the labour and socialist movements were growing in strength. Is there any significant relationship between these different kinds of development? Many have thought so, but in interestingly different ways.

One way that became common on the Left saw film, from an early stage, as an inherently popular and in that sense democratic art. It bypassed, leaped over, the class-based establishment theatre and all the cultural barriers which selective education had erected around high literacy. Moreover, in a more sophisticated second stage of this argument, film, like socialism itself, was seen as a harbinger of a new kind of world, the modern world: based in science and technology; fundamentally open and mobile; and thus not only a popular but a dynamic, perhaps even a revolutionary medium.

How does that argument look today, after three quarters of a century of primarily capitalist development of cinema? Is it simply to be dumped in that dustbin of history to which the Left, in that period, was confidently carrying so many contemporary items, but which today – and not always kicking and struggling – it finds itself and so many of its ideas labelled for? It is worth taking another look, in some re-analysis.

First, what is *popular*? The key to an understanding of the cultural history of the last two hundred years is the contested significance of that word. It was not only cinema; it was even more confidently a century earlier the press, which was seen by democrats and radicals as the extending, the liberating medium, pushing beyond the closed and controlled worlds of state power and the aristocracy. In a directly related case, there was the long struggle to restore legitimacy to popular theatre,

since a State Act of the seventeenth century had restricted the lawful practice of drama to a few selected fashionable theatres. What had come up, strongly, in the illegitimate theatres – and in the pub entertainments, in the circuses, in the music halls – was indeed, within these conditions, a popular form, a set of forms, lively and entertaining though also limited by its exclusion from some of the older arts. When the Act was repealed, in 1843, there was a whole contemporary removal of obstacles to that other insurgent popular form – the newspaper. Difficult as it may now be to recall that history, in a time in which our labour movement and so many on the Left cry angrily against 'the media', the facts are that these were seen, and by the rich and powerful often feared, as liberating popular practices, or at least in the popular interest: indeed the means, the media of – though that phrase was not yet used – a cultural revolution.

But what was often not noticed on the Left, and is perhaps not fully noticed even today, is that there are others than radicals and democrats interested in being popular. What was supposed to be a monopoly, in one selected sense of 'the People', fighting for its rights and its freedoms, turned out to be very different, and was bound, in those conditions, to be different. Certainly radicals and democrats fought for the new forms and the new freedoms. But also, commercial entrepreneurs, new-style capitalists, in an unbroken line from that day to this, saw their own versions of possibility in the new technologies, the new audiences, which were being formed in the whole vast process; and they too, as again today, at the leading edge of our own new technologies, were engaged in fighting the restrictions of state laws; fighting and manoeuvring for what we now call deregulation. They would not, it seems certain, have won in any single instance, if they had not had behind them the evidence and the pressure of solid popular demand. What we see in the case of the early cinema is in that sense entirely typical of a more general cultural history. It had to fight its way through controls and regulations. It did not always fully succeed. Consider the United States Supreme Court judgement of 1915, refusing cinema the constitutional freedoms already guaranteed to print:

> It cannot be put out of view that the exhibition of moving pictures is a business pure and simple . . . They are mere representations of events, of ideas and sentiments published or known; vivid, useful and entertaining no doubt but . . . capable of evil, having power for it, the greater because of their attractiveness and manner of exhibition.

It was because cinema was popular, in fact in several senses, that it was still to some degree controlled, as had happened earlier with the press

and was to happen later with radio, television and video.

Thus socialists are mistaken when they suppose, in any post-feudal society, that they have any kind of monopoly of the popular interest, or indeed that only they and their allies have contested both state and established capitalist power in the struggle for new freedoms. The honest way to see the real cultural history, which is in fact closely paralleled by that part of political history which concerns elections and parties, is that the new conditions and the new technologies made possible two wholly alternative directions of development: alternatives that we can now see more clearly but which for a very long time, and still in many cases today, in practice overlapped because they seemed to have a common enemy: the old regulating powers of Church and State; the relatively closed, constrained, often stuffy habits of a settled and traditionally hierarchic society; the positive organization of this received morality – in the case of the cinema the characteristic report of the National Council of Public Morals in Britain in 1916:

> Moving pictures are having a profound influence upon the mental and moral outlook of millions of our young people. . . . We leave our labours with the deep conviction that no social problem of the day demands more earnest attention.

Familiar tones, familiar enemies? Perhaps too familiar. For while, within that history, there was bound to be overlap between the alternative new directions, nothing is to be gained and indeed much is to be lost, if we go on supposing that within the rhetoric of 'the popular' there is real common ground.

On the contrary, we have to see how well placed this new and at first marginal capitalism was, both to develop and to exploit a genuine popular medium. We can see this, in the case of film, at once in institutions and in majority content. The first cinemas were called theatres, after the early sideshow phase, but a key factor of the technology soon gave them a transforming advantage. The indefinitely reproducible print, though structurally similar to the transforming technology of the press, could be used in new ways: to bypass the problems of literacy; to bypass, in the silent era, the old limitations of national languages; but above all to ensure rapid distribution of a relatively standard product, over a very much wider social and geographical area. It isn't really surprising, setting these advantages within both earlier and later industrial history, to find a symmetry between this new popular form and typically capitalist forms of economic development. Nor is it surprising, given the basic factor of centralized production and rapid multiple distribution – so different, in those respects, from most earlier cultural technologies – to see the

development of relatively monopolist – more strictly, corporate – forms of economic organization, and these, moreover, in a significant new phase which followed from the properties of the medium, on a paranational scale. Many attempts were made to preserve at least domestic corporations, but the paranational scale significantly overbore most of them. The road to Hollywood was then in one sense inscribed, and it is still important to remember that the only other organizational form able to make that kind of use of the opportunities of early film has been the comparably concentrated state corporation of 'actually existing socialism'.

But then we should never, when reviewing any phase of cultural history, suppose that the technology predetermined particular economic and social forms. All we can say, at this level, is that an available symmetry gave the actually developing forms an important though not finally decisive competitive edge. Moreover, within the development of the capitalist version of 'the popular', there have been, as people say, contradictions. We can understand some of these if we look at the majority content of early cinema.

There is one difficulty in this: that very many students of film, understandably centred on the uniqueness and originality of their medium, know surprisingly little about the popular theatre on which, in that phase, it drew so heavily. Some people still compare the new medium with such older forms as the bourgeois novel or academic painting, when they ought really to be looking at the direct precedents, with the same urban audiences, of melodrama and theatrical spectacle. I often find it difficult to convince people that well before film epics, naval battles in real sea water and train crashes with locomotives were staged in London theatres. Yet the record is quite clear. These staged spectacles were a central element of popular theatrical entertainment, on which the film camera and location shooting of course improved, in the end remarkably but not really as new content.

Or consider melodrama: originally a play with songs and music to get round the regulations about legitimate drama, which had been assumed to be confined to speech. Violent and romantic intrigue, long-lost heirs and dramatically revealed secrets, had been soaking into those old boards. Many early films were direct remakes of this material. But there was also one element of melodrama which bears on our central question, about 'the popular'. It is true of some though by no means all melodrama that a characteristic hero or heroine is poor, and that he or she is victimized by someone rich or powerful: the holder of the mortgage or the aristocratic officer are, in the tendency, typical villains. Thus it can be said, though often rashly, that melodrama was radical, and that in the same sense the poor heroes, heroines and victims of many early films

established a radical popular base.

But it is not as easy as that. One other key element of this kind of melodrama is that after many twists and turns, and seemingly hopeless situations, the poor victim is saved and the poor hero or heroine lives happily ever after. There is no problem in understanding why these resolutions were popular. But there is a problem in trying to relate these often magical or coincidental lucky escapes of individuals to anything that could be called, in the easy slide from 'popular', a genuinely radical or socialist consciousness. The resolutions are individual and exceptional, and even the wolves we can all hiss turn out to have relatives, within the same system, who are good house dogs or even guard dogs. A social pity or a social anger is at once centred and then, by the very mechanics of intrigue, displaced. Moreover, as time passed, and the broad radicalism of the early melodrama faded as steadily as the very similar radicalism of the early Sunday newspapers, the formula of the innocent individual victim could be reproduced but with some new nominations of villains. I have lost count of the modern film melodramas in which various unspecified innocents are victims of socialist and trade union bosses and organizers, and they too have made their lucky individualized escapes.

So that this rough version of the 'popular' is usually at best double-edged. We have then to look at a very different kind of argument, at times swept up with the rhetoric of the popular, at times, and with some consequent difficulties, sharply distinguished from it. This is the interesting argument that film itself, as a medium, is inherently or at least potentially radical. Several propositions have been grouped within this. There is first the relatively simple argument that mobility as such – the most obvious element of the moving picture – has a necessary association with radicalism. Many traditional arts and traditional forms were identified as essentially static: the obvious products of unchanging or conservative social forms. Closely associated with this was the claim that film was inherently open, as against the relatively closed forms of other media. These arguments eventually settled into the now conventional rejections of what are called 'naturalism' and 'classical realism'. We shall have to come back to those muddled and muddling concepts, but we must first look more directly at what it was in the medium that suggested these initially reasonable arguments.

Formal analysis, of any new medium or form, is in fact so difficult that we should not be surprised, in relatively early phases, that different people select very different elements as decisive, in fact according to their own initial presumptions. Where the modernist critic sees mobility and openness the Supreme Court justice saw 'mere representations of events, ideas and sentiments published or known'. It is not useful to try

to choose between them. In its new faculty of recording motion, the film camera could become either analytic or synthetic. To run a sequence of film in slow motion is to enter, analytically, a new way of seeing the most habitual movements, and this has always been an important use: as in the early experiments on how horses run, through the extraordinary scientific and spectacular sequences of cloud formation and plant growth, to the many and varied dramatic uses – the running of lovers and the slow spin to death. At the same time, the power, by cutting and editing film itself, to associate and combine different movements within an apparently single sequence made many new kinds of synthesis possible, offering quite new dimensions of represented action. Always, that is to say, in film, there were both frames and flows. How either was to be used was always technically open.

This has its effects on the central question of reproduction, which is so critical to any socialist discussion of cinema. For it is, one might say, an obvious illusion to suppose that film is not an extraordinarily power-ful reproductive medium, in quite the simplest sense. Much more than ever in print, or within the evident and still visible mechanics of theatre, film can reproduce what can be widely taken as simple representation; indeed seeing as if with our own eyes. It is then not only that millions of people have found pleasure in seeing what they take to be direct repre-sentations of distant or otherwise unknown places and people and events. It is also, in that extraordinarily significant cultural moment which began with photography, that pleasure is found in the reproduc-tion of wholly familiar people and places. Just as people still call, excitedly, to say that someone or somewhere they know is on the telly – or even, in the bliss of inexperience, that they themselves are on it – so many people make a point of going to see a film where someone or somewhere they already know perfectly well is to be reproduced in the magic of light. Of course, leaving aside induced ideas of importance or prestige being conferred by this selective reproduction, something else is happening in all this. It is basically the valued externalization of images, but what matters, for the argument, is how widely film has been valued as an accepted form of direct reproduction.

At the same time, of course, and from the beginning, the properties of the medium could be used for quite different and even opposite effects. Simple illusions could be directly reproduced and, as techniques developed, marvellously constructed. Complex illusions could become commonplace. Moreover – and here a specifically socialist emphasis enters the argument – real but hidden or occluded relationships could in these ways be shown or demonstrated. Already, at the simplest level, a nineteenth-century theatre melodrama could show, in successive scenes, a poor miner's family and the luxury of London to which the wife and

mother has run away or been seduced. Eventually the relative simultaneity of what are otherwise spatially distanced or separated actions could be directly reproduced. But as what, as reproduction or as illusion? For to see both more or less at once is in an everyday sense an illusion, while at the same time to see them as fundamentally related elements of a specific kind of society is to reproduce, in this new form, a real but not ordinarily visible interconnection or contrast.

Once constructive cutting and montage had become common techniques, this penetrative interaction of reproductions could be seized on as a modernism, even a revolutionary modernism. New concepts, it was argued, could be formed by the planned interaction of images. When I was a student it was usual to say that montage and the dialectic were closely related forms of the same revolutionary movement of thought. To be sure that was before we had seen what looked like the same kind of thing done in a thousand films of every conceivable ideological emphasis. That was a period in which it was still widely supposed that the new was inevitably the radical. But still, as we shall see, this capability to move beyond fixed spatial limits, to connect or to collide otherwise separated actions, to invest moments and fragments with the power of sustained or integrated imagery, this faculty of constructing a new or of altering a known flow, is indeed in its whole range a major potential for innovation.

But it is at this point that we have to look plainly at what has been called Naturalism. I would be more impressed by contemporary radical rejections of Naturalism if I did not hear virtually the same rejections by the most orthodox film and theatre people, who for a certainty don't know what it means. Naturalism, in fact, has close historical associations with socialism. As a movement and as a method it was concerned to show that people are inseparable from their real social and physical environments. As against idealist versions of human experience, in which people act under providence or from innate human nature or within timeless and immaterial norms, naturalism insisted that actions are always specifically contextual and material. The purpose of putting a lifelike environment into narrative or on to a stage or film was to introduce and emphasize this authentically shaping force. The slice of life, that is to say, was no random helping; the analogy is much more with microscopy, where the intricate formations of life can be intensively examined. The leading principle of Naturalism, *that all experience must be seen within its real environment* – indeed often, more specifically, that characters and actions are *formed* by environments, as socialists still usually say – was intended as a radical challenge to all received idealist forms.

So what happened? It is what had already happened that was to

prove decisive. The first lifelike, directly reproductive stage sets, like the thousands that were to follow them in cinema, were not constructed to explore the formation and development of a life; they were constructed as one of the special forms of spectacle: lifelike reproduction; indeed precisely the *set*, the *setting*, on which, in the majority of cases, human actions understood in quite different ways – from innate or idealist assumptions – then unrolled. In a bitter irony Naturalism came to be understood as the very thing it had challenged: mere reproduction; or reproduction as a setting, a cover, for the same old idealized or stereo-typed stories.

In practice there were things which theatre naturalism, even in its own interest, could not do. The more it offered its everyday reality, the less it could move either to unspoken thought or to actions beyond its selected sites. Typically, it became trapped in rooms in which people stared out of the windows or heard shouts from the street. Yet film in the same interest could at once move beyond these limitations. Unspoken thought could be visually represented, or could be given as voice-over. The camera could be taken and set up anywhere. All that failed to happen, on any sufficient scale, was the intensely exploring, diagnostic impulse which was the real Naturalist project. Instead there was an appropriation of the term as a kind of inert *external* reproduction or as – from the establishment – the kind of boring 'everyday reality' which must be put down so that the free play of mind – that's the public relations version; what is meant is deliberate privatization, the self-centred voice, the leisured and talkative playgroup, the bourgeois versions of legend and fantasy – could expand without challenge, even appropriate the whole name of art.

What are socialists doing in that company? Some of them, actually, some interesting if mixed things. The hardest problem, for any of us, is to distinguish between the radically different cultural tendencies which, within the whole formation of capitalist cinema, have come, in practice, to overlap. Let me begin, if necessary rudely, with just one of these distinctions: that in our kind of time the dissident bourgeois is not neces-sarily a radical, though that is often the self-presentation. The majority of the serious art of the past hundred years – in film as clearly as anywhere – is in fact the work of dissident bourgeois artists. But it is like anti-capitalism; you can go on from it to socialism, or you can go back from it to variously idealized *pre*-capitalist social orders: hierarchical, organic, pre-industrial, pre-democratic. I don't know who first made the joke about the main characters in Soviet films being tractors, but he was quite as likely to be a dissident bourgeois, even what is called a modern-ist, as the more obvious kind of reactionary. Certainly Soviet revolution-ary cinema was stupidly and arbitrarily stopped in its tracks, but not

because it moved into a world in which men and women actually worked. Similarly, you do not get to socialist film by showing, as matter on its own, the idiocies and frustrations of bourgeois life, even if you go on to show, as in that classical dissident-bourgeois formula of twentieth-century art, a selected individual getting out from under it and walking away.

In the same sense there is a crisis at that point in Naturalist theatre where someone stares from the window at a world he or she is shut off from. Dissident bourgeois art, including much of great interest and value, often stops at that point, in a moment of exquisite nostalgia or longing. But the more significant development is the growing conviction that all that can really be seen in that window is a reflection: a screen, one might say, for indefinite projections; all the crucial actions of the world in a play of psyche or of mind. The powerful images which result will of course not be Naturalist, naturalistic, or classically realist either. When Strindberg, at just that point of crisis, changed his mind about what made people unhappy, he began writing plays of great power which there, in the 1890s, were contemporary with the first films and in fact, as we read them now, are effectively *film* scripts: involving the fission and fusion of identities and characters; the alteration of objects and landscapes by the psychological pressures of the observer; symbolic projections of obsessive states of mind: all, as material processes, beyond the reach of even his experimental theatre, but all, as processes of art, eventually to be realized in film: at first, as in expressionism, in an exploratory cinema; later as available techniques in routine horror and murder films and in the kind of anti-science fiction commercially presented as SF.

Within these powerful developments, to say nothing of that majority cinema which was restructuring narrative in even more powerfully reproductive and closed-flow forms, taking up new themes and issues but showing interesting, pleasurable, even exciting or moving, accommodations to how these things *must be*, socialists, it can be unsentimentally concluded, are rather likely at times to feel lonely. The whole pressure of a social and then a cultural order is even better than it used to be at persuading us that we are probably mistaken. But then what would it really mean, in practice, not to be mistaken? What would it mean to celebrate the socialist films that we have and to find ways of making new ones?

There are different levels of answer. My main point in re-emphasizing the historical meaning of Naturalism was to prepare for saying that, over a much bigger area than we usually recognize, there are social realities that cry out for its kind of serious, detailed recording and diagnostic attention. For the central socialist case, in all matters of culture, is that

the lives of the great majority of people have been and still are almost
wholly disregarded by most arts. It can be important to contest these
selective arts within their own terms, but our central commitment ought
always to be to those areas of hitherto silent or fragmented or positively
misrepresented experience. Moreover we should not, as socialists, make
the extraordinary error of believing that most people only become inter-
esting when they begin to engage with political and industrial actions of
a previously recognized kind. That error deserved Sartre's jibe that for
many Marxists people are born only when they first enter capitalist
employment. For if we are serious about even political life we have to
enter that world in which people live as they can as themselves, and then
necessarily live within a whole complex of work and love and illness and
natural beauty. If we are serious socialists, we shall then often find
within and cutting across this real substance – always, in its details, so
surprising and often vivid – the profound social and historical conditions
and movements which enable us to speak, with some fullness of voice, of
a human history.

 I don't want to say that only Naturalism can do this; in many situ-
ations there are different and often better ways. But I do want to say that
after three centuries of realist art, and after three quarters of a century of
film, there are still vast areas of the lives of our own people which have
scarcely been looked at in any serious way. It is sometimes said that we
cannot make socialist films, within any Naturalist convention, until we
have socialism and can show it. Is not the mere reproduction of an exist-
ing reality a passivity, even an acceptance of the fixed and the immobile?
But, first, this is to overlook the long histories of our peoples, in which
movements and struggles, particular victories and defeats, reached their
own moving crises. So large a part of our histories has been appro-
priated and falsified by enemy artists and producers, or by the indiffer-
ent who have converted them to spectacle, that there is enough work, in
that alone, for several generations of film-makers. Within our own time
there are also these moving crises, these victories and defeats, and it
should be one of the particular qualities of a serious socialist that these
can be looked at as they are: not in the brief enthusiasms or despairs of
mere supporters, but in the unalterable commitment, in and through any
argument or diagnosis, to the lives of the working people who continue,
as real men and women, beyond either victory or defeat.

 This has not been, and will not be, the whole content of socialist film,
though from many countries, it has been a rich and enduring tendency.
There is at least one other important area, which is particularly relevant
to those of us who live, often ourselves making images, in what are
called the advanced but are actually the image-soaked societies. It is
here that the most creative tendency in Modernist art – often at its best

in film – can find connections with kinds of social commitment to which often, under pressure, it has become opposed. I mean that the central process of image-making itself, which as against the enclosing flow of orthodox art Modernism emphasized, cut across, is now in itself a major factor in consciousness and in gaining consciousness. There is some real social base for this in the widespread contemporary distrust of what are called, too simply, the media. Many people now see and know that they are being misrepresented, but too few – and none of us all the time – really know how this happens. A merely sullen mistrust of contemporary stereotypes is at best defensive, and often disabling. A shouted anger against them is better but nobody can go on shouting all the time.

In fact all the way through, from the simplest forms of labelling through plot manipulation and selective editing to the deepest forms and problems of self-presentation, self-recognition, self-admission, there are processes of production in which we can intervene. Here the special properties of film, most notably the bringing together of otherwise separated areas of reality and of fundamentally different ways of observing it, have already been evident and can be much further developed. This work can be done at either root or branch. It is one of the tragedies of modernism, in revolt against the fixed images, the conventional flows and sequences, of orthodox bourgeois art, that it was pressured and tempted, by the very isolation that was its condition, into an assertion of its autonomous and then primarily subjectivist and formalist world.

It was not always like that; it need not go on like that. The revolt against the fixed image and the conventional sequence can find connections with those areas of shared reality where we are all uncertain, crossed by different truths, exposed to diverse and shifting conditions and relationships, and all these within structures of feeling – not formed ideas and commitments which of course also continue – structures of feeling which can be reached as common: common in the sense that we so often see them from the past, when otherwise separated or isolated people found their minds forming, their feelings shaping, their perceptions changing, in what to them seemed quite personal but were also historical ways.

That is at the root: the deep images that preoccupy us and that are in one real sense our history. But in the practice of film, as also I think in the novel, there are available forms which are already parts of that long composition of the popular which is too easily dismissed as merely commercial art. Who, for example, could find a readier form for exploring misdirection – that concealment or contradiction of truths, from sharply opposed real interests – than the apparently known form of one kind of crime story, spy story, thriller, investigative reporting? That the truths commonly revealed or exposed by the usual mechanisms are

arbitrary or trivial, or are safely plotted to arrive at the dangerous foreigner or rough or enemy agent, should not be seen as an obstacle. For all these forms came through in a radically dislocated culture which was concealing most of the truths about itself. The false hero who reveals all but actually reveals nothing – only his own presumed sharpness and the temporary restoration of what can pass for an order – is simply the accommodation of the form; he need not be, and indeed at the most serious level cannot be, its real definition. There are crimes and disloyalties now happening everywhere around us which really need to be tracked down, not in the enclosing rhetoric of an already unknown political statement, but in the complex and surprising ways in which they actually happen and within a social order of which any serious investigator will come to know he is a participant as well as the idealized observer.

These are among the branches that we should occupy. I know, of course, that it is much easier to say than to do. We have all learned, on the pulse, the material realities of that long capitalist appropriation of the popular, and its scarcely less disturbing indifferences to the genuinely different. But we are in a very strange and perhaps hopeful situation. All the big things, just now, are against us, but within what is not only a very powerful but also an exceptionally unstable social and cultural order there are forces moving of which nobody can predict the outcome. A strong and active generation of actual and would-be film and video makers is more alive and eager in what it is beginning and wants to do than in any earlier and perhaps more congenial time. The response to an action as evident and overwhelming as the coal strike is already, at this early stage, more encouraging in film and video than in any other of our arts.

Meanwhile the economy of cinema has radically changed, and in its coexistence with television and with new forms and institutions of distribution is now far from being the old monopoly, though the old and new oligopolists still hold most of the ground. Yet there it is: only a few of the films that have been shown in this festival were made in simple supportive conditions. What socialist, anyway, would expect, in our sort of world, that it should be easier, for him or her, than for our brother and sister predecessors? It is understandable that all the short-cuts were seized on: the popular as inherently as our own territory; the medium as inherently open and mobile, before we learned that most dislocations and contradictions would, with great power, be dislocations and contradictions of us; the exploratory and the experimental and the innovative as predetermined to be on our side. Yet when we have got to know about these short cuts we are in a position to have learned something, and to go on, encouraged, to finding our own ways.

8

Culture and Technology

High technology can distribute low culture: no problem. But high culture can persist at a low level of technology: that is how most of it was produced.

It is at plausible but hopeless conclusions of this kind that most current thinking about the relations between culture and technology arrives and stops.

In a period of what is certain to be major technical innovation in cultural production and distribution and in information systems of every kind, it will be essential to move beyond these old terms. Yet there is now an effective coalition, including not only cultural conservatives but many apparent radicals, who are agreed that the new technologies are a major threat. Cultural conservatives are saying, in that once elegant argot, that cable television will be the final opening of Pandora's Box, or that satellite broadcasting will top out the Tower of Babel. As for computers, since that flurry of argument about whether they could or could not write poems, most of the old cultural intellectuals, in a diversity of political positions, have decided that they are best ignored.

At the same time, however, on quite different bearings, a new class of intellectuals are already occupying and directing the sites of the new cultural and information technologies. They are talking confidently of their 'product' and its planned marketing, and are closely engaged with the major supplying corporations and the myriad of new specialist agencies in their interstices. They are oriented, within exposed and declining primary economies, to a new phase of expanded 'post-industrial' consumerism, with its models and vocabulary firmly based in the United States.

Observing all this, many radicals draw back to defensive positions:

identifying the new technologies with the corporations which control
them, and both with a new and disastrous phase of 'paranational hyper-
capitalism'. The forces they are identifying are real, but all that follows
from so undeveloped a position is a series of disparaging remarks and
defensive campaigns, leading in many cases to tacit alliance with the
defenders of old privileged and paternalist institutions, or, worse, with
the fading ideas of the old cultural argument: a high culture to be
preserved and by education and access extended to a whole people.

 None of this is good ground. Even the best of earlier arguments need
restating in new terms. For the rest, what we have is an unholy combin-
ation of technological determinism with cultural pessimism. It is this
combination that we must now disentangle and explain.

In the early years of any genuinely new technology it is especially
important to clear the mind of the habitual technological determinism
that almost inevitably comes with it. 'The computers will take over.'
'The paperless office of the nineties.' 'Tomorrow's World of cable and
satellite.'

 The basic assumption of technological determinism is that a new
technology – a printing press or a communications satellite – 'emerges'
from technical study and experiment. It then changes the society or the
sector into which it has 'emerged'. 'We' adapt to it, because it is the new
modern way.

 Yet virtually all technical study and experiment are undertaken within
already existing social relations and cultural forms, typically for
purposes that are already in general foreseen. Moreover, a technical
invention as such has comparatively little social significance. It is only
when it is selected for investment towards production, and when it is
consciously developed for particular social uses – that is, when it moves
from being a technical invention to what can properly be called an avail-
able *technology* – that the general significance begins. These processes
of selection, investment and development are obviously of a general
social and economic kind, within existing social and economic relations,
and in a specific social order are designed for particular uses and
advantages.

 We can look at two examples, which show this to be the case but
which have interesting internal differences. Radio can be said to have
begun with Hertz's scientific discovery of radio waves, itself based on
what was already known about electrical conduction. Many people
began experimenting with their transmission, which within twenty years
was shown to be possible over very long distances. What was in mind at
this stage was a new ancillary or even substitute system for the wired
telegraph or telephone, which could pass individual messages over long

distances or to places which for physical reasons wires could not reach. As its practicability was proved, there was interest from the existing telephone and telegraph companies, and from military establishments needing better signalling forms. There were then significant developments in the terms of these existing interests, though the original sector of amateur and experimental radio persisted and is indeed still active. There was nothing in the technology as such which pointed it in any other direction.

But in a very much wider social and cultural dimension, at just this historical stage, there was active search and demand for new kinds of machine in the home, in this case for news and entertainment. There was then active research to produce a domestic radio receiver, and this proved relatively easy. Its active development was opposed by the old telegraph and telephone interests, whose signals could be interfered with, and by governments which did not want internal establishment channels overridden (and, it was said, trivialized) by general 'broadcasting'. Yet the decision was made, mainly by the existing communications companies, to market the receivers and to create a public demand for them. This proved very successful, and it was then necessary to think in new ways about both programming and financing.

Again nothing in the technology determined these plans. Programming ideas ranged from 'common carrier', as in telegraph and telephone systems, through 'sponsored' programmes, as in the North American system, to state-controlled or state-licensed programme-providing companies. The varied decisions for one or other of these, with all their specific cultural effects, were made on already existing political and economic dispositions in the societies concerned, since the technology, obviously, was compatible with any or all of them.

Thus it is not a case of a technical invention leading to social and cultural institutions. The invention itself was developed, within existing forms and possibilities, into two quite alternative systematic technologies: radio telephony and broadcasting. Broadcasting, in its turn, was developed into alternative and contrasting cultural systems, by choices quite beyond the technology itself. These facts are reasonably well known. In whose interest can it then be to reduce the real history, in all its complexity but also its openness at each stage, to the meaningless proposition that 'the invention of radio changed the lives of millions'?

The case of satellite broadcasting begins in part in the same way, but with one key difference. The general usefulness of communications satellites had been hypothesized before they were practical. What was foreseen was an improvement comparable to that of early radio signals: that they could improve the signals from existing earth-based transmitters – whether in telephony or eventually in broadcasting – and that

they could take signals to many hitherto inaccessible places. There was to be a world of political significance, eventually, in that apparently neutral term 'inaccessible'.

The key factor, however, was that satellite technology in this field was at first wholly dependent on major research, development and investment in a quite different field: that of military rocketry and its associated communication and espionage systems. All the primary investment and production was in this military field. Continuing civil developments followed, in telegraphy and telephony, and there was then a critical stage in which the technology became available for interlock with the by now well-established television broadcasting systems. At this point, within the technology itself, the matter is relatively neutral. Satellites can be used to improve and extend signals, and for fast relay of distant signals. Both uses are advantageous, though the former has to be compared with other kinds of improvement and extension of signals, for example by new forms of cabling. That is as far as the technological argument takes us. But it is clearly not as far as the actual development is taking us: a development foolishly referred to the 'inevitable' technology.

For there are at least three general purposes, deriving not from the technology but from the whole social order. First, there is great pressure, from the manufacturing corporations and their allies in governments, to initiate a new marketing phase. At one level this is the development of whole satellite transmitting and receiving systems, which can be sold to governments and sold or leased to other corporations. At another level it is to initiate a large new domestic demand, either for domestic satellite-signal receivers, or for ground-station distribution through new and more elaborate cable systems (which might also prove advantageous without reference to satellites or indeed be preferred to them, using ordinary transmitters). All these developments, with their many technical complexities, are characteristically discussed as if they were only technical. Yet especially in the speed of development now being urged they relate primarily to industrial rather than cultural intentions, and closely follow the main lines of force in economic and political institutions.

The second purpose is even less technologically determined. There is a clear intention, in the strongest centres, to use this technology to override – literally, to fly over – existing national cultural and commercial boundaries. The satellite is seen as the perfect modern way of penetrating cultural and commercial areas hitherto controlled or regulated by 'local' national authorities: that is to say, societies with their own arrangements and governments. In the distribution plans of film, television and sports-producer corporations, and in the marketing and advertising strategies of multinational companies, satellites and satel-

lites-with-cable are critical new modes of access.

The third purpose is partly connected with this: a penetration of *politically* closed areas, or of relative political monopolies, as has already happened with short-wave radio. In either of these purposes there are problems in the legal sovereignty of national air spaces, but against this there is the ideology of freedom of the skies, and there is also a range of conniving initiatives, through offshore siting and surrogate 'local' corporations. The determinations, in this whole range, are evidently economic and political, in a range quite beyond the technology.

Thus the real situation is not one of technological determinism, even in some refined version. The sense of some new technology as inevitable or unstoppable is a product of the overt and covert marketing of the relevant interests. Yet in practice it is powerfully assisted by a mode of cultural pessimism, among quite different and even apparently opposed people.

The roots of cultural pessimism are deep. The argument in terms of technologies and institutions is only a first level. Yet it must be directly engaged.

At first glance there are simply dire predictions based on easily aroused prejudices against unfamiliar machinery. Newspapers, cheap magazines, cinema, radio, television, paperbacks, cable and satellites: each phase has been announced as an imminent cultural disaster. Yet there are also phases of settlement in which formerly innovating technologies have been absorbed and only the currently new forms are a threat. At the same time it is usually not clear whether it is only the technologies that are being adduced. Past the shudder (which I have seen physically) at the very mention of cable and satellite there is a fuller position. 'Of course it isn't just the cables, it's the kind of rubbish that will be pumped along them.' To the mild question 'By whom, and by whose assent?' there is a range of answers, from the identifiable capitalist corporations – the radical version, but how radical is it to suppose that these are unstoppable? – to what is prudently called the modern world (what is meant is modern people): 'Think of it, thirty channels, a hundred channels. What else could that many carry but absolute rubbish?'

The formula underlying this type of objection is the contrast between 'minority culture' and 'mass communications' which was made and developed at each stage of the new cultural technologies. In any particular phase, it is entangled with objection to some currently new technology, but its base is always a social and political position. Thus in our own day printed books – the obvious first example of multiple mechan-

ical reproduction and eventually 'mass' distribution – are typically placed, with some paperback and other exceptions, on the minority side of the formula. In the course of the twentieth century, radio and recorded music – those other once new technologies – have also in part been shifted to this side, together with some films, since there is the new many-headed technological beast – television – to contrast with them. There is then not only a selective shift of technologies. There is also a shift to defence of certain kinds of 'responsible public-service institutions'.

I respect some of this defence. I still in part relied on it in *The Long Revolution*, though attempting also to surpass it with some new and quite different principles. Developments since 1959 have both changed the situation and clarified the necessary argument. It is now clear that it is impossible to identify any 'public service' institution without at once relating it to the social order within which it is operating. This can be shown most clearly in the actual development of 'public service' institutions: for example, in Britain, the BBC. A certain kind of 'public service', through phases of paternalism to genuine attempts to make serious work of many kinds more generally available, was possible and important in a period of state-regulated protection from market competition. When this protection was removed, in television and then in radio, the 'public service' definitions did not disappear but in practice weakened and in some areas became wholly residual. It is a difficult, because mixed, record to analyse. There has been a combination of substantial and innovative work with both old and new forms of cultural monopoly and control. Periods of relative openness and diversity have alternated, within the same institutional forms, with periods of closure and privilege. Contrast with wholly commercial systems elsewhere shows these 'public service' forms favourably. Contrast with a modified indigenous commercial system is more complicated. The 'public service' system has some residual advantages but the commercial system offers important opportunities for work beyond a monopoly employer. It is then not only the cultural systems and institutions that we have to compare, but the changing forms of their interlock with a developing capitalist society.

There are very few absolute contrasts left between a 'minority culture' and 'mass communications'. This situation has to be traced, eventually, to the deep roots of 'minority culture' itself, but we can first consider it at a more accessible level. The privileged institutions of minority culture, bearers of so much serious and important work, have for many years been fighting a losing battle against the powerful pressures of a capitalist-sponsored culture. This is the most evident source of cultural pessimism. But its deeper source is a conviction that there is nothing but the

past to be won. This is because, for other reasons, there is a determined refusal of any genuinely alternative social and cultural order. This is so in theory, in the determined objections to new forms of democracy or socialism. But it is even more so in practice, in the effective interlock – now so clearly visible – between the social conditions of the privileged institutions and the existing social order as a whole.

There are still some genuine asymmetries between the old privileged culture and the imported and indigenous commercial cultural market. It is from these that the most plausible defences are mounted. There are still authentic standards in serious art and opinion. Yet within all the available privileged institutions, from the BBC through the Arts Council and the British Council to the dominant universities, these standards are in majority inextricable from their received social conditions. They now positively emphasise their connections with state and state-theatrical forms, monarchic and military, and with the still residually preferred *rentier* and country-house styles. Some of their defenders see hope in the asymmetries, in certain sensitive areas, such as public morality, religion, orthodoxy of language, preservation of the traditional arts. But there is now too strong a functional link between a weakened privileged culture and the major economic forces by which its generally approved social order must, under pressures of its own, reproduce itself and survive, for there to be any genuinely independent cultural position of the old 'minority' kind. Indeed as one after another of the stylish old institutions, which had supposed themselves permanently protected, is cut into by the imperatives of a harsher phase of the capitalist economy, it is no surprise that there is only a bewildered and outraged pessimism. For there is nothing most of them want to win or defend but the past, and an alternative future is precisely and obviously the final loss of their privileges.

Thus, within the terms of the old formula – the 'minority' against the 'mass' – there is a losing battle which its most established participants cannot in any real terms want to win.

'It all comes down to the money', the sad voices now say. Yet money operates in so many forms. It was a condition of self-respect, in the old privileged culture, that the money was usually indirect. It came from enlightened patrons, responsible trusts, charitable bequests, and people of independent means. 'Independent means': that was the keystone of the arch. It was not necessary, it was indeed impolite, to look round the back of this independence of disposition to the evidence of its actual dependence on a general system of property, production and trade. As the need for money increased, there was a new and apparently unprob-lematic source, with which there were already close connections within

the class: the enlightened State, steering some of the tax revenues in these admirable directions. But again, if anyone looked round the back, as some taxpayers began to do, there was the vulgar question of why taxes should be paid to support minority institutions and autonomous cultural purposes. Inertia kept some indirect money, of both kinds, coming, but as costs increased there was suddenly the new ideological threshold: direct money. But if they accepted direct money were they not also accepting a frankly *commercial* culture? Through the contradictory habits and signals, pessimism, in some, went down into despair.

Yet only in some. New figleaf terms were soon found. 'An enlightened partnership of the public and private sectors': that old friend, the 'mixed economy'. But then it was pressure to *reduce* the public sector, in a new phase of capitalist competition, which was producing the need for direct 'private' money anyway. Another figleaf, quickly: 'sponsorship'. That dear old word, for was not a sponsor once a godfather? Thus no vulgar hiring. Sponsorship. The making of promises. Promises of money.

This system is now developing most rapidly in the institutions of broadcasting. The problem of the electronic institutions, throughout, has been that unlike all previous capitalist trading relations – in books, newspapers, pictures, concerts – they have no direct points of sale. The receiving machines can be directly sold, but from the nature of broadcasting there is no point of sale for actual programmes. Thus funding for production was arranged in other ways: by direct state subsidy; by licence fees, in societies where the state element in the state/capitalist combination was relatively strong; or by general advertising money, either directly for specific productions or in systematically constructed 'natural' breaks.

The advertising option had already had been seized by the 'popular' press (the new kinds of commercial high-circulation news entertainment-and-sports sheets) as a way of reducing cover prices and thus extending circulation. The option was also, at a deeper level, a way of extending and organizing a new kind of 'consumer' market, at critical stages of domestic manufacturing and of extension of the electoral franchise. The first purpose was seen as a mere 'support system' to a primary communicative function, but the second and deeper purpose was always stronger. What was earlier seen as a relative balance shifted heavily towards the 'consumer' and electoral market priorities. Deep inside their own forms, most newspapers changed their definitions of their manifest purposes. Certain necessary elements were retained, but there was increasingly open definition of the success or failure of a newspaper in terms of the condition required by its advertisers: the reliable delivery of an effective body of purchasers. There was then a rapid disappearance of newspapers, under these pressures. This is

evident not only in the reduced number of titles but in the form of those publications which are still conventionally described as newspapers but in which the regular news content is typically less than 10 per cent. Increasingly, now, these are tabloid entertainment and advertising sheets, with trailers of simplified news and aggressive opinionation. It can be said that there are only three surviving national daily newspapers in Britain, in any formerly recognizable sense. Yet even these depend closely on association with the delivery to advertisers of relatively well-off readers. In many of these cases, the tail wags the dog so vigorously that tail is rapidly becoming the definition of any useful dog.

In broadcasting, whether in directly commercial or state-protected systems, there has been a comparable shift of function. Productions are estimated in terms of the numbers of the people who can be delivered, through some interest, to either system. As in newspapers, the figures for 'viable' production have been vastly inflated, by a specialized system of reckoning. What is called a 'vast throng' at a cup final or a coronation – a hundred thousand people – is described as an insignificant or failed broadcasting audience. Pressure to adapt to the conditions of competition for a predictable and packaged market of vast size is rationalized as if it were a matter of responsible relationships with actual people. The real primary pressures are either for direct advertising money or for a major share of the political and cultural market, on which all indirect systems finally depend. It is here especially that the sponsors, the new godfathers, appear.

The cultural assimilation has been very rapid. Old institutions and competitions now have, as a matter of course, trade names attached as the first element of their description. These descriptions flow so easily from hired tongues, that it seems reasonable to ask how long it will be before other forms of competition go the same way. Shall we see, soon, a 'British Chemicals General Election'? It would certainly save all that bureaucratic overtime money. Close by-elections would facilitate market penetration by corporations which had targeted certain UK sectors. Trade sponsorship could finance stylishly open elections of trade-union officials. If these examples sound (as they should) fantastic, they would still not be much more surprising than, to an earlier generation, the definition of English cricket competitions by the names of insurance and tobacco firms. The takeover powers of corporate advertising money are now so great that a wide range of familiar social activities, effectively funded in their own terms in early and much poorer periods, are becoming dependent for their survival on calculated favours from this new sector of patronage and dominance.

This process connects with much wider movements of the society: in an increasingly home-based culture; in electronic rather than physical

assembly; in major rises in production costs, partly from the relative improvement in the wages of production workers but also heavily inflated by adaptation to the norms of an international cultural market, which have put rewards in the most favoured sectors at the level of speculative fortunes. It is the ideological interpretation, directly influencing political decisions, which then matters. The new forms of sponsorship are interpreted as 'free money', in contradiction even of the old capitalist principle that somebody, somewhere, has to pay, since 'money does not grow on trees'. Within this new blandishment, even liberal men and women, puzzling over accounts in committees, are persuaded to believe in manna: *mammon manna*, the new modern brand.

There is no free money. It is all spent for calculated and usually acknowledged purposes: in immediate trading, but also to substitute a healthy for an unhealthy association (as in tobacco sponsorships of sports), or to reassure what are called 'opinion-formers', or to enhance, as it is slyly put, a 'public image'. The specified manna is for this and that. The general manna is for the public reputation of capitalism. But it is paranational manna, from the true paranational godfathers, that has now to be most closely looked at.

The new technologies of cable and satellite, because they can be represented as socially new and therefore as creating a new political situation, are in their commonly foreseen forms essentially paranational. Existing societies will be urged, under the excuse of technical reasons, to relax or abolish virtually all their internal regulatory powers. If the price includes a few unproblematic legalities, or gestures to 'community' interests, it will be paid. 'Not only free but clean-mouthed and concerned'. The real costs, meanwhile, will be paid elsewhere. The social costs and consequences of the penetration of any society and its economy by the high-flying paranational system will be left to be paid or to be defaulted on by surviving national political entities. The costs will be paid in the relief of unemployment, as national industries are bypassed and reduced. The consequences will fall in marginalized and unprofitable regions, already bypassed industrially but increasingly unserved by the new profit-selected systems of distribution (commercial cable or commercial mail). Beyond these we can foresee the last-ditch defensive measures to preserve a penetrated and ravaged social identity and its falling social order.

Free money! The godfathers are taking us to a point where it will seem cheaper, everywhere, to be steadily ruined or simply to give up. The known alternative principle, of common provision of all necessary common services, will be made to appear a receding utopianism, though it remains our only realistic hope of varied and responsive communications systems.

If this is what has to be resisted, it is not enough to oppose this or that technology. Any such opportunism will fail and deserve to fail. Nor are there are any other ready allies in place. The capitalist state, for these purposes, is unavailable; it is now part of the agencies of the offensive. The case is different with the surviving institutions of autonomous policy and selective patronage, such as, in Britain, the BBC and the Arts Council. In the decisive areas these are now being outflanked, and will either join the new forms or withdraw to narrower and more evidently residual interests, based in a few affordable minorities. Within the forms of cultural pessimism, many concerned people have already adapted to this narrowing future. But what has then to be emphasized is how this is affecting what is still called 'minority culture itself'.

It is already significant that many minority institutions and forms have adapted, even with enthusiasm, to modern corporate capitalist culture. This is so in everyday practice, where a graded market has some room for them. It is so in the fact that the metropolitan areas of serious drama and fiction have been willingly incorporated into the market operations of sponsorship and prizes. The basic institutions of publishing and dealing have in any case been adapted to the main lines of modern corporate selling. Many other kinds of artistic enterprise, confident in the seriousness and validity of their projects, have joined the queues outside the offices of the corporations, for sponsorship money.

None of this can go on for long – indeed in some ways none of it can even start – unless deeper adaptations have already been made. What is treated as mere 'support money' never stays like that. Production itself becomes steadily more homogeneous with the sponsoring and directing institutions. For some time this can be masked by real elements in the minority culture: work from the past, which seems still to survive and flourish in its own terms; or work in highly specialized areas, typically associated with scholarly organizations and interests. Each of these is important, but there can be no full and authentic minority culture in their limited terms. It is always contemporary practice and usage which makes these elements and specialisms a *culture*.

There is now varied and active contemporary practice and policy. But it is necessary to identify, within them, certain adaptive and submissive forms. Thus a relatively overt and adaptive nostalgia is now saturating the minority arts: in contemporary reproductions of the more graceful and elegant ways of selected periods of the past; in country houses and an old 'pastoral' order; in 'classical' literature and music; in biographies of the once dazzling and powerful; in the taste for playful or suggestive myth. This is flanked by an overt exoticism: of the imperial and colonial pasts; of the peripheral, often poverty-ridden picturesque; of versions of primitivism.

But these overt contents, which make so long an inventory of current minority art and literature, are mainly its compensatory forms. Its truly adaptive forms have a much harder and rougher surface. This is where we need to look at the two faces of 'Modernism': at those innovative forms which destabilized the fixed forms of an earlier period of bourgeois society, but which were then in their turn stabilized as the most reductive versions of human existence in the whole of cultural history. The originally precarious and often desperate images – typically of fragmentation, loss of identity, loss of the very grounds of human communication – have been transferred from the dynamic compositions of artists who had been, in majority, literally exiles, having little or no common ground with the societies in which they were stranded, to become, at an effective surface, a 'modernist' and 'post-modernist' establishment. This, near the centres of corporate power, takes human inadequacy, self-deception, role-playing, the confusion and substitution of individuals in temporary relationships, and even the lying paradox of the communication of the fact of non-communication, as self-evident routine data.

Buttressed in these assumptions by popularized versions of cognate theories – psychological alienation; relationship as inherently self-seek-ing and destructive; natural competitive violence; the insignificance of history; the fictionality of all actions; the arbitrariness of language – these forms which still claim the status of minority art have become the routine diversions and confirmations of paranational commodity exchange, with which indeed they have many structural identities. They are also heavily traded, in directly monetary forms, by their intellectual agents and dealers, some of whom, for a residual self-esteem, allow themselves a gestural identity with the exposed artists and theorists of the original innovative phase. Even substantial and autonomous works of this tendency are quickly incorporated into this now dominant minority culture.

Yet what is much more decisive, altering the very terms through which the situation can be analysed, is the transfer of many of these deep structures into effectively popular forms, in film and television and heavily marketed books. Apparently simple kinds of adventure and mystery have been transformed and newly marketed in highly specific representations of crime, espionage, intrigue and dislocation, mediating the deep assumptions of habitual competitive violence, deception and role-playing, loss of identity, and relationships as temporary and destructive. Thus these debased forms of an anguished sense of human debasement, which had once shocked and challenged fixed and stable forms that were actually destroying people, have become a widely distri-buted 'popular' culture that is meant to confirm both its own and the

world's destructive inevitabilities.

The reasons are not in some abstracted 'popular taste': the idea of the 'vulgar masses' which was the first condition of cultural pessimism. The true reasons are more specific and more interesting. The original innovations of Modernism were themselves a response to the comple.: consequences of a dominant social order, in which forms of imperial–political and corporate–economic power were simultaneously destroying traditional communities and creating new concentrations of real and symbolic power and capital in a few metropolitan centres. Losing their relationships in depressed, declining and narrowing communities, the innovating artists of that period went to the new material bases and the negative freedoms of those centres, in which, ironically, the very reductions and dislocations were the material and the means for a new kind of art which the metropolis, but it alone, could recognize. The first social analyses of the newly centralized culture of the cities identified only its superficial features: typically 'commercialism' and 'democracy', forcibly yoked together from traditional perspectives. Yet as part of the same fundamental processes, new means of universal distribution, in cinema and then in broadcasting, were at just this point being discovered and developed, and control and production for them followed these same centralizing and would-be universalizing forms.

What was eventually projected as the 'global village' of modern communications was the fantastic projection of a few centres which had reduced human content to its simplest universally transmissible forms: some genuinely universal, at the simplest physical levels; others simple versions of negotiable and tradable features. The dynamic charge of the first shocks of recognition of a reduced and dislocated humanity was eventually transformed into the routines of a newly displayed *normality*. Thus the very conditions which had provoked a genuine Modernist art became the conditions which steadily homogenized even its startling images, and diluted its deep forms, until they could be made available as a universally distributed 'popular' culture.

The two faces of this 'modernism' could literally not recognize each other, until a very late stage. Their uneasy relation was falsely interpreted by a displacement. On the one hand what was seen was the energetic minority art of a time of reduction and dislocation; on the other hand the routines of a technologized 'mass' culture. It was then believed that the technologized mass culture was the enemy of the minority Modernist art, when in fact each was the outcome of much deeper transforming forces, in the social order as a whole. It was here that the simplicities of technological determinism and cultural pessimism forged their unholy alliance. The technologies were falsely seen as necessarily carrying this kind of content, while in both action and

reaction the minority art despaired both of itself and of an alien techno-
logical world.

The dominance of a few centres of 'universal' production, and the
simultaneous dominance of artistic and intellectual life by a few metro-
politan centres, have now to be seen as inherently related. The climax of
the pretensions by which this situation was hidden was the widely
accepted proposition of the 'global village.' What was being addressed
was a real development of universal distribution and of unprecedented
opportunities for genuine and diverse cultural exchange. What was
ideologically inserted was a model of an homogenized humanity
consciously served from two or three centres: the monopolizing corpor-
ations and the elite metropolitan intellectuals. One practised the
homogenization, the other theorized it. Each found its false grounds in
the technologies which had 'changed and opened up the world, and
brought it together.' But nothing in the technologies led to this theory or
practice. The real forces which produced both, not only in culture but in
the widest areas of social, economic and political life, belonged to the
dominant capitalist order in its paranational phase. But this was an
enemy which could not be named because its money was being taken.

'If we got cable television, in the ways now proposed,' a senior BBC
official said recently, 'we should have no way of making *Brideshead
Revisited* and *Smiley's People.*' He was appealing to what he took to be
incontrovertible examples of excellence. No two examples can stand for
a repertory, but these two go a long way. One is a nostalgic reconstruc-
tion of a destructive and literally decadent but still regretted elegance.
The other is an owlish confirmation of deep inner betrayals through an
almost indecipherable but politically 'inevitable' and violent code. Over
an earlier representation, through 'Smiley', of the inner filth of
espionage, the pure voice of a choirboy singing an anthem accompanied
a reverent image of the old dreaming spires. This is where corporate
production and official minority art now embrace, in the form of old
displaced pieties and the resigned and accommodating versions of war,
cold war, exploitation and arrogant wealth. Could cable television
indeed be so marvellous that it could deliver us from all this?

In no way. That is not how things happen. But it seems that we
cannot think about it at all until we have recognized our real as distinct
from any idealized current situation. What we now mainly have is a huge
sector of capitalist-sponsored art, displayed in the polished routines of
crime, fraud, intrigue, betrayal and a glossy degradation of sexuality.
Grace notes of diminishing audibility are played at its edges, and there is
a certain vitality in mimicry, parody and pastiche. The sector is
supported by light intellectual formulations of the ruling ideas: 'aliena-

tion' as violent competition and impersonal appetite; 'dislocation' as arbitrariness and human disability. There are sectors within the sector, but to anyone outside it their fundamental correspondences are evident. Beyond them, nevertheless, in what, though they are many, most know as extreme isolation, are other figures: autonomous artists and independent intellectuals, in a diversity of kinds of work. Their immediate problems are the monopolies which marginalize or exclude them, but many can then slip into the prepared ideological positions: the 'mass' culture; the 'technologized' world. Moreover, within the orthodox culture it is already 'known', from earlier periods, what autonomous artists do and what independent intellectuals think. Many such proxy figures, embellishing already incorporated forms, are busily at work and are allowed their gestures within the official culture. The more authentic figures, often doing and saying very different things, are in this situation barely visible at all, even to each other. Pessimism then spreads even where the vigour is most actual. A sobriety of real isolation darkens though it can never finally suppress the joy and vitality of innovating autonomous practice.

It used to be said that such innovating energies could only ever be fully released when they were connected to genuine communities. This may be true but in its ordinary proposition it is vague. It is the available conditions of practice that count.

There are two areas of 'popular' culture which can be seen as relatively distinct from the dominant capitalist sector. The first is a deliberately rooted popular history and action. This has emerged strongly in Britain in some television and theatre plays, in some novels characteristically placed by the metropolitan culture as 'regional', and in certain innovative forms of oral history, video and film. In other countries, over a range from new forms of oppositional theatre and television, through varieties of street performance and community arts, to popular revolutionary art within political struggles, there is a vitality of cultural activity. Even in the oldest and most established cultures, the shapes of an alternative radical culture have been forming, repeatedly, during the last fifty years and with many earlier precedents. They have not so far been institutionally strong enough to come through as general, and this actual weakness has been exaggerated, from outside them but also from inside, to their characterization as 'merely political', 'primarily political'. But their important practices and images are deeper than anything that is ordinarily meant by 'politics'. It is more general and more immediate human alternatives and challenges that the real forms now carry and inspire.

Yet there are problems of overlap, in parts of this tendency, with the dominant culture itself. Some work of this apparent kind has already

been incorporated, taking its weakest elements: radical nostalgia, leading to the familiar acceptance and ratification of loss; or roughness and coarseness inside an imposed poverty, leading to slangy recognition and matineés inside bourgeois theatres which always enjoy 'low life'. There is also a pseudo-radical practice, in which the negative structures of post-modernist art are attached to a nominal revolutionary or liberationist radicalism, though all they can do in the end is undermine this, turning it back to the confusions of late-bourgeois subjectivism. It is not surprising that, seeing all this, the strongest alternative artists have started a long march to alternative institutions, which have to be raised from the resources of surviving and potential in-place communities.

Secondly, however, there is a resilient area of a very different popular culture, much of it now marketed but much of it, also, not originated by the market. This area is diametrically opposed to an incorporated 'modernism'. It is a simplicity, of every kind, which is quite differently sustained. It is there in the genuinely popular scepticism of some comedians, who keep human fallibility at its everyday and therefore reparable levels. It is there in the intense vitality of some kinds of popular music, always being reached for by the market and often grasped and tamed, but repeatedly renewing its impulses in new and vigorous forms. It is there also (against many of our preconceptions) in some kinds of popular 'domestic' drama and fiction, in that always edged-towards-sentimental embodiment of everyday lives and situations. These often amount to little more than composed gossip, but a gossip which has some substantial continuities with irrepressible interests in the diverse lives of other people, beyond the reduced and distorted shapes of the modernist and post-modernist representations. It is in this very general area of jokes and gossip, of everyday singing and dancing, of occasional dressing-up and extravagant outbursts of colour, that a popular culture most clearly persists. Its direct energies and enjoyments are still irrepressibly active, even after they have been incorporated as diversions or mimed as commercials or steered into conformist ideologies. They are irrepressible because in the generality of their impulses, and in their intransigent attachments to human diversity and recreation, they survive, under any pressures and through whatever forms, while life itself survives, and while so many people – real if not always connected majorities – keep living and looking to live beyond the routines which attempt to control and reduce them.

The moment of any new technology is a moment of choice. Within existing social and economic conditions, the new systems will be installed as forms of distribution without any real thought of corresponding forms of production. New cable or cable-and-satellite television will rely heavily

on old entertainment stocks and a few cheap services. New information systems will be dominated by financial institutions, mail-order marketers, travel agencies and general advertisers. These kinds of content, predictable from the lines of force of the *economic* system, will be seen as the whole or necessary content of advanced electronic entertainment and information. More seriously, they will come to define such entertainment and information, and to form practical and self-fulfilling expectations.

Yet there are readily available alternative uses. New cable and cable-satellite television systems, and new teletext and cable-signal systems, could be wholly developed within public ownership, not for some old or new kind of monopoly provider, but as common-carrier systems which would be available, by lease and contract, to a wide range of producing and providing bodies.

In television there could be at least four new kinds of transmission service. First, an alternative film and video network, to be used by a variety of independent producers. Second, an exchange network, to be used between the existing television companies and independent producers of different countries. Third, a library or backlist network, serviced by an electronic catalogue from material now owned or stored by a wide range of producer companies. Fourth, a reference and archive network, drawing on material now stored in various forms of public trust.

The first three stages of these networks would be best financed, in all their early stages, by systems of pay-as-you-view. It is only in this way that revenue could be directly returned to producers. The free British public library service, with which such networks have analogies, is unsatisfactory in just this respect. It admirably distributes all kinds of books, without point-of-borrowing charge, but it fails, even after the belated introduction of Public Lending Right, to return fair revenue to their authors. An all-purpose free-using and subsidized-producing system would be a different matter, but it is damaging to have either element without the other. There is also much to be said, from the experience of centralized socialist cultural production, for the relative independence of individual and small-collective producers. They can be in more direct relations with audiences than can be achieved either through a system of hiring by capitalist and corporate programming institutions or through a supposedly 'public' system with its intermediate bureaucracy of programme controllers.

Nothing, either way, is determined by the technology, but it is an important feature of the new systems that they offer opportunities for new cultural relationships, which the older systems could not. Thus the multiplication of channels makes the programme organizers and

controllers of scarce channels unnecessary. Similarly the range of
channels allows self-selecting and self-timed viewing: an opportunity
already welcomed in the use of video recorders, though the imposition
of these on unchanged production and distribution systems quickly
becomes parasitic. More generally, the numbers games of advanced
production are capable of being transformed. 'Negligible' or 'unviable'
audiences for centralized network production are fully practicable in
systems of continued availability and exchange, beyond the terms of the
limited competition for peak network viewing and its associated
advertising.

These are examples of the many ways in which the new technologies
could be quite differently used, by starting from different basic social
and cultural positions. The technologies themselves would be assessed,
in this alternative perspective, as means to diverse and equitable
provision, rather than selective profit-taking. Thus the development of
cable television, within the now dominant order, will systematically
exclude rural populations and the poorer towns and city areas. But it is
only one of several available technologies, which in the right mix could
offer general and equitable provision: telephone signal systems, satellite
domestic receivers, community relays.

The new perspective should not be limited to the reproduction, by
some altered means, of existing services. Cultural production of new
kinds would positively depend on new local and specialist workshop
facilities for the range of alternative producers who are already working
or waiting at the edges of the existing centralized systems. The quality of
this independent work is already impressive, and there are also some
clear shifts of formal content and relationships. The same could be true
of new information systems. The early systems of medical call, metering
and security alarm could become general within a decade. This will
especially be the case if they are seen, from the beginning, as social
provision, rather than as extras to a commercial system. If adequate
switch systems are installed with the new cables, there will be room for
growth beyond the simple interactive systems in routine administration,
moneyhandling, ordering of goods, booking of travel and other facilities,
which could become general over the next decade. It is already import-
ant to move beyond these limited concepts of 'information', now funded
by existing interests in finance and travel and hypermarketing, and
supplemented by a relatively feeble range of 'general' interests,
culturally very similar to the *TitBits* stage of journalism. As is already
beginning to happen, encyclopaedias and library catalogues can be
moved into the databases, for a greatly expanded system of public
inquiry and reference. There is also a body of already stored but now
largely inaccessible information, in public hands, about the real and

comparative qualities of various goods and services; this is the public information system which could steadily replace advertising.

There is a further range beyond this. What are now called 'interactive' uses are for the most part very uneven, as between provider and user. Selected databases offer simple and determined choices. At the unprivileged end, all the rest of us do is press this or that button, as in the election booths we press buttons or make crosses. Real interaction would be very different, as can be illustrated in the case of the use of these technologies to register social and political opinions. It is easy to transfer the preformed questions of interview-polling to the technologies, and have buttons pressed in their terms. This is the format of the electoral market, which has to be distinguished from any more active democracy.

The crucial point is the relation between opinion and information. Recent research (Himmelweit et al. *How Voters Decide*, 1981) has shown that there are differences not only of degree but of kind in the range of what is called, and by simply polling registered as, 'opinion'. Some opinions are deeply grounded, with or without full information, but others, however confidently expressed at the time, are comparatively shallow and volatile, easily affected by the flow of current contexts and circumstances. This is one of many grounds for distinction between a participating democracy and a representative or apparently representative system. The aggregations without specific valuation, which now run through polling as through voting systems, flatten these real differences, stabilize the range of choices, and themselves become persuasive forms of apparent information, not only indicating but at some levels forming 'public opinion'.

More adequate and more respecting procedures are now at last technically possible. The mode of the opinion poll, by interview or by button, deploys its agenda of questions on the assumption of an existing competence to answer them in the selected terms. This is a form of the apparently flattering manipulation of a commercial or electoral market. In an alternative democratic form, it has already been shown in pilot studies that stages of questioning and of inquiry and information can be progressively correlated. Thus a first broad indication of opinion can lead into an encounter with opposing arguments and evidence, from any of the real range of points of view. Questions can then be amended and reformulated, or alternative propositions made, in a process of genuinely interactive learning and exchange. The opinions that would emerge from such processes – and they are, crucially, indefinitely repeatable and variable – would then have some real grounding in active social relations. Indeed this is a technical means of achieving, within a complex society, some of the processes of the formation of opinion in active and equitable small groups, in which grounded beliefs and the modes of

direct democratic discussion and decision were traditionally based but then in larger societies lost.

Again, one of the major benefits of the new technologies could be a significant improvement in the practicability of every kind of voluntary association: the fibres of civil society as distinct from both the market and the state. Today, though the dominant lines of communication and organization are powerfully and centrally funded and controlled, millions of people, continually and irrepressibly, set up their own organizations, either for purposes ignored or neglected by the established forms, or as means of positive support and influence. Typically they now work under serious difficulties, of resources and especially of distance. An association can have a hundred thousand members and yet not more than a few hundred, and often only one or two, in any particular place. The consequent problems of travel and funding are then devotedly addressed, but for many purposes the new interactive technologies could transform them by providing regular facilities for consultation and decision from people's own homes, workplaces and communities. In many formal organizations, such as parties and trade unions, such facilities would greatly assist the improvement of democratic communication and decisions. But there would also be a great strengthening of every kind of voluntary and informal association, from special interests and charities to alternative and oppositional political and cultural groups. This could be, in practice, the achievement of full social and cultural powers by civil society, as opposed to their appropriation or marginalization by the corporations and by the state.

These uses touch even wider possibilities, in new forms of cooperation and consultation in work. In some processes they could effectively replace the now cumbrous and expensive daily transportation of people to physically centralized workplaces, passing and repassing each other on the roads and lines. Ecologically this will be desirable and perhaps imperative, before the end of the century, for many kinds of work and service. Its flexible forms, in further applications of the technologies, would be fully congruous with new working relationships in self-managing agencies. This should be one of the main shapes of a genuinely socialized economy, in which direct relations in placeable enterprises and communities can be efficiently extended to much wider and more varied organizations over a very much larger physical space.

In education, also, there are important new possibilities, already indicated by the success of the Open University. There can be a new range of formal learning systems, which people can use in their own time and at their own pace. This will be especially important in a period in which there are ·ew needs for permanently available education. Yet what is now happening, in the existing institutions, is a steady pressure

from a late-capitalist economy and its governments to reduce education both absolutely and in kind, steadily excluding learning which offers more than a preparation for employment and an already regulated civic life. The alibi word for this reduction and exclusion is 'academic', now used for most kinds of organized and sustained learning as a way of distancing and disparaging them. The formula of 'the academic child' is similarly used to specialize sustained learning and to find an excuse for excluding a majority from it. Yet this only exploits certain real features of relatively enclosed and distanced academies, within an unequal and privileged culture. Much can be done to extend and change the existing institutions, by the serious development of the comprehensive principle, and by its extension beyond the now wholly inadequate leaving age. But use of the new technologies can add diversity and permanent availability to the most comprehensive institutions, above all in making them outward-looking, taking their own best knowledge and skills to a wider and more active society.

These are some of the general directions in which we could choose to develop the new technologies, by choosing a different kind of economy and society. Taken together they offer the possibility of new kinds of active social and cultural relations in what is going to be in any case an exceptionally complex technological world. The crude and reductive interests now engaged in capturing and directing them are outrage enough. But it is really just as outrageous if, on the threshold of these possibilities, there is surrender to the old formulas of technological determinism and cultural pessimism, among the very people whose central responsibility is to inform and propose and act to realize them. For these uses, within the processes of much broader changes, are among the indispensable means of a new radical democracy and a new socialism, in numerous and complex societies. They are also among the authentically modern movements beyond the long and bitter impasse of a once liberating Modernism.

9

Politics and Policies:
The Case of the Arts Council

One of the more entertaining delusions of English public life is the belief that the man in the middle is always right. Thus if the Arts Council is under attack from both Right and Left it can conclude, falsely, that its policies are likely to be broadly correct. If the Right alleges that the Council squanders money on subversive, obscene or trivial 'art', and the Left alleges that the Council is elitist, undemocratic and unaccountable, it seems natural, under the spell of the delusion, to look comfortably down at one's feet and see the always virtuous middle ground. Yet it should be obvious that there is no middle ground between complaints and allegations of these radically different kinds. English public life is similarly misled by the metaphor of the pendulum, swinging to left and to right but always returning to the centre. We should perhaps remember that when a pendulum stays in dead centre, the clock stops.

The idea of a virtuous middle ground, proved to be virtuous because it is attacked from opposite directions, conceals one crucial assumption: that what is being attacked is itself simple and coherent. Otherwise nothing is proved, since one variation may be attacked from one position, and a quite different variation from another. Looking at the Arts Council, I find this kind of case: deep-rooted inconsistencies; incompatible variations; indeed, for all its notable efficiency in its day-to-day business, a radical incoherence. We are dealing not with a negatively defined middle ground but with a whole series of contradictions, themselves the result of many shifting and diverse intentions and pressures.

The Arts Council, historically, is a Keynesian body. That in itself goes some way to explaining its current problems. But what is really interesting is that, as in so many other institutions and policies in which Keynes had a big guiding hand, there were from the beginning uncertainties and

confusions of definition and intentions. These are significant both in themselves and in their continuing, often muddling effects on general policy. I will briefly recall the history because we are still under its contradictory pressures.

Keynes saw much further than most of his contemporaries, and had a much broader humanity. To recognize his distinction we have only to look at the founding meeting of CEMA (the Council for the Encouragement of Music and the Arts), the immediate predecessor of the Arts Council, before Keynes was involved. The President of the Board of Education, de la Warr, who was being asked for the money,

> was enthusiastic. He had Venetian visions of a postwar Lord Mayor's Show on the Thames in which the Board of Education led the arts in triumph from Whitehall to Greenwich in magnificent barges and gorgeous gondolas; orchestras, madrigal singers, Shakespeare from the Old Vic, ballet from Sadler's Wells, shining canvases from the Royal Academy, folk dancers from village greens – in fact Merrie England.[1]

It seems fair to say that this is about as far as the English ruling class would have got on its own. Perhaps not even that far, as the dancers tried to manoeuvre in the barges or the actors shouted and the canvases shone from the gondolas. Yet this simple appropriation of the arts for a state spectacle is still their ruling perspective. From a Lord Mayor's Show to a royal wedding, versions of the arts are selected and hired to embellish what Bagehot accurately called the theatrical apparatus of the state. Keynes is very far beyond that. But, looking back, we can distinguish four different definitions of what a new kind of institution should do.

First, and best known, is the idea of state patronage of the fine arts. As Keynes said in a broadcast talk in 1945:

> I do not believe it is yet realised what an important thing has happened. State patronage of the arts has crept in. It has happened in a very English, informal, unostentatious way – half-baked if you like. A semi-independent body is provided with modest funds to stimulate, comfort and support any societies or bodies brought together on private or local initiative which are striving with serious purpose and a reasonable prospect of success to present for public enjoyment the arts of drama, music and painting.[2]

Second, however, and less well known – indeed now whimsical to recall – is an idea of what is in effect pump-priming. Keynes believed that in the long run the fine arts should be self-supporting. As his biographer Harrod records: 'His ideal for CEMA was that at the final stage, no doubt not to be reached for a long time, it should have no disburse-

ments except the cost of administration.'[3]

Yet, third, Keynes characteristically saw such an initiative as an intervention to modify the market economy, or perhaps more strictly, as an intervention to take the arts out of the market economy. As he had put it in 1936:

> The exploitation and incidental destruction of the divine gift of the public entertainer by prostituting it to the purposes of financial gain is one of the worser crimes of present-day capitalism. How the state could best play its proper part it is hard to say. We must learn by trial and error. But anything would be better than the present system. The position today of artists of all sorts is disastrous.[4]

Meanwhile, fourth, there is a different perspective. The public and potential public for the arts is very much larger than commonly supposed. The wartime success of CEMA, the successes of the BBC, already showed this. Earlier successful efforts to take the arts to people who had been deprived of access to them were recalled in this emerging (and temporary) consensus of belief in an expanding, serious and popular culture. As Keynes put it in 1945:

> The task of an official body is not to teach or to censor, but to give courage, confidence and opportunity. Artists depend on the world they live in and spirit of the age. There is no reason to suppose that less native genius is born into the world in the ages empty of achievement than in those brief periods when nearly all we most value has been brought to birth. New work will spring up more abundantly in unexpected quarters and in unforeseen shapes when there is a universal opportunity for contact with traditional and contemporary arts in their noblest forms.[5]

These, then, are the four definitions and intentions: state patronage of fine arts; pump-priming; an intervention in the market; an expanding and changing popular culture. It is evidently possible to hold them all within a single mind, indeed within a notably clean single mind. But as they pass from the level of public remarks and declarations to the level of actual policies, first differences of emphasis and problems of priority, then actual contradictions, soon emerge.

Let us take the four definitions in turn. The first has probably been dominant in the Arts Council's work. It doesn't often talk of state patronage; it talks of public money and what it primly calls its 'clients'. The effect is much the same, except that there is an immediate practical problem about that phrase 'the arts'. Keynes said 'the arts of drama, music and painting'. The Council's 1946 Charter said 'the fine arts exclusively'. This was changed in the 1967 Charter to 'the arts', which of

course returns us to the problem. Keynes, when specifying, had left out literature, where the situation of writers was and is as difficult as that of any other practitioners, but where the problem could be masked and rationalized by the fact of provision of public libraries. But public libraries are an initiative under the third or fourth definitions, and the exclusion of literature from the first had serious effects, which persist in the Council's failure to find an equitable policy for literature, even after it has marginally reincluded it in 'the arts'.

That other phrase, 'fine arts', has even more problems; traditionally understood as painting and sculpture it now offered to include music and, very surprisingly, theatre. On the other hand, with its (deliberately?) antique air, it could plausibly exclude film, photography, radio and television ('new work . . . in unforeseen shapes').

Yet the problem is deeper than this. Keynes sometimes spoke interchangeably, as we have seen, of 'the artist' and 'the public entertainer'. Yet this confused and inherited cultural division was in new ways being rationalized and fixed during the war: as well as CEMA there was ENSA; on the one hand 'art', on the other 'entertainment'. As we approach the problems of that division, in a context of spending public money, we can almost understand that draftsman's evasive 'fine arts'. This is the area of contradiction. On one interpretation, the Arts Council's task is to dispense money to support the older, traditional 'fine arts', 'exclusively' as the 1946 Charter said. On another interpretation, since it is not actually the state but the general public which is providing the money for what is not then 'patronage' (the rich and powerful with their clients) but a form of public service, can 'the arts' be limited to those received forms already recognized by existing minority publics, or must the scope be widened to the range of the actual artistic work of the time?

Clearing this confusion, which in practice leads to every kind of resentment, from very variable positions, is not helped, is indeed made virtually impossible, by the crazy division of what we can charitably call 'responsibility' between different government departments: the arts at Education, then through Keynes at the Treasury, then back in 1964 to Education; the press and publishing and cinema at Trade and Industry; broadcasting at, of all places, the Home Office. We can see even from this level that there has never been a coherent public cultural policy, and moreover that there are powerful groups who are determined that there will never be one; we should not always flatter such people by calling them stupid and muddled. And it is in this crazy structure that the Arts Council, already carrying its own unresolved definitions of 'patronage' and 'the arts', has in practice to operate.

The second definition, as pump-priming, may now induce only a certain wistfulness. Even before the worst phases of inflation, it was

obvious that neither 'the arts' nor 'the fine arts' would be, in the ordinary sense, 'self-supporting'. The sums of money now required, not only for pump-priming but for the whole waterworks, are very different from CEMA's initial £25,000 a year, or from the 1938–1939 expenditure of some £920,000 on the still separated area of museums, galleries, historic buildings and ancient monuments (the received, traditional and residual works which, in yet another division of 'the arts', the state spent public money on, for the mixed purposes of 'heritage' and public education).

Yet two points have still to be made. First, that it is not only 'the arts' but a very much broader area of cultural activity that has proved to be not self-supporting, under the conditions of corporate capitalism. It is ..ot only orchestras and dance and theatre companies and poets who work 'at a loss'; it is also, in direct revenue, most of the British press, the British cinema, most sports, and in their different ways radio and television. To specialize the problem of deficit, in capitalist terms, to 'the arts', is absurd. There is a whole general and pervasive crisis of the cultural economy, made worse by, but still quite distinguishable from, the crisis of the economy as a whole.

But then, second, it has also to be said that the whole problem of revenue from the arts is confused by a familiar kind of false accounting. In fact a significant part of the real and enduring wealth of our societies – and I mean here negotiable wealth, cash-value, rather than the important but in this context evasive 'human richness' – is in works of art. Openly and even notoriously the art works of other periods enter this world of monetary exchange, often as some of its most durable and reliable forms. Orthodox accounting excludes this whole area from the field of profit and loss in art. Yet if we were to institute two new practices – an Art Sales Levy, taking a substantial percentage of the profits of this dealing and speculation in other people's work; a National Copyright Fund in which after the interest of the author and his estate had expired (at the present fifty years after death) the copyright proceeds of some then heavily exploited work could continue to be collected – we could see the whole question of 'pump-priming' in a new and practical light. It could then be clearly seen that to say that art never makes money is a bloody lie. It could also be seen that, on one level at least, the problem of financing art is to cover or diminish short-term losses with the reasonable expectation of some very important long-term gains. And this is to speak only in money terms. The wider case for such early encouragement and support, while work has time to be done and to make its way, comes of course under a different definition.

Yet it is in this area of the third definition that the sharpest contemporary engagement must be sought. It is hardly surprising that the Keynesian idea of taking art out of the general market should get short

shrift in the period in which more widespread advances – in health care,
in education, in utilities – are in the process of being temporarily rolled
back. Instead, in art as in these other areas, the arts are under pressure
to be reinserted in a new kind of market, based not on costs and revenue
but on the new major forms of advertising and sponsorship.

I cannot, on this occasion, make the whole general case against
advertising and sponsorship, in their contemporary forms, as major
distortions of the economy and indeed of the market itself in its earlier
workings: distortions which have already wrenched our culture from its
bearings, to the point where advertising itself is virtually the only profit-
able contemporary art.

But there are two more immediate points. First, that Keynes himself
was confused in this matter. The idea of state intervention in a few
selected areas, so that they will be no longer 'prostitut[ed] ... to the
purposes of financial gain', is generous but in the end impractical. An
economy is determined by its major dominant structure and what has
been hopefully taken out to work on different principles is eventually
drawn back into the major orbit, or is at best made marginal and, in its
explicit funding, vulnerable. We have seen this, since the sixties, in case
after case, where commercial standards and priorities have been steadily
reimposed. Moreover the social relations and ideas of the dominant
economy continually replenish crude ideas of isolated profit and loss,
from which resentment against the selected areas both grows and is
nourished. The Arts Council has not been the only sufferer from this,
but that it has suffered – in tendentious and often malevolent scrutiny of
its expenditures, of a kind which is only rarely applied to commercial
enterprises themselves benefiting from more hidden forms of public
support – is clear.

Moreover, second, the dominant economy has its own ways of using
the selected areas. This has been seen most grossly in the case of trans-
port and of utilities, but it has also been the case in the small area of the
funded arts. The prestige arts institutions, already taking so large a share
of Arts Council money, are used not only as art but as tourist attractions
and for business entertaining, themselves directly commercial in
purpose. Again, many kinds of artistic production, but especially those
in the metropolis, are basically funded by the Arts Council and could
indeed not carry on without it, yet can be topped up, at relatively small
cost, by commercial institutions which are represented as 'sponsoring'
the work, and which gain prestige by association with the quality of
other people's efforts – the oldest public relations technique of them all.

The current drive to make the arts more dependent on such 'sponsor-
ship' has to be resolutely opposed, for two reasons. First, because at any
stage yet foreseen, such commercial sponsorship is getting a low-cost

ride on the back of a system of public funding which at the same time, when it suits it, it can deride. We shall be able to see how serious they are about the arts when they offer to fund anything like full cost. But, second, because the deformation of the arts, by what will inevitably be a commercially selective sponsoring, for prestige or public relations, is something that ought to be resisted while it is still at a relatively early and apparently innocuous stage. If we let in that principle, that the arts which get funded, and where they get funded, are subject to commercial and public-relations calculations, we shall have lost a half-century of effort, of achievement and of dignity.

The irony is, of course, that 'the fine arts exclusively' or shall we say 'the metropolitan fine arts exclusively', might, in certain very limited and conventional forms, be funded by a mixture of state and commercial sponsorship. That is indeed one future now foreseen for the Arts Council. It is often backed, voluntarily or involuntarily, by the plausible argument that only the 'high culture' should be supported, at the highest professional levels. Of course there are variations in this position, but at its crudest it means dropping the non-traditional arts, dropping the roadshow and small touring companies, dropping or 'devolving' arts centres and community arts and various kinds of low-cost experimental works. The regions and interests which are then not supported will have the pleasure of being told, not only that they must continue to contribute, through taxes and prices, to this amalgam of high-level state and commercial Art, but that they are themselves being excluded by that most potent criterion: standards!

There is a genuine difficulty here. I would support Keynes in his early definition of 'striving with serious purpose and a reasonable prospect of success'. I would agree that this involves professional judgements, preferably by fellow-practitioners. But it also involves genuine consideration of 'purpose', and a recognition that not all purposes in art are identical. The changes of purpose – that is of artistic intention and of foreseen relations with possible audiences which the historian knows in the transition to the great Elizabethan drama (denounced, early, on traditional standards, by Sidney), or in the awkward and prolonged transition to the bourgeois drama which now fills our serious theatres, or in the contested transition from Academy art to the independent groups and exhibitions of the painters who now take pride of place in our galleries – these changes of purpose are the real history of art. They are easy to read retrospectively, and the narrowest proponent of the idea of 'high culture' can, with these successful instances (for there were and always will be some failures), be as sharp a retrospective radical as may be wished. Yet it is in our own time that the questions are not only harder but much more real. They cannot be pre-empted by custom.

What Keynes said about 'unexpected quarters' and 'unforeseen shapes' is not only relevant and true; it is also evidence that he belonged to high culture in its only important sense, beyond prejudice and habit, and with its characteristic and essential quality of openness. These real values must not be allowed to be appropriated or suppressed by the always confident executors of a pillared patented Art.

It is here that all the problems of the fourth definition come to a practical centre. If you are indeed that kind of pillared and patented executor who *knows* – of course in advance, but afterwards will make no difference – that any ballet at Covent Garden, any play at the National Theatre, any picture in the National Gallery, is much more likely to be high art than a new play in a local theatre or in a roadshow hall, or than the experimental dance of a small touring company or than the odd canvas of an isolated man who still has paint on his hands – if you know all this, will you be an obvious candidate for appointment to the Arts Council or to the Business Sponsorship Panel?

It is in the nature of the fourth definition – that of encouraging a serious, expanding and changing popular culture – that the whole question of the nature and purposes of art is being redefined, and that the key element of this redefinition is openness. In any serious view, it is a long and complex process. Traditional art in its traditional institution has of course to be given its reasonable place. Moreover, as we have seen, new work will then appear within the sustained traditional institutions. But what is hardest to realize is that even traditional art changes when its audiences change, and that in the making of new art changing audiences are always a significant factor – not only sociologically but, as we can see in thousands of cases, formally. Thus it is never only a quantitative extension or expansion of a culture. If we take seriously the idea of making art, as practice and as works, more accessible to more people, we have to accept and indeed welcome the fact that as part of these changes there will also be changes in the arts themselves. Nobody who knows the history of the arts need fear these changes. Indeed there is much more, from the record, to fear when art is locked in to courts and academies, or when, at the opposite extreme, artists are pushed by neglect into isolation and there is no flow between them and a wide and diverse public.

I am then, on strictly artistic and cultural grounds, a proponent of the fourth definition. But I am also its proponent on the plainest political and economic grounds. Any of the first three definitions might attract some limited public support, but it is really only from the fourth definition that we can, in good conscience, raise money for the arts from the general revenue. The struggle for this idea has important cultural intentions, but it is also the only safe way of meeting the more limited and at

their best valid needs of the alternative definitions of policy. Thus instead of apologizing for the principle of public funding of the arts, or nervously excluding or reducing those aspects of policy which either the pillared and patented or the political and commercial hangers-on disapprove of, we should get together, in such numbers as we can, and fight the real battles.

Will the Arts Council do this? I began by saying that it was formed by and has inherited not only different but at times incompatible and even contradictory principles. With its 'semi-independent' status, with its members nominated by ministers of the day, with its dependence on tight departmental negotiation and funding it is not, indeed, in a good position for a fight. Yet because it is there it is where the argument has to start. The Council are trustees not only for public money but for public policy in the arts. I say 'trustees', but the accent has only to be shifted a little, to 'trusties', to name the most obvious danger. Imprisoned by the most convenient but weakest definitions, locked in by their departmental sponsors and bankers, glancing nervously at the barons of the system who can make their term more comfortable, in any case pressed and hardworked and seeing trees much more often than the wood, they can indeed function as trusties, those other men in the middle, whom neither side respects.

I have argued before, on the Council and off it, for a process of election rather than ministerial nomination of members. The details and practicalities of that belong to another occasion, and I have already put forward my own suggestions. But in the present context I want to say that the necessary public argument about these four definitions of policy (and perhaps there will be others) should be initiated by and openly centred in the Arts Council itself. Indeed that is centrally now what it is for, and what in the last few years, under pressure, it has begun in small ways to attempt. But then, if it is to be a real public argument, with all our diverse positions represented, the Council needs the range and diversity, the specific responsibility and accountability, which in my view only open public election can assure.

I have criticized Keynes, but in the present social climate I look across to him, and to the adult educator in whose name this lecture was founded,[6] in an open and recognizing spirit. For the task, as Keynes said, is still to give courage, confidence and opportunity.

Notes

1. *The First Ten Years*: Eleventh Annual Report of the Arts Council of Great Britain, 1955–56, p. 6.

2. *The Listener*, 12 July 1945, p. 31.
3. R.F. Harrod, *The Life of John Maynard Keynes*, New York 1951, p. 401.
4. *The Listener*, 12 July 1945, p. 31.
5. Ibid.
6. The occasion was the 1981 W.E. Williams Memorial Lecture [Ed.]

10

The Future of Cultural Studies

I wish here to address the issue of the *future* of Cultural Studies, though not as a way of underestimating its very real current strengths and development – a development which would have been quite impossible, I think, to predict thirty or so years ago when the term was first beginning to get around. Indeed, we should remind ourselves of that unpredictability, as a condition likely to apply also to any projections we might ourselves make, some of which will certainly be as blind. Yet we need to be robust rather than hesitant about this question of the future because our own input into it, our own sense of the directions in which it should go, will constitute a significant part of whatever is made. And moreover the clearing of our minds which might lead to some definition of the considerations that would apply in deciding a direction is both hard and necessary to achieve, precisely because of that uncertainty.

I want to begin with a quite central theoretical point which to me is at the heart of Cultural Studies but which has not always been remembered in it. And this is – to use contemporary terms instead of the rather more informal terms in which it was originally defined – that you cannot understand an intellectual or artistic project without also understanding its formation; that the relation between a project and a formation is always decisive; and that the emphasis of Cultural Studies is precisely that it engages with *both*, rather than specializing itself to one or the other. Indeed it is not concerned with a formation of which some project is an illustrative example, nor with a project which could be related to a formation understood as its context or its background. Project and formation in this sense are different ways of materializing – different ways, then, of describing – what is in fact a *common* disposition of energy and direction. This was, I think, the crucial theoretical invention that was

151

made: the refusal to give priority to either the project or the formation –
or, in older terms, the art or the society. The novelty was seeing
precisely that there were more basic relations between these otherwise
separated areas. There had been plenty of precedents for kinds of study
which, having looked at a particular body of intellectual or artistic work
related it to what was called its society; just as there was a whole body of
work – for example, in history – which described societies and then illu-
strated them from their characteristic forms of thought and art. What
we were then trying to say, and it remains a difficult but, I do believe,
central thing to say, is that these concepts – what we would now define
as 'project' and 'formation' – are addressing not the relations between
two separate entities, 'art' and 'society', but processes which take these
different material forms in social formations of a creative or a critical
kind, or on the other hand the actual forms of artistic and intellectual
work. The importance of this is that if we are serious, we have to apply it
to *our own* project, including the project of Cultural Studies. We have to
look at what kind of formation it was from which the project of Cultural
Studies developed, and then at the changes of formation that produced
different definitions of that project. We may then be in a position to
understand existing and possible formations which would in themselves
be a way of defining certain projects towards the future.

Now that is, in a summary way, a theoretical point; and I'd like to
give one or two examples of it. First, not in Cultural Studies but in one
of the contributors to it; namely English or Literary Studies. It is very
remarkable that in every case the innovations in literary studies occurred
outside the formal educational institutions. In the late nineteenth
century, when there was in fact no organized teaching of English liter-
ature at all, the demand came in two neglected and in a sense repressed
areas of the culture of this society. First, in adult education, where
people who had been deprived of any continuing educational opportu-
nity were nevertheless readers, and wanted to discuss what they were
reading; and, even more specifically, among women who, blocked from
the process of higher education, educated themselves repeatedly through
reading, and especially through the reading of 'imaginative literature' as
the phrase usually has it. Both groups wanted to discuss what they'd
read, and to discuss it in a context to which they brought their own
situation, their own experience – a demand which was not to be satis-
fied, it was very soon clear, by what the universities (if they had been
doing anything, and some informally were) were prepared to offer,
which would have been a certain kind of history or a set of dates, a
certain description of periods and forms. The demand, then, was for a
discussion of this literature in relation to these life-situations which
people were stressing outside the established educational systems, in

adult education and in the frustrated further education of women. Hence some of the most remarkable early definitions of what a modern English course might be arose from Oxford Extension lecturers who'd gone out and formed their ideas in relation to this quite new demand. And when this new kind of study of literature – outside traditional philology and mere cataloguing history – finally got into the university, its syllabus was written, for example at Cambridge, almost precisely on the lines which that early phase in the late nineteenth century and early twentieth century had defined. It was said by one of the founders of Cambridge English that the textbook of that period was virtually a definition of their syllabus.

But then look what happened: having got into the university, English studies had within twenty years converted itself into a fairly normal academic course, marginalizing those members of itself who were sustaining the original project. Because by this time what it was doing within the institution was largely reproducing itself, which all academic institutions tend to do: it was reproducing the instructors and the examiners who were reproducing people like themselves. Given the absence of that pressure and that demand from groups who were outside the established educational system, this new discipline turned very much in on itself. It became, with some notable advantages, as always happens, a professional discipline; it moved to higher standards of critical rigour and scholarship; but at the same time the people who understood the original project, like Leavis for example, were marginalized. The curious fact is that they then tried to move outside the university, to set going again this more general project. But because of the formation they were – largely, if one wants to be strict in the usual terms, a group of people from petty-bourgeois families, almost equally resentful of the established polite upper middle class which thought it possessed literature, and of the majority who they felt were not only indifferent to it but hostile and even threatening – they chose a very precise route. They went out, and sent their students out, to the grammar schools to find the exceptional individuals who could then come back to the university and forward this process. What had been taken as their project into the university was not any longer the same project, so they went outside. But because they conceived themselves as this minority institution, seeking to educate a critical minority, it was now a different project and not the general project of the first definition. And so all the people who first read what you could now quite fairly call 'Cultural Studies' from that tendency – from Richards, from Leavis, from *Scrutiny* – who were studying popular culture, popular fiction, advertising, newspapers, and making fruitful analyses of it, found in time that the affiliation of this study to the reproduction of a specific minority within

deliberately minority institutions created a problem of belief for them, and also a problem for defining what the project was.

If you then look at the site in which there was a further process of change and in which a different project was defined, it was again in adult education. Indeed, it can hardly be stressed too strongly that Cultural Studies in the sense we now understand it, for all its debts to its Cambridge predecessors, occurred in adult education: in the WEA, in the extramural Extension classes. I've sometimes read accounts of the development of Cultural Studies which characteristically date its various developments from *texts*. We all know the accounts which will line up and date *The Uses of Literacy*, *The Making of the English Working Class*, *Culture and Society*, and so on. But, as a matter of fact, already in the late forties, and with notable precedents in army education during the war, and with some precedents – though they were mainly in economics and foreign affairs – even in the thirties, Cultural Studies was extremely active in adult education. It only got into print and gained some kind of general intellectual recognition with these later books. I often feel sad about the many people who were active in that field at that time who didn't publish, but who did as much as any of us did to establish this work. In the late forties people were doing courses in the visual arts, in music, in town planning and the nature of community, the nature of settlement, in film, in press, in advertising, in radio; courses which if they had not taken place in that notably unprivileged sector of education would have been acknowledged much earlier. Only when it reached either the national publishing level or was adopted – with some recoil – in the university, was this work, in the typical ways of this culture, perceived as existing at all. There were people I could tell you about who did as much as any of us in my generation, whose names the people now teaching Cultural Studies would simply not know, and they were doing it in a site which was precisely a chosen alternative to the Leavis group. And it should be stressed that it was a *choice*: it was distinctly as a vocation rather than a profession that people went into adult education – Edward Thompson, Hoggart, myself and many others whose names are not known. It was a renewal of that attempt at a majority democratic education which had been there all through the project, but which kept being sidetracked as elements of it got into institutions which then changed it. Thus there was an initial continuity from the Leavis position of certain analytic procedures which eventually were thoroughly changed, because these people wanted precisely a democratic culture, and did not believe that it could be achieved by the constitution of a Leavisite 'minority' alone. They were nevertheless aware, because this was a very practical and pressed kind of work, that the simplicities of renouncing mass-popular education and democratic

culture, when you have to go out and negotiate them on the ground, would not be easily resolved.

I give this example because so often the history of each phase of Cultural Studies has been tracked through *texts*. Such accounts talk about this individual having done this work; this tendency; this school; this movement labelled in this or that way; which looks very tidy as this type of idealist history – a very academicized kind of literary or intellectual history – always is. Yet that is in a sense only the surface of the real development, and is moreover misleading because what is happening each time is that a formation in a given general relationship to its society is taking what you could otherwise trace as a project with certain continuities, and in fact *altering* it, not necessarily for the better. There have been as many reversions as there have been advances; and one of the reversions comes, I think, in the next phase. Because as some of this work began to be recognized intellectually, as it was both in discussion and in periodicals and to some extent in the universities, it was thought to be a much newer thing than it was. If you take my book *Communications* which was commissioned because the National Union of Teachers called a conference on 'Popular Culture and Personal Responsibility' which in fact came out of the 1950s concern about horror comics – the root is as odd as that – I actually made the book, which didn't take long to write, out of the material I had been using in adult classes for fifteen years. Thus the sense of novelty which is easily conveyed by tracing the texts is in fact misleading, since the real formation of the project was already there. But when this began to happen it made a certain significant intellectual difference in the university, though never one which could shift its most central institutions and assumptions.

But then a period of expansion in education occurred which created new sites for precisely this kind of work, and a new kind of formation – one perhaps continuous until today – came into existence. I can still remember my own students getting their first jobs and coming back and saying 'I went to meet the principal as the newly appointed lecturer in Liberal Studies, and I asked him what Liberal Studies was and he said, "I don't know; I only know I've got to have it".' They were, then, in that unprecedented situation, for most people starting their first job, of being able to write a syllabus, which otherwise you labour and drag yourself for a lifetime to climb towards, and then probably fail to do. They had the option to put down certain ideas, and what they put down, in the majority, in new universities, in polytechnics, in colleges of further education, in some schools even, as this new phase got around, was precisely this area of work which the university was rather warily looking at but keeping well outside its really central and decisive areas. And they were able to do this because the option for Liberal Studies had been so vague; it

had been based on nothing much more than the sense – itself based, perhaps, in the lingering cultural distrust of science and technology as too worldly – that people should discover certain of the finer things of life.

In this way, and without any well-established body of work to base itself on, a new formation in these new institutions began to develop, but with certain consequences. First, that precisely as you move into the institutions – as you pass that magic moment when you are writing the syllabus and have to operate it, to examine it; as you are joined by colleagues; as you become a department and as the relations between departments have to be negotiated, as the relative time and resources are given to them – what then takes place is precisely the process which emasculated English at Cambridge. At the very moment when that adventurous syllabus became a syllabus that had to be examined, it ceased to be exciting. And just at the moment when this new work flooded into what were, for all the welcome elements of expansion, still minority institutions – still, moreover, formed with certain academic precedents around departments, about the names of disciplines and so on – then certain key shifts in the project occurred.

Yet there is one other kind of institution which I'd first like to mention which also occurred in just this period – I'm talking of the sixties – and that's the Open University. On this, two crucial points need to be made, as it were, simultaneously. First, that this was an extraordinary attempt in the tradition of that movement towards an open-access democratic culture of an educational kind – not the bureaucratically centralized imposition of a cultural programme which would enlighten the masses but one of a genuinely open and educational kind. At the same time, however, it was a deliberate break with the traditions of its own society in adult education and the Co-operative Guild, in all the local self-educating organizations of working people and others, which had been based precisely on a principle which it could not realize: that intellectual questions arose when you drew up intellectual disciplines that form bodies of knowledge in contact with people's life-situations and life-experiences. Because of course that is exactly what had happened in adult education. Academics took out from their institutions university economics, or university English or university philosophy, and the people wanted to know what it was. This exchange didn't collapse into some simple populism: that these were all silly intellectual questions. Yet these new students insisted (1) that the relation of this to their own situation and experience had to be discussed, and (2) that there were areas in which the discipline itself might be unsatisfactory, and therefore they retained as a crucial principle the right to decide their own syllabus. This process of constant inter-

change between the discipline and the students, which was there
institutionalized, was *deliberately* interrupted by the Open University, a
very Wilsonian project in two senses. It was on the one hand this popu-
lar access; on the other hand it was inserting a technology over and
above the movement of the culture. This project would bring enormous
advantage but it lacks to this day that crucial process of interchange and
encounter between the people offering the intellectual disciplines and
those using them, who have far more than a right to be tested to see if
they are following them or if they are being put in a form which is
convenient – when in fact they have this more basic right to define the
questions. These people were, after all, in a practical position to say
'well, if you tell me that question goes outside your discipline, then bring
me someone whose discipline *will* cover it, or bloody well get outside of
the discipline and answer it yourself.' It was from this entirely rebellious
and untidy situation that the extraordinarily complicated and often
muddled convergences of what became Cultural Studies occurred;
precisely because people wouldn't accept those boundaries. Yet the
Open University, as a major example of a breakthrough beyond a
minority institution, had this element in it of a technology inserted over
and above the social process of education: it had this characteristic
double dimension.

I now come to my controversial point. At just this moment, a body of
theory came through which rationalized the situation of this formation
on its way to becoming bureaucratized and the home of specialist intel-
lectuals. That is to say, the theories which came – the revival of formal-
ism, the simpler kinds (including Marxist kinds) of structuralism –
tended to regard the practical encounters of people in society as having
relatively little effect on its general progress, since the main inherent
forces of that society were deep in its structures, and – in the simplest
forms – the people who operated them were mere 'agents'. This was
precisely the encouragement for people not to look at their own form-
ation, not to look at this new and at once encouraging and problematic
situation they were in; at the fact that this kind of education was getting
through to new kinds of people, and yet that it was still inside minority
institutions, or that the institutions exercised the confining bureaucratic
pressures of syllabus and examination, which continually pulled these
raw questions back to something manageable within their terms. At just
that moment – which I hope is still a moment of fruitful tension – there
was for a time a quite uncritical acceptance of a set of theories which in
a sense rationalized that situation, which said that this was the way the
cultural order worked, this was the way in which the ideology distributed
its roles and functions. The whole project was then radically diverted by
these new forms of idealist theory. Even the quite different work of

Gramsci and Benjamin was subsumed within them; and of the powerful early challenge to such Modernist idealisms launched by Bakhtin, Voloshinov and Medvedev, little or nothing was heard. Even (and it was not often) when formations *were* theorized, the main lesson of formational analysis, concerning one's own and other *contemporary* formations, was less emphasized than more safely distanced academic studies.

In its most general bearings, this work remained a kind of intellectual analysis which wanted to change the actual developments of society, but then locally, within the institution, there were all the time those pressures that had changed so much in earlier phases: from other disciplines, from other competitive departments, the need to define your discipline, justify its importance, demonstrate its rigour; and these pressures were precisely the opposite of those of the original project. Now there was indeed a very great gain in this period, as anybody who compares the earlier and later work will see. When I wrote *Communications* we were analysing newspapers and television programmes, with material strewn over the kitchen floor and ourselves adding up on backs of envelopes, and when I look now at Media Studies departments and see the equipment they have to do the job properly I of course recognize the advances as being marked. Similarly with film studies, we never knew whether the film would (a) arrive, (b) work with that projector, (c) whether in an adult class people wouldn't be so dazed after watching the film that when you asked for discussion you never got a word; now film courses operate in a proper institution, and I've never doubted the advantages of this; just as nobody in the centre of the English Faculty at Cambridge now could believe for a moment that what they do isn't infinitely superior to Leavis's work. I mean, in certain new ways it *is* always more professional, more organized, and properly resourced. On the other hand, there remains the problem of forgetting the real project. As you separate these disciplines out, and say 'Well, it's a vague and baggy monster, Cultural Studies, but we can define it more closely – as media studies, community sociology, popular fiction or popular music', so you create defensible disciplines, and there are people in other departments who can *see* that these are defensible disciplines, that here is properly referenced and presented work. But the question of what is then happening to the project remains. And in a sense the crisis of these last years should remind us of the continuing relation between the project and the formation: the assumption that we were witnessing the unfolding of some structure which was, so to say, inherent – a continuation of some simple line, as in those accounts of the history of Cultural Studies which had shown people gradually, although always with difficulty, overcoming their residual errors and moving on a bit – has been

brutally interrupted by the very conscious counter-revolution of these last years.

This is where I come to the question of the future. For what we now have is a situation in which the popular cultural institutions have changed so profoundly through the period in which Cultural Studies has been developed, with relative alterations of importance – for example between broadcasting and print – of a kind that no one would have believed possible in the fifties. We've got new sets of problems both inside the different kinds of study we do, as to which of them really bear on the project, and also the question of considering our own formation in this now very changed situation. I'll take a couple of examples first from the internal process of the subjects themselves, illustrating the contradictory effects of this welcome development but simultaneous institutionalization of Cultural Studies. If you take the question of popular culture, or popular fiction, it has been clearly quite transformed in the eighties from its situation in the fifties, not only because people have been more prepared, because of general social and formational changes, to relate directly to popular culture, putting themselves at a very conscious distance from Richards and Leavis in the twenties and thirties who saw it only as a menace to literacy – an element which survives, perhaps, although always as uncertainly and ambiguously as ever, in Richard Hoggart's book. But at the same time that earlier tension between two very different traditions and kinds of work can as easily be collapsed as explored. It is necessary and wholly intellectually defensible to analyse serials and soap operas. Yet I do wonder about the courses where at least the teachers – and I would say also the students – have not themselves encountered the problems of the whole development of naturalist and realist drama, of social-problem drama, or of certain kinds of serial form in the nineteenth century; which are elements in the constitution of these precise contemporary forms, so that the tension between that social history of forms and these forms in a contemporary situation, with their partly new and partly old content, partly new and partly old techniques, can be explored with weight on both sides. This can very easily not happen if one is defining the simpler kind of syllabus because the teacher can say 'well, for that you'd have to go to drama', or literature or fiction, 'we're doing popular fiction'. Yet how could you carry through the very important work now being done on detective stories, for instance, without being able to track back to the crime stories of the nineteenth century and grasp the precise social and cultural milieu out of which that form came, so that you are then able to add an extra dimension of analysis to what we now say about the form of the detective story? Or, in the sociological dimension of Cultural Studies, there is the whole problem of the relation between very close-

up contemporary work which is crucially necessary to history, and the
very complicated interpretations of history which are not to be dimin-
ished, in my view, simply to labour history or popular history, because
otherwise one isolates a class precisely from the relations which, in a
sense, constitute that class. I give these cases as examples of how in the
very effort to define a clearer subject, to establish a discipline, to bring
order into the work – all of which are laudable ambitions – the real
problem of the project as a whole, which is that people's questions are
not answered by the existing distribution of the educational curriculum,
can be forgotten. And people, when they are free to choose – though
they are often not, because of quite natural pressures and determin-
ations and a reasonable ambition to qualify – again and again refuse to
limit their questions to the boundaries of the set course. So that the
interrelations between disciplines, which are the whole point of the
project, have this inherent problem in what is otherwise a valuable
process of defining and modelling the subject.

But the more crucial question now is this: that even after the expan-
sion we've had, which was first halted and then turned back by a succes-
sion from Callaghan to Thatcher and Joseph, we are facing a situation
which is quite different in kind but just as challenging as that which
faced any of those people who developed the project in particular
circumstances in earlier periods. What we have got now, and what was
not available when the studies were getting into the new institutions, is
the effective disappearance of those kinds of teenage work which were
profound anti-educational pressures at just the time that some of these
developments were happening. There were then understandable
pressures of money and work against the problems of staying on with
that kind of school, that kind of education. We've now got the extra-
ordinary institution of courses which in a sense are deliberately placed
beyond the reach of education. We have the effective education of the
majority in the age-group of sixteen to eighteen being removed as far as
possible from what are conceived as the old damaging educators. We
now encounter a definition of industrial training which would have
sounded crude in the 1860s when something very like it was proposed –
and we might be glad if it *had* then happened: at least it would have
solved one set of problems. It is again being said that people must gain
work experience within the forms of the economy to which they must
adapt, and as *that* syllabus is written, as that programme of work experi-
ence is written, no place at all is envisaged for people like us. I don't
mean that individual initiatives don't happen, but rather that a whole
substitute educational provision is being made with certain very power-
ful material incentives, including the possibility of employment. And
while the labour movements say of such work experience that it's merely

'cheap labour' or whatever, I say what educators must say – and this is, as a matter of fact, where I see the future of Cultural Studies. Here is a group which – if it is given only what is called 'work experience', but which is actually its introduction to the routines of the foreseen formations of this new industrial capitalism – will be without that dimension of human and social knowledge and critical possibility which again and again has been one of the elements of our project. And if it seems hopeless that people in their own hard-pressed institutions, which of course we have to defend, should be asked to look towards this area which has very consciously, as a matter of political policy, been removed as far as possible from professional educators, I would say this: that there is the prospect, after all, within two, three, four years, of another kind of government; there is the possibility of the renewal of the existing institutions or at least the easing of some of their resource and staffing problems. When that comes, shall we simply cheer that the budgetary crisis is over, the establishment crisis relieved a bit? If we do, then those cheers should only be uttered out of one side of the mouth because if we allow an absolutely crucial area of formative human development to remain deliberately isolated from educators – moreover an area in which what Cultural Studies has to contribute is particularly relevant – then we shall have missed a historic opportunity; just as related opportunities were nearly missed or only partly realized, or to a large extent incorporated and neutralized, in earlier phases. We shall have missed that historic opportunity because we had become, in our very success, institutionalized.

I have deliberately not summarized the whole development of Cultural Studies in terms of the convergence of intellectual disciplines, which is another way of writing this history; an internal and illuminating way, but nevertheless insufficient unless you relate it all the time to the very precise formations and social institutions in which these convergences happened and *had* to happen. For that approach in terms of intellectual history may obscure from us what is, as we enter the coming period, a historic opportunity for a new Cultural Studies formation. And the time to prepare this new initiative, which would indeed be much resisted by many vested and political interests, is precisely *now*. Because it is only when a persuasive, reasoned and practical proposal is put forward to a favourable local authority or government, which would then have you sort through the ways in which you would teach it, that this new work will become more than a resented interruption from what is otherwise taught. If this is thought through now, if we fight for it, even if we fail we shall have done something to justify ourselves before the future. But I don't think we need fail at all; I think that the results will be uneven and scattered, but this is where the challenge now is. If you

accept my definition that this is really what Cultural Studies has been about, of taking the best we can in intellectual work and going with it in this very open way to confront people for whom it is not a way of life, for whom it is not in any probability a job, but for whom it is a matter of their own intellectual interest, their own understanding of the pressures on them, pressures of every kind, from the most personal to the most broadly political – if we are prepared to take that kind of work and to revise the syllabus and discipline as best we can, on this site which allows that kind of interchange, then Cultural Studies has a very remarkable future indeed.

11

The Uses of Cultural Theory

For a year or so I have been wanting to say something relatively formal about cultural theory, and this seems to be an occasion.* The point is not, at least initially, one of proposition or amendment within this or that theory of culture, but rather a reconsideration of what cultural theory, in the strictest sense, can be reasonably expected to be and to do. Moreover this will involve, as a challenging emphasis, a social and historical exploration of what, in its various forms, it actually has been and done. For cultural theory, which takes all other cultural production as its appropriate material, cannot exempt itself from the most rigorous examination of its own social and historical situations and formations, or from a connected analysis of its assumptions, propositions, methods and effects. My view of what can properly be taken as cultural theory is in itself and especially in this context controversial. For I want to distinguish significant cultural theory, on the one hand from theories of particular arts, which in some of its least useful forms cultural theory offers to supersede or indeed suppress, and, on the other hand, from properly social and sociological theories of general orders and institutions, which some cultural theories offer to replace or enclose. In our own period, any naming of these insignificant and uninteresting types of cultural theory can be taken as likely, and very rapidly, to clear the field or more specifically clear the room. Yet though something of that kind must indeed be done, it should not be rushed.

For of course I am not suggesting, as the received spatial model

*A lecture given in Oxford on 8 March 1986, at a conference on 'The State of Criticism' organized by Oxford English Limited.

163

inclines many to suppose, that the making of useful cultural theory is in
some intermediate area between, on the one hand, the arts and, on the
other hand, society. On the contrary, these now a priori but historically
traceable categories, and the conventional forms of their separation and
derived interrelation, are just what useful cultural theory most essentially
and specifically challenges. Yet I am saying that cultural theory is at its
most significant when it is concerned precisely with the *relations*
between the many and diverse human activities which have been histor-
ically and theoretically grouped in these ways, and especially when it
explores these relations as at once dynamic and specific within describ-
ably whole historical situations which are also, as practice, changing and,
in the present, changeable. It is then in this emphasis on a theory of such
specific and changing relationships that cultural theory becomes appro-
priate and useful, as distinct from offering itself as a catch-all theory of
very diverse artistic practices or, on the other hand, as a form of social
theory proposed or disposed as an alternative – though it should always
be a contributor – to more general social and historical analysis.

In fact the problem of the relations between what we now call the arts
and intellectual work, on the one hand, and the generality of human
activity which we loosely delineate as society, only arises – I mean as a
theoretical problem; the practical problems have always been there –
when certain historically significant changes have come about in both. If
we look back, for example, at the great lineage of theories of art or of
particular arts, we find no necessary tensions, of a kind to make all such
relationships problematic, between such theories and the general under-
lying forms to which, by extension, they were customarily referred. All
classical and neo-classical theories of art and of particular arts, typically
culminating in rules of practice, had as the matrix of their further
relations the general underlying forms of the idealist tradition: whether
specifically as underlying and shaping Ideas or as propositions of an
essential and unchanging human nature. Some difficulties occurred
when these Ideas or this Nature were given a defining contemporary
social form, necessarily of a normative kind, from which particular kinds
or examples of art could be seen as deviant: description of actual
relations then coming through as primarily moral – exemplary of an
established moral state or of lapses from it. These difficulties became
critical in that succeeding phase of theory which we generalize as
Romantic. Yet the change from the rules of art to the proposition of
unique creative forms did not in itself affect wider relationships, since
the new claim was based on comparably general and ideal dimensions:
notably an undifferentiated creative Imagination. The change of social
reference, from the reproduction of civilized society to an idea of
imaginative human liberation, also had less effect, in its early stages,

than one might at first suppose, since the new project was still theoretically ideal and general. It was only at a subsequent stage, with the differentiation of creative periods – historical social forms relatively favourable or unfavourable to both art and liberation – that an approach to the modern equations began to be made.

But other changes were now beginning to interact. The sense of art as both a specialized and an autonomous activity was strengthened rather than weakened by its increasing claim to represent, indeed to dominate, human creativity. The experience of practice continued to confirm, among artists, the sense of an autonomous skill. But this could again be strengthened rather than weakened by radical changes in the conditions of livelihood of artists, in the long move from different forms of patronage to different forms of the market. To set art as a priori above any market, in an ideal sphere of its own, was as regular a response to the new difficulties as their frank empirical recognition. Social changes and extensions of audiences and publics had more radical effects, and some direct interactions with production began to be observed as well as practised. Yet full specification of what we see as the modern problem did not really happen until social and historical analysis of the increasingly evident major changes – economic and political but also changes of material and of media in industrial and in cultural production – offered challenging specifications of social organization and historical development, including systemic crises and conflicts, to which many of the problems of art could appear to be directly related.

What at last came through, theoretically, in the significant new keywords of 'culture' and 'society', was the now familiar model: of the arts on the one hand, the social structure on the other, with the assumption of significant relations between them. Yet the types of theory developed from this model were not yet especially useful. This is as true of the immensely influential 'base and superstructure' version – in practice more widely adopted than just in Marxist or other socialist movements – as of the various versions of an elite, in which there was a structural affinity between high culture and forms of social privilege deemed necessary to sustain it. Theoretically there is often little to choose between these otherwise opposed positions, since the accounts usually given, in either, of the actual formative relationships between these separated categories are at best selective or suasive. In Marxism, for example, there was a shared predominance of idealist theories, in which generalized states of consciousness, which might be imputed to classes, were in ways never fully explained transmuted into forms and genres or styles and phases of art, and economist theories, in which there was some form of direct transmission of basic economic structures into modes of art, as in the proposition of what was called 'capitalist

poetry'. There was better work, drawing on earlier empirical studies within a different historical perspective, on the effects of changes in the social and economic situation of artists and of corresponding changes in audiences. Yet this, while important in itself, typically failed to engage closely enough with those actual and diverse *internal* changes in the different arts, which were of course seen as not only substantial but primary both by working artists and by an increasingly specialized analytical or technical criticism.

It was within this aroused but unsatisfied phase that the first important theoretical initiatives began to be made. I would look first at what might be called the road from Vitebsk. I mean that still imperfectly understood but major movement involving (uncertainly and inextricably) P.N. Medvedev, V.N. Voloshinov and M.M. Bakhtin, who were together in Vitebsk in the early 1920s and later worked in Leningrad. This is also my first example of the indispensability of social and historical analysis to study of the structure of an initiative in cultural theory. For the key fact of these theoretical moves was their complex situation within a still actively revolutionary society. Medvedev, notably, had been Rector of the Proletarian University and was actively engaged in literacy programmes and in new forms of popular theatre. We might then expect some simple affiliation to what was already known as a 'sociological poetics', in which the transformations of audiences and of the position of artists could be seen as leading directly to a new and confident theory and practice of art. But that was not the way the initiative went, quite apart from the fact that its work was interrupted and broken off by the Stalinist consolidation of control and dogma: a period of which Voloshinov and Medvedev appear to have been direct – and mortal – victims, and in which Bakhtin was marginalized.

For what had been seized was the problem of specificity: one which applies just as closely to their own intellectual work as to their understanding of art. What they were faced with was just that polarization of art and society characteristic of the received models. In those turbulent years, shaking free from so many old forms, the dominant theoretical trends were, on the one hand, formalism, with its emphasis and analysis of the distinctive, autonomous elements of art, and, on the other hand, a generalized Marxist application of social categories to the conditions of cultural production. What this group moved, correctly, to try to identify were the real gaps then left: the actual and specific relations between these practically unconnecting dimensions. They still nominally retained the model of base and superstructure, for they were writing as Marxists, but everything they said about it emphasized the complex and oblique practical relations which the formula typically overrode or obscured.

There is a special problem for us in a subsequent history, itself

socially and ideologically determined (and, in some complex ways, also politically determined). What appeared in the West from the 1960s, following these internal and privileged lines of force – and what is still sometimes offered as modern literary theory as if it had not, within years of its first appearance, been comprehensively analysed and refuted – was that early Formalism which had itself been a reaction against the externalities of a then 'sociological poetics'. Medvedev and Bakhtin correctly identified this formalism as the theoretical consequence of Futurism, in which, as they put it, 'extreme modernism and radical negation of the past is combined with complete absence of inner content.'[1] Yet they could see also what was both formative and positive in this bourgeois-dissident version of the modern and the avant-garde. In striking for art as autonomous, Formalism was simultaneously rejecting the reduction of art by the bourgeois social order (and with that the forms and institutions of established bourgeois culture) but also those forms of thinking about art which connected it with that or indeed any other social order. The great gain of formalism was in specificity: in its detailed analysis and demonstration of how art works are actually made and gain their effects. And there could then be no serious going back to applied general categories.

On the other hand, though, the move to specificity, for example in the ways in which the different arts visibly change through time, was beyond the formalist perspective. The best they could eventually manage, moving on from the hopeless cataloguing of a timeless repertory of styles – that staple of inert academic analysis – was the idealist notion, eventually to be urged again by what became known as structuralism, of systemic evolution within a still autonomous activity: the complex internal interactions of possible strategies and devices. Yet of course, as has continued to be overlooked by orthodox sociological poetics, this process in which working artists and writers – and indeed theoreticians – learn from, adapt, move away from, return to methods used by their specific predecessors, in quite other societies and historical periods, is itself undeniable and even crucial. What the formalist could not see was that this specific and complex process is itself historical; yet not a specialist history dependent on the given forms of a more general history, but a distinct historical practice, by real agents, in complex relations with other, both diverse and varying, agents and practices.

Thus the a priori rejection of history as relevant or even possible, which has distinguished this tendency from Formalism through structuralism to what has called itself post-structuralism, was actually a move away from some key forms of specificity, under the cover of a selective attention to those versions of specificity which Medvedev and Bakhtin defined as the Formalist assumption of an 'eternal contemporaneity'.

Moreover, and as a true effect of this, the expulsion of intention which had followed the translation of all content into form had a particularly abstracting effect. Excluding the real and serious pressures of the actual making of art, the formalists and their successors necessarily reduced the language of culture to a rationalism. As Medvedev and Bakhtin put it: 'They reduce both creative and contemplative perception to acts of juxtaposition, comparison, difference and contrast, i.e., to purely logical acts. These acts are treated as equally adequate to both the perception of the reader and the creative intention of the artist himself.'[3] It is very sobering to think that this was in (Russian) print fifty-eight years ago, long before the errors it identifies were again, and devastatingly, propagated as theoretical novelties.

As it happened, this critique, which marked a major theoretical advance, moved only partially and incompletely into direct analysis. Only Bakhtin, but then remarkably, was able to complete that kind of life's work. Formal analysis within a consciously historical dimension continued, but as a mode subordinate – perhaps still subordinate – to academic cataloguing and to those modes of formalism which until they were again theorized, in very much the original terms, found their practical base in specialist forms of criticism. These, meanwhile, were both less systematic and less fiercely exclusive of history, which was converted, as and when needed, to 'background': a new form of the old familiar polarization. Cultural theory, especially in its English and French-speaking sectors, then largely reverted to idealist and economist modes.

It is now necessary but obviously (for local reasons) difficult to look at another moment of initiative in cultural theory, which has been widely and indeed generously catalogued but too little analysed. I do not mean those loops in time – their slack, I would now hope, becoming more evident to everyone – in which a reinstated formalism offered ever more elaborate and rationalized constuctions of systemic production and evolution, or where a reinstated idealism found a new general category – ideology – which could be applied in essentially undifferentiating and unspecifying ways to the most general forms. Compared with these, the widening stream of empirical studies, in forms and changes of the position of artists and even more of publics and audiences, and their eventual theorization in forms of reception theory, were moving in useful directions. But I am thinking past these to a very specific moment, in Britain, in which cultural theory of an elite idealist kind was interacting with a very deliberate development of empirical cultural studies, including the now influential new media, and this within a complexity of class relationships which had much to do with the eventual theoretical outcome.

It is true that this work was in all its early and middle stages well behind other significant projects. The work of Gramsci on cultural formations had been a major advance, especially in its historical and analytic elements, though the theoretical indication of types of formation was still relatively simple. Again, there had been the important practice of the early Frankfurt School in Germany, which had genuinely found, though on its own distinctive base – radically influenced by psychoanalysis – new and penetrating methods of formal-historical analysis. The work of Benjamin, early Adorno, Löwenthal and others was a striking advance, which cannot be cancelled by – though it has to be separated from – the eventual and enclosing, even self-cancelling theorization of its survivors, in radically changed and dislocating social and historical situations: their strange reinstatement of the autonomy of art in what was in effect the ending of significant history by the development of what they called 'mass society' – a rejoining of what had been a Marxism to the central bourgeois theorization of its own crisis.

The point is apt in that the English theory which accompanied the intensive early empirical investigations was already, rather earlier, of this kind. History, in effect, had become a general topical term for decline and fall. Even historical investigation was at once intensive and terminal. It is here that the actual and developing class relations were decisive. For in the 1930s, notably in *Scrutiny*, this was the work of a marginal petite bourgeoisie, which combined the general fatalism of its class with an aggressive campaign against those who were shielded by establishment or privilege from recognition of the true depth of the crisis. It is this double character of what emerged, though unsystematically, as theory which explains both the continuity and the discontinuity into the next phase. The continuity was, first, in the intensely practical emphasis on the specificities of art: that element which properly resisted, and continued to resist, the broad generalizing applications of epochs and categories. The continuity was, second, in the general area of rejection of established and privileged accounts: an emphasis which connected, powerfully, with all those who were coming into higher education from classes largely excluded from it, as well as – at first sight – with the radical politics of these and others. Yet it was also in this precise area that the discontinuity was to be based.

For by the late 1940s and notably the 1950s the newly spelled-out social consequences of the underlying theoretical position came to be in sharp conflict with the deeply formative social and political beliefs and affiliations of a new generation of students from working-class families and of other socialists. It is easy now to say that this should have happened much earlier, when Leavis and *Scrutiny* were attacking Marxism and yet when many Marxists shared not only literary-critical but

anti-establishment cultural positions with them. One reason, which lasted well into the postwar period, was precisely the advantage in specification – so notable in contrast with economist or idealist left applications – which in the twenties in the Soviet Union had led the Vitebsk group to recognize the same advantage in the formalists, by contrast with more official Marxist versions.

Yet the key area in which a discontinuity, and eventually a break, came through in Britain was of a different kind: not the turbulence and diverse construction of an actual revolutionary society but the quieter yet still tense area of a changing and contested structure of public education. It has been noticed, but not, I think, analytically, that the leading figures of what came to be called, in this and related areas, the British New Left had chosen to work, in these critical years, in adult education. This was the social and cultural form in which they saw the possibility of reuniting what had been in their personal histories disrupting: the value of higher education and the persistent educational deprivation of the majority of their own originary or affiliated class. The practice of actual adult education, at the edge of a largely unchanged establishment, was to be complex and even in some ways negative, but the intention is still very clear. Moreover it can be usefully contrasted with the dominant initiative of the otherwise continuous educational perspective of *Scrutiny*, where the site chosen was the grammar school with lines of minority connection to the existing universities.

This contrast between the attempt at a majority education and the – in fact more successful – attempt to enlarge a significant cultural minority has an almost exact correspondence with the break in cultural theory of the late 1950s. Moreover, and interacting with this, the break in European communist movements from 1956 released some members of this tendency from the cultural emphases which still passed as Marxism: at its best an alternative selective tradition, which was however simply counterposed rather than theorized; at worst formulaic applications of economism or populist idealism. In some individuals, of course, this break had come some years before the open political fragmentation.

One of the advantages of the whole shift that was made especially possible by the political break was the inpouring of a whole range of less orthodox Marxist cultural theory from elsewhere: work of the most serious kind, from Lukács and Goldmann to Gramsci and Benjamin and Brecht. A still relatively untheorized new position now began to interact with several (in fact alternative) forms of this work. Yet within a few years, in one of those awful loops in time which may, on further analysis, be properly seen as explicitly anti-popular and anti-radical (but then with the necessary disguise, as earlier, of an avant-garde rhetoric), this developing theoretical argument was overridden and for perhaps fifteen

years obscured. There was a simple recrudescence of early formalism, running from the United States through France, but much more damaging were the accommodations with it now made by a self-consciously modernist Marxism. In this great period of inpouring, nothing, or virtually nothing, was heard from that lost moment in Vitebsk, though its significant identification of Formalism as the theorization of Futurism – that precisely violent but empty and unaffiliated moment – could have saved many wasted years. An essentially undifferentiated avant-garde in culture, which already between the wars had shown its formational and political range from revolutionary socialism to fascism, and more directly, in art, from new forms of exploration to new forms of human reduction, was offered as the cutting edge of what was reputedly new theory. Undifferentiated rejections of 'realism' and of 'humanism' were catatonically repeated. The precise mix of incompatible theories which had been confronted in Vitesbsk – a version, now increasingly false and misleading, of Saussure in linguistics; a version of individualist human sources and intentions from Freud and psychoanalysis; a rationalized abstraction of autonomus systems, which had been the theoretical defence of those bourgeois dissidents who had primarily constituted the avant-garde, against not only bourgeois society but the claims of any active, self-making (including revolutionary) society – this precise mix now poured over Western cultural theory and radically altered its intentions of practice.

For what was now also the case, by contrast with the problems of relatively lonely tension and emergence in the 1950s, was that a version of a reformed and expanding public education was coming through, in the new universities and polytechnics, as the key site. At the same time, the importance of new media, and especially television, was changing all received definitions of majority or popular cultural enterprise. In terms of practice, what happened between the 1960s and the 1980s was in the main a brave and sustained attempt to enter the new forms with new kinds of cultural production: whether as new content and intention within the dominant media, or as a surge of independent and marginal enterprises, from roadshows to video and community publishing. This body of practice, uneven as of course it has been, needed theory, even when it was most on the wing. It indeed cited, from time to time, general positions or aspirations from the arguments of the late 1950s. But the theory it practically coexisted with was just that body of work, often strenuous enough intellectually, which was deficient above all in this key area, of the nature of cultural formations and thus of ongoing agency and practice.

It was here (it is a point that applies in different degrees to all of us) that for all its own often useful energies the new centring of theory

within what were still minority educational institutions had its worst
effect, including upon itself. Blocks of ideology could be moved around
in general historical or cultural analysis, but in practice – and as what
anyone next actually does – they lacked almost any useful form of speci-
fiable extending agency. Again, it had been shown in Vitebsk that a
literary work is invariably full of content and intention just because it is
also a specific disposition within a specific form. Yet what was now
again being said, by nearly everyone, was that specification depended on
the excision of such naiveties as 'external' content and agency, and the
name for this specification was *text*. Ironically this was from the same
vocabulary as the academic 'canon'. A text: an isolated object to be
construed and discoursed upon: once from pulpits, now from seminar
desks. Nor could it make any useful difference when this isolated object
began to be opened up to its internal uncertainties and multiplicities, or
to the further stage of its entire and helpless openness to any form of
interpretation or analysis whatever: that cutting loose of readers and
critics from any obligation to social connection or historical fact. For
what was being excluded, from this work reduced to the status of text or
of text as critical device, was the socially and historically specifiable
agency of its making: an agency that has to include both content and
intention, in relative degrees of determinacy, yet is only fully available as
agency in both its internal (textual) and social and historical (in the full
sense, formal) specificities.

Of course in practice many other things went on being done, both
because there were so many different kinds of people and because the
whole period – which I am now, at least programmatically, taking as
ended – was marked by an extraordinary eclecticism and by very rapid
theoretical and quasi-theoretical – not to say merely fashionable – shifts.
Yet the key task of all theoretical analysis is identification of the matrix
of any formation, and here the affiliation is clear: there were texts
because there were syllabuses and there were syllabuses because there
were institutions and there were institutions of that only marginally open
kind because the drive for a majority public education of the most
serious sort, as part of a more general democratization of the culture and
the society, had been first halted, leaving an expanded but still privileged
and relatively enclosed space, and then in the counter-revolution of the
last ten years – from Callaghan to Joseph and Thatcher – pushed back,
spreading unemployment and frustration among a generation which was
still, on the whole, theoretically contained by the protected and self-
protected modernisms of the intermediate stage.

It is from this condition, not in spite of the cuts and pressures but
indeed because of them – the disruption of what had seemed and in
many of its theoretical elements actually was a stasis – that we have now

to break out. Most of this will be done, if at all, in ways quite other than
cultural theory, but it is still important – as we can recognize even from
the story of Vitebsk, within dislocations and pressures much greater than
any we now confront – that at least theory does not *hinder* anyone.

For imagine what might have happened if that brief major inter-
vention of the late 1920s had succeeded not only intellectually – as in
my view it so decisively did – but socially and politically. Its emphasis in
specification and on real as distinct from imputed social and cultural
formations would have offered key resistance to the bureaucratic
imposition and rationalization of an applied and externally determined
art. At the same time, by linking artistic specificity to the real and
complex relationships of actual societies, it could have ended the
formalist monopoly of those kinds of attention to art and its making
which practitioners above all, while they are working, must value. This
would not only have prevented the relapse to an unfounded idealism of
'art for art's sake'; it would have foreclosed the discovery within a
revolutionary society, or indeed any working society, of this so much
more convenient an opposition: one relatively easy to dispose of, in hard
times, when what is then actually also being disposed of is the necessary
working independence of any artist. We have paid, all of us, and in areas
far beyond art, for that failure, which was also, as far as it went, so strik-
ing an intellectual success.

Related issues now again matter. I began by asking what significant
cultural theory can be and can do. This question is still more important
than the internal history of any phase of theory, which becomes useful
only at that point where it identifies key linkages and key gaps within a
real social history. The picking over of texts and individuals, from above,
which is the worst legacy of academic criticism, and which determined
the tone, the complacency, of a whole generation of dependent exegesis
and critique, has to be replaced by the practice of an equal-standing
involvement, including in new works and movements. Or to put it
another way, in the words of Medvedev and Bakhtin: 'Works can only
enter into real contact as inseparable elements of social intercourse
It is not works that come into contact, but people, who, however, come
into contact through the medium of works.'[3] This directs us to the
central theoretical question in cultural analysis: what I defined at the
beginning as analysis of the specific relationships through which works
are made and move. It is an explicit and challenging contrast to what has
been a dominant mode, which John Fekete defined in this way: 'The
variants of the language paradigm offer a definition of human life that
invites us to be satisfied with the brute factuality of the multiplicity and
serial succession of symbolic and institutional systems, whose signifi-
cance we have no standards to evaluate and about which nothing can or

need be done.'⁴ Certainly that 'brute factuality' declines, within privilege, to mere play: nothing actually brutish, but multiple games.

Yet the 'language paradigm' remains a key point of entry, precisely because it was the modernist escape route from what is otherwise the Formalist trap: that an autonomous text, in the very emphasis on its specificity, is, as Voloshinov had shown, a work in a language that is undeniably social. The Formalist move to 'estrangement' was similarly an ideological substitute for the more complex and diverse actual relations, in different social and historical situations, between the shared language and the still, in whatever obliquity of relationship, sharing work. It is then precisely in this real work on language, including the language of works marked as temporarily independent and autonomous, that modern cultural theory can be centred: a systematic and dynamic *social* language, as distinct from the 'language paradigm'. This was already clear, theoretically, in Voloshinov's work of the late twenties (*Marxism and the Philosophy of Language*). And then with the return of language, in any full sense, we enter the most available evidence of the full and complex range of agencies and intentions, including those agencies which are other than analytic and interpretive: creative and emancipatory agencies, as in Fekete's correct emphasis that 'the *intention* of emancipatory praxis is prior to interpretive practice'.⁵ Precisely so, because any such social or cultural or political intention – or, we can say, its opposite – is drawn not, or at least not necessarily, from the objects of analysis but from our practical consciousness and our real and possible affiliations in actual and general relations with other people, known and unknown.

What then emerges as the most central and practical element in cultural analysis is what also marks the most significant cultural theory: the exploration and specification of distinguishable cultural formations. It has of course been necessary, within corporate-capitalist and bureaucratic societies, to analyse the more sociologically manageable institutions of culture. Yet unless more specific formations are identified this can decline into such abstractions as the 'state ideological apparatus', or the still relatively loose 'traditional' and 'organic' intellectuals. It is often as much in movement, tension and contradiction within major institutions as in their undifferentiated dominance that we find the significant specific relations. Moreover, since our kind of society began, and especially since the late nineteenth century, it is a cultural fact that relatively informal movements, schools and campaigning tendencies have carried a major part of our most important artistic and intellectual development. What we can learn from analysing these historically, from the Pre-Raphaelites to the Surrealists, from the Naturalists to the Expressionists, can then be taken forward to try to analyse our own

actual and changing formations. What we learn above all, in the historial analyses, is a remarkably extending and interpenetrating activity of artistic forms and actual or desired social relations. It is never only a specifying artistic analysis, though much of the evidence will be made available through that, nor only a generalizing social analysis, though that reference has to be quite empirically made. It is the steady discovery of genuine formations which are simultaneously artistic forms and social locations, with all the properly cultural evidence of identification and presentation, local stance and organization, intention and interrelation with others, moving as evidently in one direction – the actual works – as in the other: the specific response to the society.

There is intellectual satisfaction in this kind of analysis, but as it is theorized we know that it also involves us directly, in our own formations and work. Thus I could say that what has been most remarkable in the last thirty years is the energy and proliferation of a diversity of radical artistic and intellectual initiatives: that liveliness which is real and which might be reassuring if we did not have to remember, for example, the comparable liveliness of Weimar culture in the 1920s, which had also gone as far as its Red Shirts and its Red Rockets and which was not only repressed by Hitler (the constant political warning) but which, when it came under pressure, was shown to have been all along a double-edged vitality, unified only by its negations, as throughout the whole period of the avant-garde.

Are we now informed enough, hard enough, to look for our own double edges? Should we not look, implacably, at those many formations, their works and their theories, which are based practically only on their negations and forms of enclosure, against an undifferentiated culture and society beyond them? Is it only an accident that one form of theory of ideology produced that block diagnosis of Thatcherism which taught despair and political disarmament in a social situation which was always more diverse, more volatile and more temporary? Is there never to be an end to petit-bourgeois theorists making long-term adjustments to short-term situations? Or, in the case of several kinds of recent art, can we raise again the question whether showing the exploited as degraded does not simply prolong the lease of the exploiter? Are we not obliged to distinguish these reductive and contemptuous forms, these assayers of ugliness and violence, which in the very sweep of their negations can pass as radical art, from the very different forms of relating or common exploration, articulation, discovery of identities, in those consciously extending and affiliating groups of which, fortunately, there have been at least as many? Can theory not help in its refusal of the rationalizations which sustain the negations, and in its determination to probe actual forms, actual structures of feeling, actually lived and

desired relationships, beyond the easy labels of radicalism which even the dominant institutions now incorporate or impose?

Through a hundred local tangles and rivalries these questions can, I believe, be positively answered. The central problem of actual and possible class relationships, through which new art and theory can be made, has a new and in some ways unprecedented complexity, but in practice – and surely now as a decisive bearing – there is a mode of formation based primarily on location, for example in the English cities and in parts of Scotland and Wales, where the cultural and artistic intention is shaped, from the outset, by the acceptance and the possibility of broader common relationships, in a shared search for emancipation. Of course we have also to move between and beyond these identifying formations, but the more usefully as we carry their strengths as ways of refusing and opposing the systematic dislocations, the powerfully funded alienations, which are now the true source of the whole formalist tendency and its arts in a late bourgeois world, and which everywhere stand waiting to displace and to divert our diverse actual confusions, pains and anxieties. And then the challenge comes in theory as clearly as in everything else: this our content, this our affiliation, this our intention, this our work; and now tell us, for or against – and it will run both ways – each of these of your own.

Notes

1. M.M. Bakhtin, P.N. Medvedev, *The Formal Method in Literary Scholarship*, Harvard 1985, p. 171
2. Ibid., p. 170.
3. Ibid., p. 152.
4. John Fekete, ed., *The Structural Allegory*, Minneapolis 1984, p. 244.
5. Ibid.

APPENDIX

Media, Margins and Modernity

Raymond Williams and Edward Said

Raymond Williams: Sometimes, and it should be always, a method of analysis, on which you can base a method of teaching, is put to the hardest test of practice that you have to find it somewhere on the ground. It was extraordinarily encouraging to me that the analysis of the country house which I had written in *The Country and the City*, in a very general way, about country houses in general – a history I was fairly confident in but I had no particular place in mind – found a quite extraordinarily accurate, rich embodiment in Tatton Park, which Mike Dibb found, when he was thinking of making the film.[1] What had been a quite general, indeed academic analysis of the development of these houses, of the sources of their income, of what they did to the real country, was there on the ground with a richness which one could hardly have expected. Who could have believed that we would find a country house which had been made out of a city fortune in colonial trade, which had obliterated an old, real English village and turned it into a deer park? And which then, through accidental inheritance, got that precise part of South Manchester which was where Engels had written *The Condition of the Working Class in England* in 1844? Who could have thought that that was so clearly on the ground? But any analysis, however academic and theoretical, has to submit to that kind of test.

Of course it could still be a correct analysis and you couldn't find any one place which would exemplify it. But I think this is one of the problems in intellectual work now, that at a certain level one has to do the work at a very considerable professional standard, just because one is contesting an established culture. At certain levels the established culture is stupid, and at certain other levels self-interested, but it includes some good and often some tough and increasingly some

177

aggressive professionals serving a different interest. This means that a
commitment to a democratic and popular education, which has to take
place on the ground and which has to be looking for communicable
ways, had nevertheless to include work of this, at first, apparently
remote and difficult kind.

So the first point I want to make is that there can be – one should
gain confidence from this – ways of embodying in directly teachable and
viewable material, analyses which in their first work at a research level,
or in their first presentation (*The Country and the City* is not an easy
book), may be relatively inaccessible. We should not, I think, under the
pressure of the problems of everyday teaching and the very real
problems of communication, give too much credit to what is sometimes
a rhetoric among us, that because the problems of direct popular teach-
ing and communication are so urgent, the other kind of work can, so to
say, be done on the side. Of course it's a different matter if such work is
moving, as some recent work has done, so far from any possible contact
with reality on the ground that one could conceive no empirical test for
it. I am thinking of certain positions that circulated in the universities a
few years ago. I first heard of them when one of my graduate students
said: 'You mentioned the word *history* just now. Do you mean you
believe there *is* history?', in a rather pitying way to one of these old
fogies, you know, who have still got this curious notion that there has
been a material past. The sort of current he represented (fortunately
he'd forgotten it a couple of years later) could never meet this kind of
contact with reality and therefore its communication, which of course
that sort of theory also eventually ruled out as impossible.

But we can be committed to what can be sometimes the most intract-
able material, at the level of exploration of difficult kinds of conscious-
ness, complex imagery, complicated history – and still there can be that
kind of connection right the way through to material which is very
directly communicable.

And the other way, I think, that a method of analysis is put to a very
hard empirical test is this: if we are saying, as I think both Edward and I
are, that the analysis of representation is not a subject separate from
history, but that the representations are part of the history, contribute to
the history, are active elements in the way that history continues; in the
way forces are distributed; in the way people perceive situations, both
from inside their own pressing realities and from outside them; if we are
saying this is a real method, then the empirical test it's being put to here
is that comparable methods of analysis are being applied to situations
which are very far apart in space, have many differences of texture, and
have very different consequences in the contemporary world. There is
an obvious distance from what is happening in the English countryside,

or in the English inner cities, to the chaos of Lebanon. Yet nevertheless I think it is true that the method, the underlying method, found a congruity. Not to flatten the history into a source of images, because that was not what I think either of us were doing, but to say: 'If you analyse the representations with the history, if in the representations you trace their sources, you see what is absent from them as well as what is present. And you then also see how the form of these images actually contributes to the way people perceive, and act within, those situations.' If we say this about a method of analysis, then we must put it to this test of applying it to two very different geographical, historical locations. And it seems to me to work. For example, I was able to look at the case which was not my own more objectively. One could see that tracing the sources of the images and the representations, in this consciously historical, analytic and finally political way, was successful as a method, and was therefore something available not only for analysis but for teaching.

So, those are my two points: that I think a method of analysis, often initially of a strictly academic kind, can find concrete embodiments which are more teachable and viewable and communicable beyond a narrow academic milieu. And second, that you can test the method of the analysis of representations historically, consciously, politically, in very different situations, and find that – subject always to argument about this detail and that – the method stands up.

Edward Said: What I'd like to contribute is, to a certain extent, an embellishment or further expansion of what Raymond was talking about, except that I'd like to come at the topic from a different point of view. For the problem of representation that we both were dealing with, that is to say how you get images that acquire a great deal of power, at the same time shedding or incorporating their history in various ways, is from my point of view a problem really of dealing with what, for want of a better word, one could call specialization or compartmentalization. For instance, in my own professional field and background – which was literature, and English literature in particular – I had realized that as one develops professionally, goes through the steps of a career from education to employment and then within employment to advancement, the tendency is – unless one resists this very consciously – to narrow oneself more and more, and separate off from earlier experiences in various ways. One is even *forced* to do that, though by forcing I don't mean that it's a coercive thing necessarily – simply that it turns out to be worth one's while to do so.

And in my own case – it's pathetic in a way, and perhaps amusing too – my particular background, which is in the Middle East, was precisely that which I had to jettison in order to become better at, or more 'pro-

fessional' in, the study and teaching of English. And that in turn led on, because of circumstances in the real world, as it were, to a general understanding of my background and the background of many like me whose lives had become in fact compartmentalized by – to borrow a phrase from Raymond's film – processes that took place elsewhere. So that I grew up in the Middle East knowing more about Britain than I did about the country in which I was growing up; knew more about its history and so on, and even knew its language better. And so this process of separation was very important to me, and it generated the need to reintegrate somehow these facts and processes and experiences. In fact, it then led me to a study of another field, which in the university has been separated off completely. The fields there are all completely divided up – I'm speaking of the American situation, which is probably a magnification or intensification of what occurs here, I assume. But the whole point was to say in response: look, these are *not* separate things. They may appear to be separate and images may be just images, but in fact they have a relationship to things that appear to be distant. In the case in point there is a particular kind of relationship between Europe and the Orient. What then about looking not so much at the relationships *only*, but also at the problem of connecting them. In other words, the whole problem of access to them, to these relationships which have been either hidden or protected or denied.

For instance, in the film we've just watched, the scene in Jerusalem at the beginning – the magic carpet and the images of the people running across the desert – is accessible to everybody. Now that Jerusalem sequence was filmed by Geoff Dunlop and a crew when I wasn't able to be there. And quite by coincidence, if you like, the next scene into which it fades is of the boy being arrested in the city – a coincidence, but it made the point that these things are connected. And the problem of access or of being denied access is there too. Similarly, in other parts of the film, as when we show the scene in the castle of Beaufort. This is filmed, as it were, from the Palestinian viewpoint, when the camera speaks to those two young Palestinian men. That was done in the early part of 1982, and the scene was filmed again after the Israeli invasion when for obvious reasons I couldn't go to Lebanon which is where part of my family live. (My mother lives there at any rate now.) So the whole background of this rather complicated and in a complex way accessible and inaccessible matter is fused through the medium of film, and makes a point that couldn't actually be made experientially but *can* be made through a film, which is of course a continuous form.

So the first and the main point I'd like to make is this whole problem of exclusions, compartmentalizations, which work in many different ways. Representations may seem to have a kind of floating life of their

own but they need always to be anchored back in the realities that produce them. And this is crucial because in America now for instance there's a tremendous emphasis placed upon what is called both expertise and objectivity and more particularly, in my field, humanism. Humanism has become a codeword in the Reagan years for ethnoparticularism, ethnocentrism and patriotism – that is to say, what 'we' want to do is to feel more confident and happy about our Great Tradition, and the Secretary of Education, William Bennett, has recently published an important screed in which he says 'we' should reclaim our tradition. Everybody should be required to read the twenty great works, you know, Homer etc, or from Plato to Nato. More or less saying this is what *we* are, and the rest of the world *isn't*. So all of these exclusions and emphases and affirmations occur, and what gets lost, obviously, is any kind of connection. And it's done not only in the interest of patriotism, but, more alarmingly, also in the interests of objectivity. These local, interested positions are presented as Unquestionable Realities – the very word 'unquestionably' or 'undoubtedly' keeps coming back in this discourse.

Yet I couldn't really accept myself as part of that without denying a lot about myself. I'm sure that's true of everybody, but perhaps it's more dramatically true of somebody who is a Palestinian. So the second point I'm trying to make, is the urgent need to make these connections not simply as 'objective' but as alternatives. Certainly in education and writing, and looking at materials such as this, one proceeds in a responsible, disciplined way, looking at evidence and so on. But also connecting them in ways that rely upon human intervention, that are alternative and both challenging and challenged, articulated from the point of view of the student or the outsider, and thus giving others a chance to see another view – that other view is precisely what is so often missing. I don't mean 'balance' because that is another kind of fetish, if you've got one side you've got to have the other side. But what I do believe is that one should present these alternatives responsibly; I insist upon this.

This is in effect my third point. For my work since *Orientalism* has really depended very much on Raymond's work, or one sentence in Raymond's work which I always struggle to realize but by the end of the book I've just got to the point where I can begin to tackle it, and I perhaps still haven't fully done so. That is – though I forget where you say this Raymond – the need to unlearn the inherent dominative mode: the kind of badgering, hectoring, authoritative tone which has even come through in Cultural Studies. In challenge to that, we must find a rather more critical, engaged, interactive, even – though one hates to use the word dialogical because of the recent cult of Bakhtin – a dialogical approach, in which alternatives are presented as real forces and not

simply to provide a kind of balance leaving, of course, the holder of the balance invisible behind the screen – the person who really has the power. And this can only ultimately be done in a collaborative or cooperative way. This is the last, perhaps the most important point I'd like to make. The great horror I think we should all feel is towards systematic or dogmatic orthodoxies of one sort or another that are paraded as the last word of high Theory still hot from the press.

I mentioned for instance the interest in Bakhtin, but it could equally have been the interest in many varieties of theory in the past two or three decades; you become a convert to them and see the world entirely through those eyes. But that is precisely what education at its best tries to question and evaluate and also to dislodge and provide alternatives for.

Question: *I'd like to ask you, how would you find an opening for religious perspectives to be accommodated in the analysis of the text? I have been fascinated by some of the work of the Marxist critics and Russian Formalism, which to me doesn't seem to really be Marxism, but it does offer a way to think of the text as itself, as an important thing in itself. Marxist perspectives don't exactly accommodate our traditions, especially traditions either in the Middle East or here in the West. Because those perspectives are very much religious perspectives, if you think of a people's culture as including religion. How do you suggest ways of accommodating religious values, religious cultural symbols, etc., into your analysis of a text in order to do justice to the actual world as it is?*

Edward Said: I feel rather strongly and programmatically that what I'm interested in is what I call secular criticism. I'm really not interested in the elucidation of ideas of the Divine or of the sacred, except as they are secular facts and historical experiences. And there's a particular reason for my attitude, since I believe in all sorts of ways that – and perhaps this is excessive, but I don't think it's completely irrational – that the amount of heat as opposed to light generated by religious practices has, at least in my experience, produced a lot of the things that I wish never had happened – to put it as mildly as I can. And therefore I think it's important also to mention that in cultural and literary studies there is a quite striking return to, if not religious practice, at least to religious ideas. Recently, for instance, there was a great, tremendous, trumpeting attack upon modern critical theory in the *Times Literary Supplement* by George Steiner. His idea – not one unique to him, although he states it, I would have thought, in a rather unique way – was that there had been a loss of the sacred and we should return to it, that art can only be

understood in terms of the divine and religion. Well, I'm completely opposed to this notion. And certainly in the field of criticism, its consequences have been for the most part rather disastrous.

Raymond Williams: Could I come in on this on the wider theoretical point? It was very significant in that row at Cambridge a few years ago that the majority opinion chose the phrase the 'literary canon'. I mean that borrowing from Biblical studies was extraordinarily interesting because the question of what is a canon in scriptural writings, which are held by some to be works of literature and history and by others to be divinely inspired, is something that can hope to be settled by scholarship, by comparison of origins and dates and so on. Now what was being represented, in borrowing that word – it was a very significant, I think probably unconscious, transference – was the notion that there was something unchallengeably authoritative about certain literary works which isolated them from any kind of alternative reading or examination, and which also closed off other kinds of approaches to them. Here precisely what was being excluded was a mode of reading which didn't begin with the notion – it's not too much to say – of *sacred* texts.

Now I would like to relate that approach, which has come through mainly in this country as the resistance of stubborn traditionalists, to what is in fact a very close position which has represented itself as the new challenge. First, it's a cultural study in itself how what is known, usually wrongly, in this country as Russian Formalism, made its way through curious emigrations and exports and reimports to be a highly selective version. I mean that what most people know as formalism, and what they reproduced in the sixties and early seventies, is a very early phase which was, however, translated and publicized well before the rest of a powerfully continuing argument – which is absolutely decisive for understanding it – was introduced. It is a complex story worth unravelling in itself, and it still has its effects on people's ideas here because the simple version was so intensively propagated.

Formalism was a reaction against what was called in the early stages a crude sociologism, which never really looked at the work at all but looked at elements which could be extracted from it and handled in other transferred ideological terms, or else simply related a text to the conditions of its production. Now the first phase of the response to that is to say that however important those questions may be, we also have to look at what the work specifically is. And this insistence has to be understood within the context of the debate. We need then to look at the second stage of the formalist argument, in the mid and late twenties, in works which have received much less publicity. Works with that tangled authorship of Bakhtin, Voloshinov, Medvedev are much less well known

in the West, with the exception of Bakhtin recently, then Shklovsky and
Eikhenbaum and so on. It was agreed: let us look at what is specific in
the text. But looking at what is textually specific does not rule out, rather
it encourages, new ways of exploring the relations between the creation
of something very specific and these more general conditions. Then, as
against the previous practice which had not looked analytically at the
work but which had gone straight to what was extractable as ideology or
as general social conditions of authorship, let us indeed go specifically to
the text as a way of finding new methods of analysing the relations
between its precise composition and these conditions.

Now this kind of work is what has been called, in Britain especially,
Cultural Studies. I mean the break of Cultural Studies in the fifties from an
earlier kind of sociological and indeed so-called Marxist study was
precisely that it started from the close analysis of works. The contrast
couldn't be more marked with earlier positions which had postulated a
bourgeois economy and then a bourgeois ideology, then certain texts
which reproduced bourgeois ideology. Whereas, if I can take the
example of my analysis of the country house poems, this starts from the
texts themselves. It starts from analysing in 'Penshurst' a formal
sequence of negatives, which is a very important clue to the specific
literariness of that poem. But what it does not do, what it refuses to do,
is to stop at that point. Now precisely the version of formalism that was
imported and intensively propagated was to say 'and when you have
done that, there is no more to do'. Although in fact the second stage of
the formalist argument that was lost from the late twenties, and that is
still not properly perceived and understood, was that when you have
done that, you then have the problem of finding ways in which to
analyse those specificities of the work or text, which uncover new kinds
of evidence that weren't available by other methods. Then you can ask
in new ways, how is the specific *kind of literariness* produced? How are
certain forms produced? How do certain negations and absences which
can be well identified by formalist methods constitute themselves in the
social and historical structure? And suddenly you're into a new kind of
inquiry.

But just at the moment that this work was making progress, back
came – in a fifty-year historical delay, going via the United States and
France and reappearing intensively propagated here – the old first stage
of the argument, as if there had been no move beyond it either by that
Leningrad School of the late twenties, or in many of the developments in
Cultural Studies in the West. The new formalism started as if it were
fighting an enemy which no longer existed: the enemy which did not
start analysis from specificities, but postulated the big abstractions of a
society and economy and ideology, on a base-and-superstructure model,

and then deduced the work, leaving many of the facts of the composition of the work unaddressed. And then we were asked to choose in this absurd way between work which was very specific within the texts and which said it didn't interest itself in other questions, and work which was still projected as talking only about reading publics, audiences, social conditions of writers or the most general facts of history. Yet in fact the other real work had been done.

One is then very sad when the kind of propagation of theory that went on – including incidentally the reference to Saussure which was almost entirely misleading, even at times fraudulent, because it was never the representation of the whole of what Saussure had said – takes over from the development of actual new work. It's a very long and difficult job, how to carry through this very powerful task, which is to see how, in the very detail of composition, a certain social structure, a certain history, discloses itself. This is not doing any kind of violence to that composition. It's precisely finding ways in which forms and formations, in very complex ways, interact and interrelate. That was what we were doing. I think the interruption is now over, but I do want to say that I think it has been extraordinarily damaging, especially since theory – so-called – is much easier than this actual analytical work. You only have to read the five points of formalist technique or the three distinguishing marks of a dominant ideology; I mean you can write it in a notebook and you can go away and give a lecture on it the next day. Or write endless books about it. It's an extraordinarily easy intellectual practice. Whereas this other analytic task is difficult, because the questions are new each time. And until the last few years there was this very complicated business of finding your way around what was called Theory. It failed to understand what kind of theory cultural theory is. Because cultural theory *is* about the way in which the specifics of works relate to structures which are not the works. That is cultural theory and it is in better health than it is represented.

Discussion

The first question is to Raymond, about compartmentalization in relation to his own work, and why he's kept his novels and his criticism separate for such a long time.

Raymond Williams: A very interesting question, the notion that *I* have kept them separate, [*laughter*] I wrote them and sent them off to publishers, and they more or less made their way out. I think what happens is that there is a particular 'set' within which you are read, and

people find your name on a reading list and then that's within a given context to which they expect you to contribute, so they almost read out certain things . . . and one of the great advantages of being called Williams is that you can be thought to not be the one who wrote those long academic books [*laughter*].

I have never tried to separate them. I mean, they always seem to me to be deeply connected, and I have said that what I learned in writing *Border Country*, the first novel, which went through seven rewritings, was the first real insight into how form, literary form, is determined by a particular social, ideological set of expectations. When I started to write it in the late forties, there was clearly a place still for the novel of working-class childhood which was, so to say, pre-formed to end with the person leaving a working-class environment, going right away from it. The classic of this is still, after all, Lawrence's *Sons and Lovers*, and indeed when it was said that a wave of working-class novels came out in the fifties and sixties, it's amazing that the majority of them included that form – childhood, adolescence and going away – that Lawrence movement of walking towards the city with all your life ahead of you. The working-class experience has been important, but it is something you remember from a distance. Now, everytime I tried to write *Border Country*, although the material was different, it came out that way. But I couldn't accept it. I mean it doesn't require much thinking to realize that the working-class parent who is a characteristic figure in that kind of novel was also a young man or a young woman, with particular perspectives making that history; they weren't just important as the parents of the child. And if they are only perceived as the adults to whom the adolescent is responding, an important part of their experience is lost. But what if that form is already deeply there, and in interesting ways you don't know you are following it until you find in the writing that it's coming out like that? I think this is the truth about deep forms in a culture. Another element of this form of working-class experience is that you get a sensitive, bright child in this deprived environment. The world of working-class adult work is not in the same way present in that kind of novel. So what I kept doing was to rewrite it, so that the father was also present in the novel from the beginning, in effect as a young man, although he ages through the novel and the climax is his death. Still, he is there a young man in the same way as the son is a young man, and until that is so, you have not altered the stereotype.

Now I am saying that it was the experience of struggling with that form that first gave me the ideas I have often written since theoretically: about deep cultural forms, about structures of feeling, all those things that are theoretically there. But then if you are within an academic environment you write those things and curiously they communicate,

and they then stereotype *you* in turn. You know, you write literary
criticism, you write literary history, you write cultural theory, com-
munications, and so on. And this other – it's also of course very
common in English academic departments – this other, this fiction, is a
sort of side amusement.

So, I am not going to plead guilty to the charge of keeping them
apart. Perhaps in a way I have let them interact too much. There have
been times when I've had to set aside one or the other because the
presence and mood of one was pressing too hard on what has to be
another pressure and mood. You do have to keep the forms distinct.
They are different forms but not in the sense that the author is wishing
to separate them.

*The next question is specifically to Edward Said, but there are ways in
which certain of the themes that Raymond has just mentioned in relation
to autobiography will keep on emerging. It asks in what way you have
incorporated the autobiographical into your work outside this instance of
Geoff Dunlop's programme and its introduction to* Orientalism.

Edward Said: Everybody who begins to write in an academic setting
obviously picks subjects that are close to him or her; I don't think it was
an accident that the first book that I wrote was about Conrad, and I have
been very interested in and haunted by Conrad all my life. One needn't
say more. Yet, as I stressed in my presentation, a great deal of what I
consider to be interesting and valuable experience autobiographically,
had to be kept away professionally. It was certainly the case when I was
beginning to teach at Columbia that I was really considered two people
– there was the person who was the teacher of literature and there was
this other person, like Dorian Grey, who did these quite unspeakable,
unmentionable things. If I could give an example: I was very friendly
with Lionel Trilling, who had his office across the way from mine, and
he was very kind and solicitous, and I have always liked him a great deal,
but we never once, in the fifteen years that we were friendly, let these
other matters come up; and I trained myself to live that way.

It wasn't until later that I began to realize how much I was interested
in the fact that one could compartmentalize oneself in many different
ways. And the problem is then not so much of integrating the fragments;
I am not sure one can integrate disparate things, you tend to lose bits of
them if you try and look for formulae that will do that. But here really is
the theme of my work, its main 'figure' if you want to give it a poetic
equivalent, the figure of crossing over. Raymond too, of course, has
written about boundaries and borders. The fact of migration is extra-
ordinarily impressive to me: that movement from the precision and

concreteness of one form of life transmuted or imported into the other.
Obviously I began to try to do this in *Orientalism*; but I wrote *Beginnings* before that, in which I thought about the need for postulating
beginning points, in what was in a sense an almost immediate dissenting
reaction to Frank Kermode's *The Sense of an Ending*. Clearly before
you had endings you had to have beginnings!

I went on to an attempt – without wishing to bare my soul in a book –
to look at the history of this object which in a sense I had become and in
which I had participated; namely, the Orient or the Oriental. That led
me to the other side of the coin, to testify to a particular experience
which had been, as had many of the others, suppressed. Yet there is a lot
of complicity in these things; one doesn't get confined simply because
others are stronger than you; rather, in a certain way you participate in
it, I think, and I was interested in that fact as well. So I wrote about
Palestine, and then the main problem was of course the problem of the
media at that time. It was during the Iranian crisis, so I wrote a book on
the Iranian revolution. It is very difficult to live in these quite unrelated
worlds. You think you live as an academic and, of course, have political
and other affiliations which really run quite counter to this, and then
tend to be sometimes surprised at the way in which if you don't make
the connections others will. For instance, I gave some lectures about
imperialism and culture about a month ago, in Kent. During the course
of the third lecture, I think, I had some things to say about Fanon
because I was talking about the culture of resistance which begins to
arise in the colonial world, and then I passed on to other subjects. Then
the massacres at Vienna and at Rome occurred, and the *Observer*
published an article by their Middle East correspondent, Patrick Seale,
who did not attend the lectures. The title of his article was 'PLO Returns
to Terrorism', and mid-way through it he said, as an instance of this
changing mood of the Palestinians, that Edward Said had given a series
of lectures at Kent in which he talked about Fanon and the need for
revolutionary violence! [*laughter*] There I was, used as a kind of cover,
if you like, for those events. That happens a great deal. So it's not just a
matter of one's own wish to try to do justice to the different aspects of
one's life without reducing them to each other or vulgarizing them; it's
done for you.

Or again, the phrase Bob Catterall read this morning from my book
on criticism,* in fact in America is considered to be a highly inflam-

*'Criticism must think of itself as life-enhancing and constitutively opposed to every form
of tyranny, domination and abuse; its social goals are non-coercive knowledge produced in the
interests of human freedom.' (*The World, the Text and the Critic* p. 29)

matory phrase, probably a PLO code phrase for massacring. I am really quite serious, my book was reviewed in a magazine called *Contentions* (which gives you an idea) and most of what I said, even though I was talking about Matthew Arnold or Raymond Williams or whatever, was translated back into: kill all the Jews. I am not trying to put it as a semi-comic matter, it's actually quite scarey to discover suddenly that there is this other world which can do things with you; and America or New York is in this respect like an echo chamber. So on the one hand you want to deal with the problems that are of particular importance to you, but on the other you have to be careful of their being collapsed into each other after which they get out of control in some of the ways I have mentioned. But the last thing I want to say on this point, is to stress how exciting, in the process of doing this cross-connecting, are the other kinds of experience or work to which you are led outside your own narrow field, in my case professional English Studies; the discovery of work that means something to you that's been done in anthropology and in war fiction, in the Caribbean, in sociology. It's these linkages, after all, that one continues to work for, hope for.

The next question is a bit like an exam question to you both. Do you see yourselves as engaged in similar intellectual projects and where would you place your differences? [laughter]. *And because in conversation earlier we were talking about the way in which it was possible to obliterate the very specific differences between the United States and England, I wondered whether we might bring that in here as well.*

Raymond Williams: Perhaps that's the best way to talk about it! I am not going to be provoked into any differences I could think of with Edward. I am sure we'd find them if we talked long enough. And very nice it would be to talk about them. But I wouldn't want to lead with it. I did say something about the elements of a common kind of analysis, a project in that sense, with all the differences of material and situation. But I do think there is a different sense which I know Edward can talk about interestingly, about doing this work here and doing it in the current United States. I don't think that the pressures which are now on here – bad as they are, with certain kinds of work singled out for discrimination and with the general offensive against education in general and any kind of social critical thought in particular – I don't think these pressures are comparable with those that have for a long time been present within American culture and specifically within the period of Reagan. I mean, obviously, Edward can speak about that more authoritatively than I, but what has happened here and it has been of crucial importance, is that from the mid fifties on I have never in any of this

kind of work felt anything remotely like isolation or problems of
isolation. This is not just at the level of getting on with professional
colleagues in professional work, but in this kind of critical activity. There
was a period of extreme isolation for me immediately after the war,
because most of the people who thought at all like I did were in the
Communist Party, which I could not be. The work of the Communist
Historians' Group which was eventually to bear such extraordinary fruit,
in people like Edward Thompson, Christopher Hill, Eric Hobsbawm
and others, was being done there, and I had occasional contacts with
them. But their political position was one I couldn't accept, especially in
my own fields, especially in what they said about culture or about liter-
ary theory. I was convinced they were wrong and wrong in very damag-
ing ways, which made the Right's job of defeating them comparatively
easy. Therefore one could feel for a time one was in a quite idiosyncratic
position: of being a radical and yet not in contact with the radical poli-
tical and cultural formations, which were then quite different. But, you
see, from the mid fifties that situation began to change, and precisely on
those issues. It had been happening internally, if you read Edward
Thompson's book on William Morris. We were doing common projects
although separated by this political position. But that proved dispen-
sable in the crisis of 1955/56. Suddenly there emerged what people
started calling the New Left in Britain, and through that there was a
connection on the ground, never as big as it should be, never as effective
as it should be, between this kind of work and the sense of other people
who weren't only working on comparable issues but who were working
in that attempt at political and cultural change.

Now I think that this situation determined a lot of my work. It had a
big effect later in the seventies when some people's impression of that
project turned – in a sense in reaction after 1968 – to a certain distan-
cing from what was felt to have been a rather naive attempt to put
material into what was felt to be a common movement: that you could
put educational reforms, or proposals for changing communications in
institutions, into a political agenda which had a hopeful bearer in the
labour movement, if not precisely in the Labour Party. This new posi-
tion had also an intellectual formation of a quite strong kind in the
universities. But the time came when humanism and moralism became
dirty words, and the naivety of this earlier project was widely
commented upon. After that, in a way before that project could reform,
there was the new experience – I am putting this, I suppose, quite
unfairly – the new experience, as it came to that generation, of being hit
when they put their heads above the parapet. I don't want to say this in
any bitter way, because there is a sense in which, if you read this society
as it is, it is pretty amazing if you can keep your head above it as long as

most of us have managed to. Then again, when people started talking in what seems to me very submissive ways about Thatcherism, as if it's been the worst blight that's ever visited the human race and never had there been such cruelty and repression, I really wonder where these people see themselves. Not just in terms of what's happening in the world but even in terms of our own immediate situation. So I do think we should look at the much more pressing experience, as other American friends have told me, the sense if you do this work of isolation, the sense of exposure and the crude political connections of the kind Edward's just mentioned, being made in ways that, well, you'd need one or two of our more egregious right-wing intellectuals with an extra thickness of fibre to dare to make. I am not saying it doesn't happen here. I have felt some of it all the time. But it would be interesting to hear what Edward thinks about what seems to me a clear difference of degree.

Edward Said: The American situation . . . well, first of all, the scale is staggering in its power, in a society that seems to cover everything. Take the instance, as an example of a very simple professional case, of literary theory. As recently as ten years ago, literary theory was considered a province of strange people who were probably Communists and anti-American and somehow dangerous and silly at the same time. Now, it's virtually impossible to think of any major department of English or comparative literature that doesn't advertise for jobs in the annual or monthly job lists of the Modern Languages Association that doesn't say 'needed: specialist for eighteenth-century English or eighteenth-century French literature, preferably also competent in literary theory.' So literary theory which was a very outside thing has now become absolutely central, Yale being the most famous example of all.

On the other hand, there is a narrow kind of minor industry in talking about what happened to the sixties, which are symbolic in everybody's mind for the period of social and political activism, particularly on the campus and in relevant studies and cultural studies and so on. Well, that's all past, and you have a situation now where the prevailing orthodoxies in literary studies are two – both of them part of the general phenomenon of specialization. One of them is 'professionalism', varieties of new pragmatism – Richard Rorty, Stanley Fish, and company, all those associated with what is called anti-theory theory – where we see essentially not just a kind of laissez faire but, in that phrase from the English film of the fifties, 'I'm all right Jack', 'We've never had it so good', so why bother to change? These theories about the absence of change have now insinuated themselves into the literary scene. The other orthodoxy is humanism, where humanism becomes the canon of works that everybody should read, with the Secretary of Education on

down or up depending on your position, celebrating that fact. A third
matter which is, I suppose, a form of isolation but yet consensus at the
same time, is to say people simply don't or shouldn't interfere in other
people's fields or works. If you are an eighteenth century specialist, you
don't involve yourself in Peace Studies or foreign affairs. As everyone
says, we'd better leave that to the experts, and the acquiring, marketing
and merchandizing of expertise is extremely evident everywhere you
look.

The great difference really is that there never has been in America a
central left tradition. I don't just mean this in terms of the consensual
two-party system, Democrats and Republicans. In a more substantial
sense, everything else you see also seems to have died with the sixties,
including the New Left. You have various possible examples. Tom
Hayden who was running in California was one of the principal figures
of the New Left, and is I would say scarcely to the left of Gary Hart; it's
called new liberalism now. There is this compressing centre which – you
know, I have learned so much from Raymond, I feel I am simply resort-
ing to quoting him, in this case from a seminal essay he wrote on base
and superstructure – exerts pressures and sets limits. It operates all the
time in the most unconscious way, so that everybody internalizes these
norms – particularly I would say in the universities where the notion of
specialization is extremely powerful and one finds oneself always having
to look to subaltern groups, Blacks, feminists, various ethnic groups and
so on, for affiliations.

In my particular case, I've just left that to the end, the fact that I am a
Palestinian facing the enormous sort of echo chamber of terrorism
makes it very, very hard for me to do much more than say: you know, I
may be that but don't put me away [laughter] One of the things I
have done is to answer back in a way by writing essays here and there
showing the extent to which the question of Palestine has insinuated
itself in the oddest places, in places which have nothing to do with it; in,
for example, certain types of moral philosophy, in theories of war,
theories of just war in particular. For instance, in a book that appeared
and was widely read about five or six years ago, the author tried to show
that there were norms that allowed one to make a distinction between
just and unjust wars. He is a philosopher, a political philosopher, but in
all instances – pre-emptive strikes, killing of civilians, etc. – the exception
was always Israel; and in a certain sense the construction of the theory of
a just war, I thought, was done to exempt a chosen group in this particu-
lar instance. So, it's a very strange atmosphere made the more contradic-
tory by the fact that in a sense you can say anything you want to say! I
certainly have not found it difficult to say what I want to say; it would be
dishonest of me to tell you that I am silenced all the time. Partly because

of tokenism the *New York Times*, say, needs a Palestinian to say something 'reasonable', I suppose, so they ask me to do it; I don't mind doing it. But somebody like Chomsky who played a really important role – an admired friend of mine – has now in fact become marginalized; he may be brought back but he is off to the corners and *that* happens a great deal. So it's a very different situation, I think, from here; partly also because the stakes are so large.

There are three questions – one general question and two specific questions – that are associated with problematic emphases in the work of Raymond or Edward. The first question concerns the way in which Edward and Raymond use the concept of a 'common culture' and the extent to which working with an idea of a common culture is problematic in theoretical terms in marginalizing the kinds of voices to which the body of their work is directed. The other two questions relate to gender, and as the token woman next to the token Palestinian, I am quite pleased to be reading these out. First, a direct question about gender in relation to Raymond's and Edward's work: how significant is it in your writings that questions of gender are not only suppressed but are often used in a problematic way in order to enhance a progressive analysis of class in Raymond's case or race in Edward's case? And we might want to extend that problematic use of gender images to certain ways in which representations of difference about race were carried out in Orientalism *and possibly differences around class in relation to the beginning of* The Country and the City.

Raymond Williams: On the question of a 'common culture', I think it's one of those phrases that got around from a stage of this argument which basically belongs to the fifties and very early sixties, where precisely the concepts of a common culture and of culture in common were being deployed against the then dominant, the only then dominant, notion of culture; I mean a strict equivalence between culture and high culture, and this phrase 'common culture' – culture in common – was strictly a position against that. It was an argument that culture was both produced more widely than by the social elite which appropriated it, was disseminated more widely than this notion presumed, and that the ideal of an expanding education was that what had been restricted in distribution and access should be opened out. Now I emphasize that it belonged to that phase of the argument. I have seen some very unhistorical transfers of the concept of that phase to later stages of the argument. Because, of course, the way the argument went, the way it necessarily went, and the way that in a sense in another parallel line of argument was already there, was that this was a deeply divided culture and that

these divisions were crucial; moreover, that they included relations of
actual conflict. Well, the problem of this overlap is very complex: that
on the one hand, you use the notion of an extending and participating
common culture against the notion of a reserved or elite culture; on the
other hand, you argue that this common culture isn't just there, or even
there to be distributed in some way, but that the very idea at the moment
challenges these divisions, separations and conflicts, which are yet rooted
in real historical situations.

This overlap belonged to this very particular phase. But as often
happens with phrases, they get circulated in contexts outside their imme-
diate base of argument. I mean, what I have mostly been writing about
since that time has been divisions, problems, inside the culture; things
which *prevent* the assumption of a common culture as a thing which now
exists. In the same way, if you track the word 'community' through these
uses, and certainly this would be true if you track the word through my
work, you would find, on the one hand, that you are opposing a notion
of community to a notion of competitive individualism, and then you are
finding that the idea of community is being appropriated by precisely the
people who say that we have a national community which sets boun-
daries to the way people think and feel and, moreover, which imposes
certain responsibilities. So that you could get in the miners' strike the
two uses: that the miners said they were defending their community, and
they meant the places they lived, and the Coal Board and Thatcher were
saying that this was damaging the community, by which they meant the
existing national social order of which this was a subordinate part,
which if it was genuinely a member of the community could be expected
to *adapt to* the prevailing norms. Now, that's another instance of the way
in which the whole notion of the common and community is precisely
what all this work has been analysing. So, if one says, does the use of this
idea create problems and so on, it *is* the problem; this is what the analy-
sis has been about. Certainly, the project is something 'common' in that
sense, something in the sense of a shared culture includes diversity. But
the moment the notion of community is appropriated for a version
which is going to be dominant, and to which variations are going to
be subordinate, then the same value has turned in an opposite
direction.

As for the issue of gender, well, I think the way people see suppres-
sion is always important, because I have never been conscious of
suppressing gender. If somebody tells me I have, then I have to attend to
that, in the same way that when I say that people have 'read out' aspects
of my experience, I hope they attend to it! They usually don't. I certainly
would attend to this because I have been very conscious of it although in
ways which are necessarily my own. I mean, I would not be a spokes-

person for a suppressed feminine experience; I could not be. On the other hand, again, I think, one gets a certain selectivity of reading in this. I remember in what was actually my central teaching all through the sixties, which was published as *The English Novel from Dickens to Lawrence*, there *is* a discussion of just this issue, and this occurred before, I think, so much consciously feminist literary analysis was being written. I talked about the phenomenon of the women novelists of the English nineteenth century carrying so much of the most questioning consciousness in that culture and in that form and yet – and this is the question whether this was because they were women – a conclusion which I rejected in a way that I know now many women analysts would agree with. I said that they were of course working in an area where it happened that by the very condition of women within a domestic environment and shut off from higher education – not shut off from reading – writing was the one practice to which they had an access which was much less uneven than that in any other public field. It was then not only one in which they excelled, a point in itself, because, after all, in any shortlist of the English nineteenth-century novelists the majority would be women. I said that they had contributed in a major way, that they had represented as a group many of the highest points of consciousness in that culture and in that form and yet – and this is the point I would still argue and expect difference about – not primarily because they were women but because they had escaped certain of the masculine stereotypes which were not the men either. I related this very specifically to the moment in English life and English fiction when men stopped crying. I don't know whether men stopped crying before then; there are no statistics on how often men wept through our history or have wept since or weep today on the relevant occasions. But I know this was the moment in admitted social life and in fiction when men stopped weeping and it is exactly the same moment as the emergence of that remarkable generation of women novelists from Gaskell through the Brontës to George Eliot. And I am saying that I see it as a rejection of the stereotyping. They admitted a kind of intense personal feeling which I analysed in different ways in that book, an intensity of feeling which was immediately categorized as women's fiction and is still, as a matter of fact, in some feminist history today described as important because it is specifically women's fiction. But I was saying that what they kept going was what a certain mutation in masculine self-perception and in certain norms of public life had excluded from permissible male behaviour. Now, that's an incomplete analysis, but you've got to put it beside the notion that I have suppressed the question of gender. I wish I could have done more on it and say more on it, and I listen and get interested in the analysis that is being done by people who should do it,

who are bound to be better able from their experience to see things simply not perceived by people who are not in their situation.

Edward Said: I just want to say something very quickly about culture. I am glad Raymond has spelled it out. The notion of culture is a deeply ambivalent one, about which one *should* feel very ambivalent. I remember a moment in *Politics and Letters* where midway through the discussion of *Culture and Society* one of the questioners asks Raymond: you talk about culture in nineteenth-century England for the most part, but what about the Empire? He is taken to task about not discussing the relationship of the two, and Raymond I think you related that to the unavailability at the time of your Welsh experience that hadn't been as important to you then as it later became. And for me, though perhaps I am putting it too strongly, culture has been used as essentially not a cooperative and communal term but rather as a term of exclusion. Certainly if you read *Culture and Society* again, and take almost without exception all the major statements on culture in the nineteenth century by the great sages and novelists, they refer to 'our' culture as opposed to 'theirs', 'theirs' being defined and marginalized essentially, in my argument, by virtue of race. And so I think culture has to be seen as not only excluding but also *exported*; there is this tradition which you are required to understand and learn and so on, but you cannot really be of it; you can be in it but you are not *of* it. And that to me is a deeply interesting question and needs more study because no exclusionary practice can maintain itself for very long. Then you get the crossings over, as I said earlier, and then of course the whole problematic of *exile and immigration* enters into it, the people who simply don't belong in any culture; this is the great modern or, if you like, post-modern fact, the standing outside of cultures.

Now, as for the question of gender, you cannot possibly look at imperialism or certainly let's say Orientalism without noting the prominent position in it of women – that is to say, prominent by virtue of their simultaneous subordination and centrality. The role of the oriental woman in the whole discourse, the whole imagination of the Orient, is absolutely central and pretty much unchanged; that is to say, it very rarely goes beyond the kinds of essential functions assigned to women – subordination, gratification for the male, all kinds of sensuality and wish fulfilment and so on – that really is to be found everywhere in the worst as well as best writers. And to that extent I wouldn't consider myself to have *suppressed* that. I really do feel that in that situation, in the relationships between the ruler and the ruled in the imperial or colonial or racial sense, race takes precedence over both class and gender. That is a theoretical question which I feel hasn't so far been much debated and

discussed in feminist writing – I mean in historical terms as opposed to just theoretical terms.

The other point I'd like to make is that although I believe certainly in the authenticity and concreteness of experience, I don't believe in the notion of exclusiveness of experience, that is to say, that only a Black can understand black experience, only a woman can understand women etc. I find that a problematic notion, the problem of insider versus outsider as the sociologists have it. So, I think that in those respects I have tried to deal with some aspects of gender but I have always felt that the problem of emphasis and relative importance took precedence over the need to establish one's feminist credentials.

Notes

1. The conversation was preceded by a showing of Mike Dibb's film of Raymond Williams's *The Country and the City*, and Geoff Dunlop's film *The Shadow of the West*, which is based on Edward Said's *Orientalism*.

Raymond Williams: Select Bibliography

Culture, Communications, Politics

Culture and Society 1780–1950 (London 1958)
The Long Revolution (London 1961)
Communications (Harmondsworth 1962; 3rd edn with afterword 1976)
May Day Manifesto, ed. (Harmondsworth 1968)
Television, Technology and Cultural Form (London 1974)
Keywords (London 1976; enlarged 2nd edn 1984)
Problems in Materialism and Culture (London 1980)
Culture (London 1981)
Towards 2000 (London 1983)
Raymond Williams on Television (London 1989)

Literary Criticism and Theory

Modern Tragedy (London 1966; revised edn with afterword 1979)
Drama from Ibsen to Brecht (London 1968)
Orwell (London 1971; 2nd edn with afterword 1984)
The English Novel from Dickens to Lawrence (London 1970)
The Country and the City (London 1973)
Marxism and Literature (Oxford 1977)
Cobbett (Oxford 1983)
Writing in Society (London 1984)
Resources of Hope (London 1989)

Fiction

Border Country (London 1960)
Second Generation (London 1964)
The Fight for Manod (London 1979)
The Volunteers (London 1978)
Loyalties (London 1985)
People of the Black Mountains (London 1989)

Interviews

Politics and Letters: Interviews with *New Left Review* (London 1979)

Index

Raymond Williams
in Verso

POLITICS AND LETTERS
Interviews with New Left Review

'absolutely riveting' *New Society*

'an outstanding feat of composition' *The Guardian*

PROBLEMS IN MATERIALISM AND CULTURE

'The essays gathered together [here] reveal a mind ever
open to new ideas yet careful to subject them to
critical scrutiny.'
New Statesman

WRITING IN SOCIETY

'Williams at his most historically sensitive and intellectually
powerful, grasping the social relations of an age in the
stylistic detail of a literary text.'
New Statesman

RESOURCES OF HOPE
Culture, Democracy, Socialism

'superb . . . a toughly analytic mind is fuelled by the rich
emotional resources of a creative writer.'
The Observer

These titles can be ordered direct from Verso at 6 Meard
Street, London W1V 3HR; or 29 West 35th Street, New York,
NY10001-2291 for US orders.